Study Guide

A World of Art

THIRD EDITION

HENRY M. SAYRE

Oregon State University

The Annenberg/CPB Project

Part of a college-level telecourse in art appreciation
based on *A World of Art*, Third Edition, by Henry M. Sayre.

PRENTICE HALL, *Upper Saddle River, New Jersey 07458*

ISBN 0-13-021500-7
Printed in the United States of America

Contents

Acknowledgments

The *World of Art* telecourse, and this Study Guide in particular, owe their existence to the Annenberg Project at the Corporation for Public Broadcasting, a project designed to make education more accessible to the American public. Annenberg Project Officer Pete Neal and Senior Project Officer Hilda Moskowitz Goodman have provided invaluable insight and direction from the outset. They have helped us understand what a good telecourse should be.

A national Board of Advisors has overseen the project at every level: David Antin, of the University of California, San Diego; Bruce Jenkins, of the Walker Art Center in Minneapolis; Lynn Hershman, of the University of California, Davis; Suzanne Lacy, of the California College of Arts and Crafts; George Roeder, of the School of the Art Institute of Chicago; and John Weber, of the San Francisco Museum of Modern Art. While I must accept responsibility for all of the weaknesses of what we have done, most of the strengths of the project are the result of these people's expert advice. I owe them more thanks than I can even begin to measure. Thanks also to the numerous test audiences—in Miami, Minneapolis, and Portland, Oregon—whose ideas have contributed significantly to the quality of the final project.

The television series, *A World of Art: Works in Progress*, was produced by Oregon Public Broadcasting in cooperation with Oregon State University. John Lindsay, of OPB, and I have served as co-executive producers of the series, and John not only has been generous with his time and help—to say nothing of his extraordinary know-how—but he has been an advocate and a friend. In fact, one of the great advantages of working on a project this large is that it requires the collaboration of everyone involved, and collaboration makes friendships. I count myself lucky to think of the many people at OPB who have helped make this series possible. They are too many to name here, but their names appear in the credits to every segment of the series, and if I do say so myself, we have had a wonderful time together.

A World of Art: The CD-ROM was designed and produced by two recent graduates of the Oregon State University Art Department, both of whom are already making an impact on the design profession, Karen Hsu and Andrew Reid. I think their work is extraordinary, and I feel privileged that they were willing to work for me on this project.

My colleague and friend John Maul, the author of the Test Item File and Teacher's Resource Manual for *A World of Art* and a master teacher who regularly teaches art appreciation to classes of 300 students, helped summarize the chapters for the overviews in each Study Guide lesson, a task for which I owe him my every gratitude.

Finally, Project Producer Sandy Brooke has kept track of everything, kept me on schedule, and kept me sane. That she managed to stay my wife and friend through all of this, I am particularly grateful.

Introduction
How to Use This Study Guide

I have taught in a distance education environment for several years, via closed-circuit satellite with two-way audio and video transmission between sites. Even in this situation, where I have direct visual and verbal contact with my students, it has become apparent to me that students at remote learning sites require the extra guidance and direction that a study guide such as this can provide. There will be many students, as *A World of Art* becomes a national telecourse, who will not have the advantage of direct visual and verbal contact with their instructor, and this study guide should be even more useful to them. But perhaps the most extraordinary lesson I have learned teaching via satellite is just how much students in regular classes on campus benefit from study guides as well. A good study guide should help you to organize your time efficiently. It should help you ask yourself the right questions from the outset. And it should stimulate you to think beyond the obvious. Every student can and should benefit from this book.

The Study Guide follows the organization of the Second Edition of *A World of Art*. It consists of 17 lessons matching the first 17 chapters of the book. An eighteenth lesson summarizes the material comprising the last five chapters of the book, the historical time-line. Each lesson, with the exception of the last, begins with a set of Learning Objectives for the lesson and a list of the Key Concepts that you will be required to master. A Study Plan that presents a step-by-step approach to mastering the material in the lesson follows. Each chapter in the book is then summarized in an Overview.

Depending on whether you are on a quarter system, a semester system, or working on your own , you may have to work at a pace somewhat faster than one lesson per week. The television series *A World of Art: Works in Progress* consists of 10 half-hour videos. Obviously, there is not a separate video for each chapter, and only ten of the lessons have accompanying video material. You need to plan your time accordingly. Consult the Study Plan in each lesson to help you judge how long the lesson will take. Whenever a *Works in Progress* video is to be viewed, a Viewing Guide is included in the lesson. This Viewing Guide extends the text materials on the video presented in *A World of Art* with a biographical sketch of the artist, a set of ideas for you to consider as you view the video, and answers to questions that have frequently been raised by test audiences.

A World of Art: The CD-ROM is designed to give you both a hands-on experience manipulating the formal elements and principles of design, and also to supplement the experience of the videos by providing you with short films depicting particular processes of artmaking, especially ones that are difficult to understand fully without seeing them "live." Directions for use of the CD-ROM are included in the appropriate lessons in a section called Navigating the CD-ROM.

At the end of each lesson we have included a short set of Review Questions that should help you prepare for an examination. This is by no means a complete set of questions covering each and every important aspect of the chapter. Rather, these ques-

tions are designed to help you judge for yourself how well you have mastered the materials in the lesson.

More questions of a similar type can be found on the website that accompanies *A World of Art* (**www.prenhall.com/sayre**). If you have access to the Web, this site can offer you considerable study help. Of special interest are the related sites linked in both the Modern Artists and Galleries and Museums areas.

Finally, each chapter concludes with a set of Supplemental Activities, essay questions, and Suggested Further Reading. Even if you are not required to complete any of these last activities, it is probably worth your while to read them. They are all suggestive enough that, simply by considering the issues they raise, you will have a greater conceptual grasp of the importance of the material dealt with in the lesson.

We believe that the package we have put together here—the Second Edition of *A World of Art*, the video series *Works in Progress*, the CD-ROM, the website and the Study Guide— provides you with the most complete, and the most exciting, set of materials ever created for an art appreciation course. We hope that this Study Guide helps you to get the most out of what we have made for you.

Henry M. Sayre
Oregon State University
June 1999

Study Guide Lesson for

Chapter 1

A World of Art

LEARNING OBJECTIVES

This lesson will help you understand both how artists see the world and how we see what artists make. At the end of this chapter you should be able to:

1) Begin to define the concept of the *aesthetic*.

2) List the four traditional roles of the artist.

3) Briefly describe the creative process.

4) Describe the physical process of seeing.

5) Describe the psychological process of seeing.

KEY CONCEPTS

The traditional roles of the artist, which are:

(1) to record the world.
(2) to give tangible form to feelings.
(3) to reveal hidden or universal truths.
(4) to help us see the world in a new
 or innovative way.

the creative process
reception> extraction> inference
the physical vs. the psychological process of seeing

STUDY PLAN

Step 1: Read Chapter 1, "A World of Art," in your text, *A World of Art*, pp. 2-17.

Step 2: Attempt to answer the questions posed in the CRITICAL PROCESS section at the end of the chapter. Don't worry if you find that you have a difficult time. Proceed to the next step.

Step 3: Read the OVERVIEW of Chapter 1 in this study guide lesson. When a specific work of art that is illustrated in the text is discussed, try to visualize it. If you are unable to remember it, open the text to that illustration and refresh your memory.

Step 4: Return to the LEARNING OBJECTIVES and KEY CONCEPTS sections at the beginning of this study guide lesson. Demonstrate your mastery of each of the learning objectives. Define each of the concepts—each is discussed in the text and each appears in the glossary at the end of your text as well.

Step 5: Return to the CRITICAL PROCESS section at the end of the chapter. Having reviewed the material, attempt to answer the questions again. Turn to the back of the text, p. 513, and compare your answers to those provided by the author.

Step 6: Answer the REVIEW QUESTIONS.

Step 7: Complete the assigned SUPPLEMENTAL ACTIVITIES and WRITING ASSIGNMENTS in this study guide lesson.

Step 8: Pursue any title from the SUGGESTED FURTHER READING that is assigned or that interests you.

OVERVIEW
of Chapter 1 - "A World of Art"
A World of Art

This chapter is an introduction to the process of making and seeing works of art. It begins with a consideration of a recent work by the artist Christo. In unveiling *The Umbrellas* (Figs. 1 and 2), a monumental sculpture work set up simultaneously in Japan and California, Christo pushes our understanding of the space of art to new limits. We must consider the actual three-dimensional space in which each individual umbrella exists; the space of the local landscapes themselves; and finally (if not amazingly) the fact that Christo has created a work that demonstrates "global" space. One must negotiate the actual space of the globe to see the work in its entirety! *The Umbrellas* also points up similarities and differences between the two cultures. In California, the umbrellas spread out over distances relaying the vastness of the California landscape, their yellowness complementing the dry, light golden brown of the terrain. In Japan, their close proximity to one another speaks to the preciousness of physical space, their blue color complementing the lush green of the Ibaraki valley. The differing colors signify differences between cultures, yet in both cultures the umbrella serves as a symbol of shelter and protection, of community life and volunteer spirit.

While the project was undoubtedly different for its Japanese and American viewers, both groups probably asked similar questions—What is the work's purpose? What does it mean? What are the artists's intentions? Was it a waste of time? These questions are examples of the types of things readers should ask themselves about any form of art. They should inspire students to analyze and think critically about what they see.

The Umbrellas project demonstrates that while art is something that all cultures share, it does not carry the same meaning from culture to culture. While we in the West might view the objects of Asian, African, or Native American culture in a museum as "works of art," in those cultures, they might have served as tools with ritual, social, or utilitarian functions. They might have served to document events or establish family and community relationships. They might also be thought of as *aesthetic* object, works intended to suggest beauty to the viewer. This last function has traditionally been a Western function of art, but many artists now question this ideal, seeking to make statements about social, political, and moral dillemmas. They want to engage the world.

The World as Artists See It

A World of Art begins by examining four different treatments of the same subject—landscape. Of particular interest is the fact that each artist treats the subject differently in form and content. Each artist sees the world in a different way.

Albert Bierstadt's *The Rocky Mountains* (Fig. 3) appears to be an objective representation of the American West

that, in 1863, few Americans had actually seen. In describing the work, the critic H. T. Tuckerman states that it is faithful in its reproduction of color and accurately describes the grandeur of the scene. However, in truth, it is really an exercise of Beirstadt's recollection of the Swiss Alps and is not an accurate depiction of an authentic scene anywhere in the western United States! As the text says, it's as if Bierstadt "longs for America to be Europe," so he paints it that way. Still, Bierstadt's role as an artist in this case appears to have been to *(1) record the world*, and although the work does not record it accurately, it reflects Bierstadt's feelings about it.

A second traditional role of the artist is to *(2) give tangible form to feelings*. Wu Chen's handscroll, *The Central Mountain* (Fig. 4) is composed according to strict artistic principles of unity and simplicity, elevating a bland and common view to the highest level of beauty, and in the process revealing profound truths about nature. His background in Taoist philosophy caused him to paint in a manner which revealed the complementarity of the world, known as *yin* and *yang*. *Yin* is nurturing and passive, and is represented by the earth and its cool moist valleys. *Yang* is generative and active, represented by the sun and the mountain. Wu Chen's goal was to reveal this relationship or universal truth through his work.

Like Wu Chen, the Australian aboriginal artist Erna Motna also wishes to reveal something "larger than himself" in *Bushfire and Corroboree Dreaming* (Fig. 5). The third traditional role of the artist, *(3) to reveal hidden or universal truths,* is one both Wu Chen and Motna share. Motna reveals larger truths through the organizational logic of the "dreaming." The *Dreaming* is a unique Aboriginal system of belief indicating the presence or mark of an ancestral being in the world. Images of these Beings—representations of myths about them—make up much aboriginal art. To the aboriginal people, the entire landscape is a record of a series of marks made upon the earth by the Dreaming. The landscape serves to record an ancestral spirit's passing, and painting is then understood as a concise vocabulary of abstract marks conceived to reveal the ancestor's being, both present and past, in the Australian landscape.

Traditionally these marks and motifs were made on rocks, the ground, or peoples' bodies. They were created for ceremonial or ritual purposes and were often temporary. When Geoff Bardon arrived in Australia and introduced acrylic paints to the aboriginal artists, the resulting works became not only permanent, but portable, and soon drew a market in the West. Consequently, the immediacy of the paintings was lost, and in come cases, they became commodities. Conflicts have arisen over how much secret ritual information has been revealed, but, at the same time, the paintings have tended to revitalize traditions that were thought to be extinct.

While Westerners have trouble deciphering Motna's marks as landscapes, artist Robert Smithson's giant earthwork *Spiral Jetty* (Fig. 6) is not only similar to, but, in fact, IS landscape. Constructed of earth, mud, rock, and salt crystals, it is a geological record of the place. The spiral form exists in nature as a whirlpool, an expanding nebula, and as a nautilus snail shell. In

that sense, Smithson shows how these forms or forces are at work in the universe, and like Wu Chen's landscape, reveals a greater truth. In providing this manmade spiral, Smithson also demonstrates a fourth traditional role of the artist—*(4) to help us see the world in a new or innovative way.* Finally, all four artists assume all four of the traditional roles to some degree. All four create visual images, and all four have the necessary ambition to bring their creativity to fruition. As artists, their work exemplifies the necessity of seeing.

═══════════

WORKS IN PROGRESS
The Creative Process

The first Works in Progress segment in *A World of Art* examines the roles of the artist and looks at the creative motivation behind two artists, Albert Bierstadt and Robert Smithson.

The text suggests that all people are creative, but not all people "possess the energy, ingenuity, and courage of conviction required to make art." In order to produce a work of art, the artist must be something of an explorer and inventor. John Constable spoke of "the art of seeing nature," an art of seeing that promotes to imagining and leads in turn to making.

Albert Bierstadt's *The Rocky Mountains* (see Fig. 3), with its apparent contradictions—more European than American, more a figment of his imagination than a reality—is discussed first. Through comparisons to an earlier oil sketch (Fig. 7) far less dramatic than the final work, we gain insights to Bierstadt's creative process. He felt it his right, even his duty, to "elevate"

the scene. In fact, his writings reveal a similar "elevation," comparing the Rockies to the Bernese Alps.

By contrast, Robert Smithson's sketches for the *Spiral Jetty* (Fig. 8) explore how the earthwork will appear from twenty different, mostly aerial points of view. Smithson realized that the *Jetty* would exist, for most people, only in its photo-documentation, and he is anticipating that "photo-reality" in his drawings. Smithson is as interested in his audience as he is in the work itself. But, like Bierstadt's manipulation of his mighty peak, Smithson's drawings of the *Jetty* literally "elevate" the scene. Smithson's *Jetty*, in other words, participates in the same love of the sublime that Bierstadt celebrates in *The Rocky Mountains*, and the drawings help us understand how.

═══════════

The World as We Perceive It

The text states: "Many of us assume, without question, that we can trust in the reality of whatever we can see." However, that perceptual knowledge does not necessarily provide a complete understanding of the subject before us.

Childe Hassam's *Allies Day, May 1917,* and Jasper Johns's *Three Flags* (Figs. 9 and 10) are compared to one another. *Allies Day* was inspired by the patriotism of World War I. It is a straightforward representational "scene." By contrast, *Three Flags* (three U.S. flags superimposed upon one another, with each becoming progressively smaller) has an unclear meaning. To some viewers it would seem to demean the American flag. Created at a time (1958) when patriotism was largely inspired by nationalism, and colored by McCarthyism

and the fear of Communism, Johns's image forces us to examine the meaning of our national symbol.

The Physical Process of Seeing

There are three steps in the physical process of seeing:

reception > extraction > inference.

First, external stimuli enter our eyes, we receive the image—"we see the light." Next, the retina of the eye extracts information and sends it to the visual cortex. At this stage, a great deal of "selection" or physiological "natural" editing takes place. Finally, our information becomes an inference, based upon what the first two facets of the process have selected for us to understand. As we are all different, we all perceive things differently, and we do not see things as thoroughly as we assume. Seeing becomes a physically creative process.

The Psychological Process of Seeing

Seeing is also, however, a psychologically creative process. The way we see psychologically is filtered through all the experiences of our lives—the fear, prejudices, desires, emotions, customs, and beliefs of both artist and viewer. In three examples of art all featuring the U.S. flag, we see three very different interpretations. Freedom, victory, and respect for those who gave their lives for their country, is inherent in De Weldon's *Marine Corps War Memorial* (Fig. 11), the flag raising at Iwo Jima. The flag described by black feminist artist Faith Ringgold (Fig. 12) carries an altogether different meaning. The white woman who pledges allegiance to the flag also bars the black American from the vote. The crib quilt (Fig. 13) represents both Kansas's entry into the union in 1861, and the entry of the baby for whom it was made into the

world. Beneath this is yet another interpretation. Kansas was a state torn between joining the Union or the Confederacy. This quilt might serve as a statement of support for Lincoln's Republican Party.

One of the most controversial images concerning the flag was Dred Scott Tyler's installation, *What is the Proper Way to View the American Flag?* (Fig. 14). The flag, a symbol of freedom, was displayed on the floor under a book in which the observer was asked to write comments. Because many people refused to "insult" the symbol by stepping on it, the flag effectively became the barrier that prevented the freedom of expression (writing in the book). The exhibit created a controversy that begged a reconsideration of freedom of expression vs. the interpretation of laws that are designed to "protect" the flag.

In summary, the traditional roles of the artist—to record the world, to give visible or tangible form to feelings, to reveal hidden or universal truths, and to help us see the world in new ways—are part of a general impulse that leads to an artist creating a work of art. Once the work is made, it is up to us to interpret and understand it.

THE CRITICAL PROCESS
Thinking about Making and Seeing

In the Third Edition of *A World of Art*, a new segment has been added at the end of every chapter called The Critical Process. It is intended to direct students toward asking critical questions regarding the ideas put forward in the chapter. To "guide" the student further, additional insights are provided at the end of the text, in the section titled The Critical Process: Thinking Some More about the Chapter Questions.

In Chapter 1, Andy Warhol's *Race Riot* (Fig. 15) is considered. It depicts events of May 1963 in Birmingham, Alabama, when civil rights demonstrators led by Reverend Martin Luther King, Jr. were dispersed with use of force. With this image in mind, consider the traditional roles of the artist: 1) to record the world; 2) to give visible or tangible form to ideas, philosophies, or feelings; 3) to reveal hidden or universal truths; and 4) to help us see the world in new or innovative ways. How do they relate to Warhol's work?

REVIEW QUESTIONS

Answers to the following questions appear in the APPENDIX: ANSWER KEY at the end of the *Study Guide*.

1. In Western culture we are used to approaching objects made in African, Oceanic, Native American, and Asian cultures as "works of art." What other ways are there to approach them? *Tools of Ritual, Social, or Utilitarian function Document Events, Record family & community relationships*

2. In this chapter, we have discussed the four traditional roles of the artist by looking at the work of four artists who approach the landscape in different ways. We have seen that while each emphasizes a different role, all of them take on, at least partially, all four of the roles. But what basic trait unites all four artists? *Create Visual Images, They are creative people.*

3. In what way is the act of seeing a *creative* process? *Seeing is creative we choose what we want to process from the information we see*

4. Which of the following come into play in the act of seeing? *Prejudices come into play, fears, customs, desires beliefs*

 a) analysis
 b) prejudice
 c) inference
 d) reception
 e) inception

5. Which of the following statements are *true*?

 a) The landscape in Albert Bierstadt's *The Rocky Mountains* is sublime.
 b) Wu Chen's *Central Mountain* is inspired by the Tao.
 c) Erna Motna's aboriginal painting utilizes materials long known to his people.
 d) Robert Smithson's *Spiral Jetty* is utilizes one of the most widespread of designs, the spiral.

SUPPLEMENTAL ACTIVITIES AND WRITING ASSIGNMENTS

Supplemental Activities: A good way to explore the process of seeing is to poll friends and acquaintances about images of the American flag. Show them Jasper Johns's *Three Flags* (Fig. 10) in your book. Ask them if they like or dislike it and ask them why. Record their responses. Then show them Scott Tyler's *What Is the Proper Way to Display the American Flag?* (Fig. 14). Explain it to them as necessary. Ask them if they like or dislike it and ask them why. Record their responses. Summarize this research.

The Website: Go to the *World of Art* website (**www.prenhall.com/sayre**). Proceed through the Chapter 1 materials. Consider your command of the objectives as stated in the website. Take the multiple choice and fill-in-the-blanks self-tests. Briefly respond to both the critical analysis and the compare and contrast questions, either formally or informally. Visit the related sites linked in both the Modern Artists and Galleries and Museums areas. A hands-on project related to the course material is suggested. Even if you are not assigned the Project, think about how you might approach it. Finally, consider participating in the Message Board or Chat Discussions.

Writing about A World of Art: Scott Tyler's *What Is the Proper Way to Display the American Flag?* (Fig. 14) is a controversial work of art. In fact, many people do not think it qualifies as a work of art because they see no aesthetic merit in it. Write a brief essay defending Tyler's work as art, not necessarily by arguing that it has aesthetic merit but by exploring what other objectives art might reasonably seek to accomplish.

Writing to Explore New Ideas: One of the most important sets of prejudices that every student brings to a course on art appreciation is their preconceived feelings and ideas about art itself. It is entirely possible that, even after just this first chapter, your feelings and ideas may have changed somewhat. But it is important for you to state your feelings now. What, in your estimation, is art? What should it do? What purposes, if any, does it serve? Why, it may even be worth asking, should we bother to study it in a college course? Try to state your ideas truthfully, as opposed to saying what you think the teacher wants to hear. Later in the course we will reexamine your feelings and ideas to see if they have changed.

Suggested Further Reading: For more on Chinese painting such as Wu Chen's *Central Mountain*, see Jerome Silbergeld, *Chinese Painting Style* (Seattle: University of Washington Press, 1982).

The story of Australian aboriginal acrylic painting is told in *Dreamings: The Art of Aboriginal Australia*, ed. Peter Sutton (New York: George Braziller and The Asia Society Galleries, 1988).

Chapter 2
Developing Visual Literacy

LEARNING OBJECTIVES

This lesson will help you understand the basic ways by which works of art communicate meaning. At the end of this chapter you should be able to:

1) Discuss some of the problematic relationships between words and images.

2) Distinguish among representational, abstract, and nonobjective works of art.

3) Distinguish both between subject matter and content and between form and content.

4) Understand how conventions, including iconographical traditions, contribute to the meaning of works of art.

KEY CONCEPTS

visual literacy
calligraphy

representation
subject matter
content
form
composition

representational art
abstract art
nonobjective art

conventions
iconography
ethnocentricity

STUDY PLAN

Step 1: Read Chapter 2, "Developing Visual Literacy," in your text, *A World of Art,* pp. 17–35.

Step 2: Attempt to answer the questions posed in the CRITICAL PROCESS section at the end of the chapter. Don't worry if you find that you have a difficult time. Proceed to the next step.

Step 3: Read the OVERVIEW of Chapter 2 in this study guide lesson. When a specific work of art that is illustrated in the text is discussed, try to visualize it. If you are unable to remember it, open the text to that illustration and refresh your memory.

Step 4: Read the VIEWING GUIDE to *Works in Progress: Lorna Simpson* in this study guide lesson.

Step 5: View the video *Works in Progress: Lorna Simpson*, following the VIEWING GUIDE as you watch. Take notes and jot down ideas in response to the VIEWING GUIDE. Your instructor may require you to hand in written responses, formal or informal, to some or all of the topics that the VIEWING GUIDE sets out for your consideration. View the video a second time if necessary.

Step 6: Open the Photo-Silkscreen Printing area in the Visual Demonstrations room of the CD-ROM. It explains the technical process that Simpson and her printer, Jean Noblet, employ to make the prints seen in the video.

Step 7: Return to the LEARNING OBJECTIVES and KEY CONCEPTS sections at the beginning of this study guide lesson. Demonstrate your mastery of each of the learning objectives. Define each of the concepts—each is discussed in the text and each appears in the glossary at the end of your text as well.

Step 8: Return to the CRITICAL PROCESS section at the end of the chapter. Having reviewed the material, attempt to answer the questions again. Turn to the back of the text, p. 513, and compare your answers to those provided by the author.

Step 9: Answer the REVIEW QUESTIONS in the study guide Complete the assigned SUPPLEMENTAL ACTIVITIES and WRITING ASSIGNMENTS in this study guide lesson or at the website.

Step 10: Pursue any title from the SUGGESTED FURTHER READING that is assigned or that interests you.

OVERVIEW
of Chapter 2 - "Developing Visual Literacy"
A World of Art

In Chapter 2, we begin to introduce the vocabulary—terms and defintions—that we need to think critically about art. To understand what we see and to be able to communicate it, we must develop visual literacy.

The mass-appeal and effect of media in Western culture, derived from such sources as magazines and television, have made us visually dependent, but not necessarily visually literate. We tend to take the visual world for granted. If we see it, we assume we understand it. However, visual images exist apart from visual reality.

Words and Images

The degrees of distance between "real" things and the words with which we refer to them is the point of Rene Magritte's *The Treason of Images* (Fig 16). We tend to look at the painting as if it were a pipe, and of course, it isn't—it's a representation of a pipe. Furthermore, the word "pipe" is not the same as the image of the pipe. The word is an abstract set of marks that represents in language the thing and its image. Language, therefore, is further removed from reality than visual representation.

In the West, we sometimes confuse words with the things they represent. This is not true in other cultures. In Muslim culture, the separation of word from what it represents is seen as a virtue. To create a representative image of the human figure suggests the creation of the human, and hence the artist's arrogance (hubris) at entering into competition with the Creator himself. For that reason, **calligraphy** is the chief form of Islamic art.

The Muslim calligrapher is actually thought to be the medium through which Allah expresses himself. "In the name of Allah"—a phrase called the *bismillah*—once began all Islamic books. It was thought that a scribe who wrote the *bismillah* in as beautiful a form as possible would receive forgiveness for his sins.

═══════════════

Works in Progress
Lorna Simpson's *The Park*

The *Works in Progress* video series begins with a discussion of Lorna Simpson, whose work continually addresses the relationships between words and images. See the VIEWING GUIDE in this lesson.

═══════════════

Printed words have their limitations as well. In the example of three trees (Fig. 20), we begin on the left with C.E. Watkins photograph of a tree, followed by a drawing of a tree, followed by the written word, "tree." Written words require a knowledge of language in order to be understood. A photograph of a tree, a drawing of a tree, and the written word "tree" are all abstractions, yet the written tree requires that one have a knowledge of English in order to understand the concept. The photograph and drawing have more universal recognition. This points out the power of images, but at the same time, the necessity of a language to verbalize or contextualize those images.

A case can be made then for the primacy of images over words, but even photog-

raphy, the most "objective" form of "real" image documentation, can deceive us. Duane Michael's photograph of an embracing couple (Fig. 21) purports to be a document indicating that the couple was once really in love, yet we have no way of actually knowing this.

Describing the World

Words and images then are seen as two different systems of representation. In a **representation**, things from the real world are "re-presented" is a different form, but some represented things seem more naturally real than others.

Representational, Abstract, and Nonobjective Art

When we use words to talk or write about art, most of us can rely upon a basic set of terms, and we begin with three: **Representational**—an art that depicts things in the real world "realistically" (traditional photography is an example); **Abstract**—an art that reduces the world through abstraction to its essential qualities, or distorts it to heighten its expressive impact; and **Nonobjective** (or non-representational)—an art in which shape or form serves as the actual subject matter itself.

The four images presented on pages 24-25 illustrate four degrees of representation, from photographic realism, through the abstract, to the nonobjective.

Pat, by John Ahearn and Rigoberto Torres (Fig. 22), is so true to life that it almost looks real. This type of sculpture is often called **super realist** (**photorealist** is a term usually reserved for two-dimensional art). *Pat* attains this high level of naturalism because the sculpture is life cast directly from the person.

Baby Girl, by the artist Marisol (Fig. 23), is more abstract. The human form is represented as stacked blocks of wood, with the features drawn on the surface of the wood, or crudely carved as in the legs and feet. This image is more **abstract**, and does not try to recreate the world exactly. In fact the huge size of the work suggests the emotional presence of a monster, an all-consuming, all-demanding force, larger than actual size.

Untitled, by Joel Shapiro (Fig. 24), is a barely representational, highly abstract version of a human lying on its side. Shapiro believes that we see representational ideas in many forms, so he lets us see the nine wooden blocks as a figure.

Redan, by Carl Andre (Fig. 25), is **nonobjective**. It makes no reference to the objective world. Andre's primary interest is in the form itself, not what it might represent, even though *redan* by definition refers to an architectural placement of walls at right angles to one another.

One cannot always make exacting distinctions between the representational, the abstract, and the nonobjective. Shapiro's work illustrates that work can be more or less abstract or representational. Purely nonobjective art, such as Malevich's *Suprematist Painting* (Fig 26), is concerned only with form.

Form and Content

The term "form" means everything from materials used to make the work, to the way the work employs various visual or "formal" elements, to the way these elements become a composition. To Kasimir Malevich, form becomes the content, whereas Monet's *Grainstack* (Fig. 27), while making use of nearly identical forms, carries a far different content, or meaning.

The *Grainstack* series was intended to capture the moods of the environment like a series of mirrors, with the primary changes in the paintings described through quality of their light. Monet was interested not only in light, but the dynamism of an ever-changing world.

In successful works of art, form and content are inseparable. The two figures of heads (Figs. 28 and 29) demonstrate how very different forms of the same subject can create radically different meanings. Kenneth Clark fails to recognize this in his comparison of the two heads—the Greek *Apollo Belvedere* and the Sang Tribe Mask. He states: "I don't think there is any doubt that the Apollo embodies a higher state of civilization than the mask. They both represent spirits, messengers from another world.... To the Negro imagination it is a world of fear and darkness...To the Hellenistic imagination it is a world of light and confidence...." It is Clark's Western tradition, if not outright fear, that causes him to see the mask as foreboding.

Conventions in Art

Clark's reliance upon Western values causes him to view the mask by the Gabon artist with disdain and also demonstrates **ethnocentricity**, one culture imposing its values upon the art of another. His comparison demonstrates the potential misunderstanding from an "ethnocentric evaluation." Individual cultures always develop a traditional repertoire of visual images and affects they tend to understand in a particular way.

Such ways of seeing are called **conventions**. The best light in which Clark's comparison can be seen is through the typical Western convention that assumes a face is the reflection of the psychological reality within (Fig. 30).

There are many Western collectors who value African Masks for their forms and perceived horrifying emotional expressiveness, though this is clearly not how the artists and cultures that produced such masks see them. The Baule mask (Fig. 31), though valued by its makers and users for its form, is an important part of a sacred dance. Its appearance in the community signifies a completely different set of associations—joy and happiness.

This explains in part why Africa has been traditionally viewed as the "darkest" continent, ever since Europeans arrived there in the sixteenth century. It is Clark's Western tradition, if not outright fear, that causes him to see the mask as foreboding.

Iconography

Jan van Eyck's *The Marriage of Giovanni Arnolfini* (Fig. 32) is a good example for understanding symbolic form or **iconography**. Most of the represented objects in the room are symbols that would be readily understood by a fifteenth-century audience, but not necessarily by any other. The most obvious is the dog, which in Western culture has always symbolized fidelity. (But remember, in Islamic culture, the dog serves as a symbol of filth.)

Similarly, most of us recognize an image of Buddha when we see one, but few of us understand the meaning of the *mudra*, or hand gestures that the Buddha makes (Figs. 34 and 35). One of the most popular of the mudra is the gesture of touching the earth, which represents the moment at which Buddha attained enlightenment.

Symbolic story-telling of this nature has a Western equivalent in the stained glass panels in the windows of Chartres Cathedral (Fig. 32). The windows at Chartres tell the story of Christ from the Annunciation to the Adoration, and

because of their illumination they in effect transcend their material glass composition to become an ethereal and inspirational expression. Beyond the image and the symbol, the church leadership understood that it was "their art" which gave them power—the transformation of "material into that which is immaterial."

THE CRITICAL PROCESS
Thinking about Visual Literacy

In Chapter 2, two images are presented that document the same event from the point of view of two different cultures. One is by John Taylor, a journalist hired by *Leslie's Illustrated Gazette* (Fig. 37), and the other is by the Native American artist Howling Wolf (Fig. 38), son of the Cheyenne chief Eagle Head. Both images depict the October 1867 signing of a peace treaty between the Cheyenne, Arapaho, Kiowa, and Comanche peoples and the U.S. government at Medicine Lodge Creek in Kansas.

Taylor's illustration is based on sketches done at the scene, and it appeared soon after the events. Howling Wolf's work, actually one of several depicting the events, was done nearly a decade later, after he was taken east and imprisoned at Fort Marion in St. Augustine, Florida, together with his father and seventy other "ringleaders" of the continuing Native American insurrection in the southern Plains. While in prison, Howling Wolf made many drawings such as this one, called "ledger" drawings because they were executed on blank accountants' ledgers.

The conventions used by this Native American artist differ greatly from those employed by his Anglo-American counterpart. The reader is asked "Which, (work of art) in your opinion, is the more representational? Which is the more abstract?" Each work possesses the same overt content, yet the works are different in form. Interestingly, while Taylor's drawing might be seen as more representational, Howling Wolf's drawing exactly describes the symbolic features of native dress—his characters are readily identifiable. The questions that follow all ask the student to consider the ideas of convention, ethnocentric appraisal, and iconography.

VIEWING GUIDE
to *Works in Progress: Lorna Simpson*

Lorna Simpson
Biographical Sketch

Lorna Simpson was born in 1960 in Brooklyn, New York. She was trained at the School of Visual Arts in New York and then at the University of California, San Diego. She began her careeer as a documentary photographer and, though her work maintains its roots in the documentary photography tradition, addressing themes of cultural, political, and social significance, it has moved farther and farther from photography per se. She is best known for her series of life-size "portraits" of African-American women in which most of the models' facial features cannot be seen. These portraits are accompanied by texts which intentionally "twist" or problematize the image itself. An example is *Necklines* (Fig. 18).

Simpson's ability to challenge the meaning of the visual image by means of her texts is matched by her desire to challenge our expectations about photography itself. In the mid-1990s, for instance, she began to experiment with printing her images on felt, as opposed to glossy photographic paper. Where photographs normally seem to reflect light, her images on felt seem to absorb it. She continues to experiement with printing techniques, questions of size and scale, and the relation between the image and the viewer—so much so that it is increasingly difficult to think of her as simply a photographer. Her art, rather, approaches painting, sculpture, and even film, in its relation to its audience.

Summary and Introduction

Works in Progress: Lorna Simpson details Simpson's making of a series of large, multi-paneled photographs for the November 1995, inaugural exhibition at Sean Kelly's new Mercer Street gallery in Soho, New York City. Simpson had initially thought that the series would be printed on felt by a lithographic process (described in detail in Chapter 11, Printmaking) in which photographic emulsion is transfered to a lithographic stone. Three weeks before the show, however, it became evident that the process would not work—the stone could not hold enough ink, nor was the image consistent enough for Simpson's purposes. She had worked a couple of years earlier with Jean Noblet, one of the leading silkscreen printers in the world. She called his New York studio, and he agreed to help her produce the series. Silkscreen printing (described in Chapter 11, Printmaking, p. 229) had the advantage of allowing large amounts of ink to be transferred to the felt. Furthermore, Noblet owned a laser drier that would allow them to see the finished product almost as soon as it was printed. In the short time they had to work, this proved crucial.

Noblet himself had never printed on felt, and so the collaboration between artist and printer was for all parties involved experimental. The time pressure was enormous. Sean Kelly, whose new gallery would open with the show, believed that Simpson could pull the show together, but even on the day of the opening, Simpson was still printing the final piece.

The six pieces finally produced for the show are large, multipaneled works. Each is accompanied by a text designed to alter the viewer's sense of what they are seeing. In this sense, the theme of the works could be said to be *change*—the change the viewer undergoes in the process of seeing. But the overt theme of the works is "public sex," a theme inspired by a book called *Public Sex: The Culture of Radical Sex* (Pittsburgh: Cleis Press, 1994) that Simpson discovered with a friend. Written by Pat Califia, Simpson was interested in the fact that in order to conduct research, Calafia had to become a sort of professional voyeur, albeit in the interests of social science. Thus, one of the central motifs of the series is the act of looking, the ways in which both the photographer and the audience become engaged in an act of voyeurism. But, curiously, it is not the act of seeing that tells us the most intimate details of these scenes. Rather it is the act of reading the texts that Simpson has written to accompany each image.

Works in Progress: Lorna Simpson moves between Simpson's actual process in making the series and the process of hanging it at Sean Kelly's gallery. In the CD-ROM, we have detailed the photo silkscreen process employed by Jean Noblet in a step-by-step sequence. If you are interested, or confused, you should turn to the CD-ROM guide in this lesson. It may also be useful for you to review this video when you get to Chapter 11, Printmaking, later in the course.

Ideas to Consider

1. Though Lorna Simpson is usually classified as a "photographer," early in the video she denies being very interested in photography per se. What other sorts of issues interest her? What other labels might be appropriately used to describe her as an artist?

2. Consider the relationship of text to image in these works. Which work changes the most dramatically for you when you read the text? Or what text surprises you the most?

3. Consider the relationship between seeing these images in a gallery and the essentially private act of reading? Can you relate this experience to the theme of the work itself?

4. Sean Kelly, who owns the gallery Simpson shows in, has a vested interest in promoting her work. Another way to say this, is that he is not necessarily the most objective person whom we might have chosen to discuss her work. But we made an editorial decision to include his point of view, not only because he knows her work well and is articulate about it, but because we thought it would be useful for you to see first-hand something of the relationship that exists between many artists and their dealers. The gallery is an important part of the artist's world. Having seen the video, what issues does Kelly's participation in it raise?

Frequently Asked Questions

How were the artists featured in the Works in Progress series chosen? The artists were selected by an advisory board of national experts whose names appear at the end of each episode. They are:

> David Antin, Professor Emeritus and former Chair, Department of Visual Studies, University of California, San Diego;
>
> Lynn Hershman, Professor of Intermedia, University of California, Davis;
>
> Bruce Jenkins, Curator of Film and Video, Walker Art Center, Minneapolis, Minnesota;
>
> Suzanne Lacy, Dean, California College of Arts and Crafts, Oakland, California;
>
> George Roeder, Dean of Undergraduate Studies, The School of the Art Institute of Chicago;
>
> John Weber, Curator of Education and Public Programs, San Francisco Museum of Modern Art.

Before the project began, this board of advisors met for two days, together with the series producers and directors. Each arrived with his or her own list of people whom they thought ought to be included. The lists were compared, and the group arrived at a consensus decision.

What criteria were used to pick the artists? Because we wanted to cover a range of media, we asked each of the advisors to name one or two artists in each of as many different media as possible. Since we had also decided to let the artists speak for themselves as much as possible, we insisted that each artist be articulate. We didn't want to make a video on anyone about whom important videos or films had already been made by others. Finally, we were committed to representing the diversity of art-making in this country, but this last never really became an issue in the selection process. In picking those artists whom we considered among the best working today, we ended up with a group almost as diverse in terms of age, gender, and ethnic background as we could have hoped for if that had been our first consideration.

NAVIGATING *A World of Art*: THE CD-ROM

The *World of Art* CD-ROM contains one doorway, in the Visual Demonstrations Room, that will help you to understand the material in the Lorna Simpson *Works in Progress* episode.

Photo-silkscreen: One entire area is dedicated to the completely mechanized silkscreen process employed by Jean Noblet to make Lorna Simpson's images. Move the pointer to the directional arrow and hold down the mouse button as the room spins until the Photo-silkscreen doorway appears. Stop, then double-click on the doorway, and the Photo-silkscreen QuickTime video will open. Follow each step of the process as the video progresses.

Notice that as you scroll through the video, you can slow it down, speed it up, even stop it. As you move through, each step in the process appears in the text block below the video. You have the opportunity here to see the entire process from beginning to end.

REVIEW QUESTIONS

Answers to the following questions appear in the APPENDIX: ANSWER KEY at the end of the *Study Guide*.

1. Which of the following images is the most abstract?
 a) Monet's *Grainstack* (Fig. 27)
 b) Sang African mask (Fig. 29)
 c) Simpson's *The Park* (Fig. 19)
 d) Smithson's *Spiral Jetty* (Fig. 6)

2. Which is the most representational?
 a) Monet's *Grainstack* (Fig. 27)
 b) Sang African mask (Fig. 29)
 c) Simpson's *The Park* (Fig. 19)
 d) Smithson's *Spiral Jetty* (Fig. 6)

3. What is the difference between subject matter and content?

4. In what type of artwork are form and content most closely related?

5. In what way is Kenneth Clark's reading of the Sang mask ethnocentric?

6. Who do we see in the mirror at the back of van Eyck's *Marriage of Giovanni Arnolfini and Giovanna Canami*?
 a) Giovanni Arnolfini
 b) Giovanna Canami
 c) the artist, van Eyck
 d) all three of the above

7. *Mudra* are
 a) conventions of Buddhist sculpture.
 b) iconographically significant.
 c) hand positions.
 d) all of the above.

SUPPLEMENTAL ACTIVITIES AND WRITING ASSIGNMENTS

Supplemental Activities: The chief purpose of Chapter 2 is to provide you with a working vocabulary for describing works of art. But one of the issues that is raised by the question of description is the tricky relationship between words and images. Titles are in many instances the first words used to decribe an image, and an interesting way to explore just how tricky—and arbitrary—the relationship between words and images can be is to give a single visual image as many different titles as you can. Invent four or five new names for Kasimir Malevich's *Suprematist Painting* (Fig. 26). How do your new titles change the way you look at or think about the painting itself?

The Website: Go to the *World of Art* website (**www.prenhall.com/sayre**). Proceed through the Chapter 2 materials. Consider your command of the objectives as stated in the website. Take the multiple choice and fill-in-the-blanks self-tests. Briefly respond to both the critical analysis and the compare and contrast questions, either formally or informally. Visit the related sites linked in both the Modern Artists and Galleries and Museums areas. A hands-on project related to the course material is suggested. Even if you are not assigned the Project, think about how you might approach it. Finally, consider participating in the Message Board or Chat Discussions.

Writing about Understanding Visual Art: If titles change the way we feel about a work of art, descriptions can have an even greater impact. In Chapter 22, "The Twentieth Century," we have reproduced a painting by Giogio de Chirico entitled *Melancholy and Mystery of a Street* (Fig. 715). First, describe the painting's *subject matter* as fully and straightforwardly as possible. Then, based on your description, attempt to arrive at some sense of the painting's *meaning*.

Writing to Explore New Ideas: Iconology can be a powerful contributor to the meaning of works of art. Sandro Botticelli's *Primavera* (Fig. 645) is rife with iconographical or symbolic meaning. Many of the meanings of Botticelli's work are obscure, even to contemporary scholars, but some are more or less obvious, especially after you know that "primavera" is the word for "spring" in Italian, but also means, literally, "first truth." Can you determine who or what any of the figures in the painting might represent? In a brief paragraph, write down your guesses. Test your hypotheses by doing research in the library. Describe where and how you looked for help and cite your sources.

Suggested Further Reading: An extremely useful reference book for students of art is James Hall's *Dictionary of Subjects and Symbols in Art,* available in an inexpensive paperback from Harper Icon Editions, published in 1979.

A short book that explores the ethnocentricity of traditional Western art history is Sally Price's *Primitive Art in Civilized Places* (Chicago: University of Chicago Press, 1989).

Chapter 3
The Themes of Art

LEARNING OBJECTIVES

This lesson will help you understand the major themes addressed by art. At the end of this chapter you should be able to:

1) Begin to articulate the complexity of the idea of representation by considering the themes of art in terms of representing nature, representing everyday life, and making everyday things and public space more beautiful.

2) Further this understanding of representation's complexity by considering the ways in which artists represent themes that are less concrete, such as the spiritual world or the human mind.

3) Appreciate the relativity of many concepts that we take for granted, particularly the idea of the beautiful.

4) Define, in ways more complex than saying it is the representation of the beautiful, the idea of the aesthetic.

KEY CONCEPTS

the documentary function of representation
genre painting
aesthetic objects
aesthetic pleasure
objective vs. subjective degrees of representation
Surrealism
the *vanitas* tradition

STUDY PLAN

Step 1: Read Chapter 3, "The Themes of Art," in your text, *A World of Art*, pp. 36-52.

Step 2: Attempt to answer the questions posed in the CRITICAL PROCESS section at the end of the chapter. Don't worry if you find that you have a difficult time. Proceed to the next step.

Step 3: Read the OVERVIEW of Chapter 3 in this study guide lesson. When a specific work of art that is illustrated in the text is discussed, try to visualize it. If you are unable to remember it, open the text to that illustration and refresh your memory.

Step 4: Return to the LEARNING OBJECTIVES and KEY CONCEPTS sections at the beginning of this study guide lesson. Demonstrate your mastery of each of the learning objectives. Define each of the concepts—each is discussed in the text and each appears in the glossary at the end of your text as well.

Step 5: Return to the CRITICAL PROCESS section at the end of the chapter. Having reviewed the material, attempt to answer the questions again. Turn to the back of the text, p. 513, and compare your answers to those provided by the author.

Step 6: Answer the REVIEW QUESTIONS.

Step 7: Complete the assigned SUPPLEMENTAL ACTIVITIES and WRITING ASSIGNMENTS in this study guide lesson.

Step 8: Pursue any title from the SUGGESTED FURTHER READING that is assigned or that interests you.

OVERVIEW
of Chapter 3 - "The Themes of Art"
A World of Art

Audrey Flack's *Solitaire* (Fig. 39) is an example of a form of art called **photorealism** or **super-realism**. However, it also alludes to other realities. To Flack the work is very personal, reflecting her own family's love of card playing. Flack arranges objects in a still life then photographs the scene. She projects the image onto a canvas and paints it in. While we are fascinated by the image, Flack is fascinated by the color, which results from the chemically created and intensified color of a slide transparency. In many regards, the work points out that we know much of the real world through film and media.

Perhaps the greatest theme of art is art itself, the challenge of representing the world in all its various aspects. Artists have traditionally tried to represent nature exactly as it appears before them, and even represent those things which they cannot see, including God and spirit.

Representing the World

It is difficult to determine why we in the Western world are so preoccupied with representing the world around us when many other cultures are not. In part, we admire artists who are skilled in exacting representation, and in part, through most of our modern history, we have used art to catalog and document our world and events.

Representing Nature
The desire to represent nature perhaps derives from the tension between the natural world's transience and the relative permanence of the work of art. Claude Monet's *Grainstack* series, referenced in Chapter 2, documents this change, while Dürer's *The Large Turf* (Fig. 40) documents the fertile density of a summer pasture.

The representation of human life and character is a subtheme of representing nature. We have a desire to preserve our image after our passing. In ancient Rome, death masks in wax were often taken from the deceased's face shortly after passing to allow a sculptor to render a precision likeness in stone later. The *Portrait of a Roman* (Fig. 41) tells not only of the man's physical features, but from the hollowed cheeks and battle scars, something of his life as well.

Representing Everyday Life
If life is a fleeting event, experiences in life are even more so. A traditional theme of art is capturing these experiences, especially the more pleasant ones, in a form of painting called **genre** painting. Renoir's *Luncheon of the Boating Party* (Fig. 42) depicts an afternoon gathering on a restaurant terrace. The impressionist brushstrokes seem to add to the sensual reality of the scene.

Making Things and Creating Space
One of the purposes of art is to make everyday things—utilitarian objects—more beautiful or pleasurable to see. Westerners often see the objects of African, Oceanic, Native American or Asian cultures as "works of art." However, these same

objects in their cultures of origin might have far greater significance. Such items might be sacred tools, or offer divine insight, or define social orders or record significant events. They might also be simple utilitarian objects designed to carry water or for eating food.

Ghanese artist Kane Kwei was asked by a dying uncle to build a coffin in the shape of a boat. Kwei's coffins soon became popular in the community, and he produced coffins in the shapes of cars, fish, whales, as well as the *Cocoa Pod Coffin* (Fig. 43). When his coffins were brought to the U.S. and put on display by a San Francisco art dealer they became recognized as art. Kwei now produces coffins for both funerary and purely aesthetic function.

Perhaps the object upon which cultures lavish their attention most is clothing. Much more than protection, clothing tells others "who we are"—our taste, our self-image, even our social status. The actor's *Kimono* (Fig. 44) was designed as an **aesthetic** object, one intended to stimulate a sense of beauty in the viewer, and explain the character's status and dignity.

Most of us try to apply an aesthetic sense to the places in which we live. We decorate our homes with pictures, choose apartments based on visual appearance, and plant flowers in our gardens, all in pursuit of an aesthetic appeal. We want city planners and government officials to work with us to make our living space more appealing.

Public space is especially subject to aesthetic treatment. The Gothic cathedrals of the late Middle ages were conceived to unite the spiritual with the aesthetic. One of the most appealing examples is the chapel of Ste. Chapelle in Paris (Fig. 45). Built to house reliquary objects including the Crown of Thorns, is was conceived as a jewelry box with its resplendent stained glass. In fact, sometimes a concern for aesthetics can override function to the detriment of a building. Jorn Utzon's extremely aesthetic Sydney Opera House (Fig. 46) was plagued with design flaws which had to be corrected at great expense. Ironically, the completed building is not suitable for opera, but still remains a source of great civic pride.

Representing Other Realities

We often have difficulty explaining very real emotions, such as love, in concrete terms. Intangible realities and their representation, from spiritual feelings to our innermost desires and dreams, are often the subjects of artists.

Representing the Spiritual

For example, the idea of daring to represent God has aroused great controversy throughout history. In seventeenth-century Holland, images of God were banned from all Protestant churches, such as Pieter Saenredam's *Church of the Assendelft*. (Fig. 47). In the Christian world, images of God have been banned during various time periods, although Jesus, the "son of God," is often represented. Representing the person is easier than representing the spiritual unknown.

Still, artists of all cultures have attempted to depict their gods. The image of *God* (Fig. 48) by Jan van Eyck is that of an unimposing, non-threatening God. Merciful and kind, Van Eyck's God is ironically also "wealthy," or richly adorned.

Pedro Perez, a Cuban artist, in his work *God* (Fig. 49), uses the images of traditional Spanish Catholicism combined with kitsch jewelry in a manner that suggests the collision of two cultures: an undeniably "cool" Santa Claus.

Representing the Mind

Most people, if asked to choose between owning Paulus Potter's *The Young Bull* (Fig. 51) or Frank Stella's *Leblon II* (Fig. 50), would probably choose the former. Potter's painting seems to be a more objective rendering of reality. Stella's painting seems more subjective, relating Stella's personal interests in formal matters of painting. However, Stella finds Potter's painting very similar to his own, claiming that the "heads of the peasant, cow, and bull form a triangle within which the X-shape of the tree trunks is inscribed. The triangle of both paintings is the compositional focus." While Stella should be granted his interest in composition, most people don't share his interest. Their acceptance of his work comes only after his explanation.

Abstract and nonobjective art have always been charged with being subjectively inaccessible to the average person. Picasso, in attempting to paint a portrait of *Gertrude Stein* (Fig. 52) in a naturalistic manner was routinely perplexed at his inability to portray her face in an objective likeness. After some 80 sittings, he put the work aside and returned several months later to paint a more "subjective," or personal, interpretation of Stein. This example suggests that artists can paint subjectively what they want, in the manner they want, while ignoring any preexisting ideas regarding the value of faithfulness to the objective image. This notion was asserted by Andre Breton, the leader of the Surrealists, in his 1928 book *Surrealism and Painting*. Breton's statement that the primary mistake of painters was to assume that "a model could be derived only from the exterior world" fueled the Surrealist movement. Surrealist Salvadore Dali, in his 1931 painting *The Persistence of Memory* (Fig. 53) creates a landscape that seems removed from both time and mind.

The Surrealists explored subjectivity or nonobjectivity even further, through an exploration of the subconscious. To the Surrealists the "reality of the dream" held more subjective reality than the observation of everyday life. This point is further emphasized by the artist Robert Motherwell, who, in referring to extremely abstract works such as *Elegy to the Spanish Republic* (Fig. 54) states, "I never think of my pictures as 'abstract.' Nothing can be more concrete to a man than his own felt thought, his own thought feeling." The painting's title refers to the Fascist defeat of the democratic Spanish Republican forces just before World War II. Motherwell painted the black shapes on the light background to demonstrate the "struggle between life and death."

Representing the Beautiful

Matthias Grünewald's *Crucifixion* (Fig. 55) is one of the most grisly known depictions of Christ on the Cross. The work raises questions about art and beauty. Can that which seems ugly be art, or can ugly be made by the artist to appear beautiful? The fact is that it was intended to provide comfort in a hospital chapel, consoling patients in their knowledge that Christ too endured terrible suffering. The ugly seems to merge with the beautiful, because, as many Christians believe, resurrection and salvation follow the crucifixion. The altarpiece,

in fact, opens up to reveal Christ in the glory of his resurrection. This tension that exists between the horror and the beauty of the total work makes the work dynamic. It demands our active response.

This dynamic tension is illustrated in the **vanitas** tradition of paintings. "Vanity paintings" are intended to demonstrate the relationship between the fleeting earthly existence of the viewer and the finality of the death of all things; the material vs. the spiritual. The presence of the skull as the finality omnipresent against the other momentary images in Champaigne's *Vanitas* (Fig. 56) illustrates this perfectly. In many ways, Robert Mapplethorpe's *Self-portrait* (Fig. 57), taken shortly before his death from AIDS in 1989, serves as a contemporary example. The irony in Mapplethorpe's work lies in that he accepts death as the price of his lifestyle, or pleasure.

═══════

WORKS IN PROGRESS
Pablo Picasso's *Les Demoiselles d'Avignon*

Picasso's *Les Demoiselles d'Avignon* (Fig. 60) was begun shortly after he had finished his portrait of Gertrude Stein. The painting has been X-rayed to reveal the initial sketches on the canvas. Originally Picasso had included other figures, a sailor and a medical student, but he elected to remove these, in effect opening the work up both visually and for viewer involvement.

While painting *Les Demoiselles*, Picasso was impressed by the raw power in the faces of African masks. This influence freed him from the slavish concern for accurate representation. This is demonstrated in the "makeover" of the composition, in which many of the original shapes are used in the composition, but in different context—illustrated by the torso of a reclined figure becoming the head of another figure. As a whole, *Les Demoiselles d'Avignon* represents the freedom of invention that defines all of Picasso's art.

═══════

THE CRITICAL PROCESS
Thinking about the Themes of Art

Chapter 3 concludes with a discussion of Robert Mapplethorpe—arguably the world's most notorious photographer at the time of his death, due to his photographs of sadomasochistic and homoerotic acts (the "X Portfolio"). Ironically, Mapplethorpe's fame can partially be attributed to Senator Jesse Helms of North Carolina. Helms raised issues over government funding of exhibitions that featured Mapplethorpe and other artists deemed "pornographic" by Helms and his supporters.

However, the "X Portfolio" was meant to be seen in conjunction with a "Y Portfolio," a series of still lifes of flowers. Mapplethorpe's flower photographs, such as *Parrot Tulip* (Fig. 61), take on a special poignancy in relation to his other work. Sayre asks students to consider the flower photographs in the tradition of *vanitas* paintings (See Philippe de Champaigne's *Vanitas*, Fig. 56), and to consider the tensions that are created in the collision of erotic and *vanitas* themes.

REVIEW QUESTIONS

Answers to the following questions appear in the APPENDIX: ANSWER KEY at the end of the *Study Guide*.

1. According to the text, the desire to represent nature in art derives from
 a) a photographic tendency within the mind itself.
 b) our fascination with the natural world.
 c) the tension between the natural world's transcience and the relative permanence of the work of art.
 d) the fact that we are, ourselves, part and parcel of nature.

2. What is a **genre** painting?

3. Kwan Kwei, of Ghana, begin carving his elaborate decorative coffins because
 a) he wanted to sell them in the Western art market.
 b) in Ghana, a coffin possesses a ritual significance, celebrating the successful life of the person buried in it.
 c) in Ghana, a coffin carries the soul into the afterlife.
 d) he thought of them as jokes on the deceased, thereby alleviating the pain of death.

4. In the following sentence, fill in the blanks:
 Though in the cultures of their origin, objects such as cooking utensils or clothing might serve a simple utilitarian_____, they are nevertheless all suscep-tible to _____treatment.

5. Picasso's *Les Demoiselles d'Avignon* (Fig. 49) can best be described as
 a) the work of an artist who was unable to draw realistically.
 b) a painting that is both enticing and alluring.
 c) a work that is about the ambiguity of experience.
 d) a work that offers us a single, disturbing point of view.

6. A work of art is *aesthetically* pleasing if it
 a) is beautiful.
 b) is intellectually stimulating.
 c) creates a sense of tension that makes it seem dynamic.
 d) accomplishes any or all of the above.

7. A *vanitas* painting shows us
 a) the vanity of the artist, who as a creator dares compete with God.
 b) our own vanity, as we are reminded that our world is fleeting.
 c) the vanity of those who self-indulgently buy works of art.
 d) the vanity of representation itself, as if anyone could represent the world.

SUPPLEMENTAL ACTIVITIES AND WRITING ASSIGNMENTS

Supplemental Activities: A good way to begin to come to grips with the idea of the aesthetic is to consider to what degree, if any, various everyday items in your own environment are treated aesthetically. For instance, a roll of plain white toilet paper is simply functional, but one decorated with floral patterns is more aesthetic. Find ten everyday items in your environment that range from the most functional to the most aesthetically pleasing and describe them.

The Website: Go to the *World of Art* website (**www.prenhall.com/sayre**). Proceed through the Chapter 3 materials. Consider your command of the objectives as stated in the website. Take the multiple choice and fill-in-the-blanks self-tests. Briefly respond to both the critical analysis and the compare and contrast questions, either formally or informally. Visit the related sites linked in both the Modern Artists and Galleries and Museums areas. A hands-on project related to the course material is suggested. Even if you are not assigned the Project, think about how you might approach it. Finally, consider participating in the Message Board or Chat Discussions.

Writing about A World of Art: If asked to name their favorite painting, many people would pick Salvador Dali's *The Persistence of Memory* (Fig. 53). Write a brief essay explaining the popularity of Dali's work. What are its thematic concerns? What are its aesthetic merits? What does it have in common with, for instance, Philippe de Champaigne's *Vanitas* (Fig. 56)?

Writing to Explore New Ideas: One of the leading art critics of our time, Arthur C. Danto, wrote an essay at the end of the 1980s entitled "Bad Aesthetic Times." The essay begins: "There is an uneasy consensus in the artworld today that we are living through what . . . has been called 'bad aesthetic times.' [Painter] Roy Lichtenstein [see Fig.] said in a recent interview: 'There's a lot of style, but there doesn't seem to be much substance. The eighties don't seem to have a soul, do they?. . . And the seventies seem a kind of nonentity." What about things from 1990 to the present, from your point of view? Don't limit your discussion necessarily to art. What about music? MTV? Television? Movies? Have things gotten better, stayed the same, gotten worse? What kind of "aesthetic times" are we in?

Suggested Further Reading: Picasso's relationship with Gertrude Stein is detailed in Stein's *Autobiography of Alice B. Toklas*, available in a number of editions. The book is a delightful history of life among artists in Paris in the first quarter of the twentieth century.

Arthur Danto's essay, referred to above, can be found in his book *Encounters & Reflections: Art in the Historical Present* (Noonday Press, 1991).

Chapter 4
Seeing the Value in Art

LEARNING OBJECTIVES

This lesson will help you understand the complex ways in which we determine the value of a work of art. At the end of this chapter you should be able to:

1) Appreciate just how relative a term "value" is.

2) Recognize how important it is for an audience to understand the intentions of the artist and how historical hindsight contributes to this understanding.

3) Map the four roles of the artist and distinguish among them.

4) Outline the role of public agencies—the NEA and Per Cent for Art programs particularly—in creating "public" art.

5) Distinguish between "public" art and "activist" art.

6) Recall the history of the reception of each of the major works discussed in this chapter—Manet's *Déjeuner sur l'herbe*, Duchamp's *Nude Descending a Staircase, No. 2*, Maya Lin's Viet Nam War Memorial, Carl Andre's *Stone Field Sculpture*, Richard Serra's *Titled Arc*, and Michelangelo's *David*.

KEY CONCEPTS

the aesthetic (art for art's sake)
public art
activist art

Four roles of the artist

experiencer analyst
reporter activist

STUDY PLAN

Step 1: Read Chapter 4, "Seeing the Value in Art," in your text, *A World of Art,* pp. 53–69.

Step 2: Attempt to answer the questions posed in the CRITICAL PROCESS section at the end of the chapter. Don't worry if you find that you have a difficult time. Proceed to the next step.

Step 3: Read the OVERVIEW of Chapter 4 in this study guide lesson. When a specific work of art that is illustrated in the text is discussed, try to visualize it. If you are unable to remember it, open the text to that illustration and refresh your memory.

Step 4: Read the VIEWING GUIDE to *Works in Progress: Guillermo Gómez-Peña* in this study guide lesson.

Step 5: View the video *Works in Progress: Guillermo Gómez-Peña,* following the VIEWING GUIDE as you watch. Take notes and jot down ideas in response to the VIEWING GUIDE. Your instructor may require you to hand in written responses, formal or informal, to some or all of the topics that the VIEWING GUIDE sets out for your consideration. View the video a second time if necessary.

Step 6: Return to the LEARNING OBJECTIVES and KEY CONCEPTS sections at the beginning of this study guide lesson. Demonstrate your mastery of each of the learning objectives. Define each of the concepts—each is discussed in the text and each appears in the glossary at the end of your text as well.

Step 7: Return to the CRITICAL PROCESS section at the end of the chapter. Having reviewed the material, attempt to answer the questions again. Turn to the back of the text, p. 513, and compare your answers to those provided by the author.

Step 8: Answer the REVIEW QUESTIONS. Complete the assigned SUPPLEMENTAL ACTIVITIES and WRITING ASSIGNMENTS in this study guide lesson.

Step 9: Pursue any title from the SUGGESTED FURTHER READING that is assigned or that interests you.

OVERVIEW
of Chapter 4 - "Seeing the Value in Art"
A World of Art

In this chapter we consider the ways in which works of art are received by their audience, as well as the sometimes volatile relation of art to public issues and politics.

Mapplethorpe's photography, a discussion of which concludes the last chapter, raises key questions about the value of art. After the controversy in Cincinnati, the show moved to other exhibition sites and brought in record crowds. The value of Mapplethorpe's work in terms of its monetary worth (its sales price) began to rise, but the question of its artistic value still confronts us. Jessie Helms did not think the work had artistic value. When Dennis Barrie, the Director of the Cincinnati Art Center, went to trial for showing Mapplethorpe's work, Judge David Albanese agreed.

In the Cincinnati trial the judge ruled that each photograph should be judged on its separate identity, removed from comparison with related works. However, the jury was shown that all the photographs possessed visual qualities that subscribed to traditional rules of composition and organization. Additionally, the testimony of Robert Sobieszek of the International Museum of Photography in Rochester, N.Y., pointed out that Mapplethorpe's work related both what was beautiful and torturous in the artist's life. It was similar to van Gogh's self-portrait with his ear cut off. The jury found that Mapplethorpe's photographs were of "serious artistic value." Mapplethorpe's work makes clear that "value" is a relative term.

To more fully understand the value of art, we must examine the social value of art, which must be done in conjunction with consideration of art's aesthetic value.

Art and its Reception

In her book, *Mapping the Terrain*, Suzanne Lacy presents a diagram (Fig. 64) representing the possible roles for an artist, which correspond closely with those presented in Chapter 1—artists as reporters represent their world; artists as "experiencers" give tangible form to their feelings; artists as analysts look for universal truths; and artists as activists help us see the world in new ways. Lacy's chart takes us from the moment when artists first experience the world privately to the social activism of a fully public figure. In each step, the artwork becomes increasingly more involved with social issues.

The artist's relationship to the public is often dependent upon what the public can understand. Manet's *Luncheon on the Grass* (Fig. 65) was highly ridiculed for everything from its seeming disregard of academic painting techniques to its blatant use of nudity. Manet's disregard for academic painting was however intentional. His work addressed his own modernity, and his subject was derived from a much earlier work by Raimondi (after Raphael) of the *Judgment of Paris* (Fig. 66), in which Paris judges who is the most beautiful woman in the world. Playing with the title of this ear-

lier work, Manet thus both rejects the academic painting style and passes judgment on the social immorality of Paris, France.

In 1913, Marcel Duchamp's painting, *Nude Descending a Staircase* (Fig. 67) met similar ridicule at the Armory Show. Described by some as "a staircase descending a nude" and an "explosion in a shingle factory" by others, the work appeared to contain no trace of the human figure. Duchamp was influenced in part by work that was being done in movement analysis, specifically the galloping horse photographs of Eadweard Muybridge (Fig. 68) and the "chronophotographs" of Etienne-Jules Marey (Fig. 69), which bear a striking visual similarity to Duchamp's *Nude*. The work of Muybridge and Marey was building toward the first motion pictures of the Lumière brothers, which were shown in Paris in 1895. In one film, a locomotive charging toward the camera caused some viewers to leap up in terror. Duchamp's vision had already been confirmed, but the public had not yet learned to see it.

A more recent example is Maya Lin's 1982 Vietnam War Memorial (Fig. 71). The work insulted some who preferred the notion of a grand monument on the Washington Mall. Furthermore, it seemed to represent nothing in particular. There were no soldiers planting the flag on the hill at Iwo Jima. What many visitors came to recognize was that it symbolized the war itself. Its gradual slope descending from upper ground level to a lower level, then ascending up again, is similar to our gradual entrance, eventual heavy involvement, and final exit from the war. Lin's creation, initially misunderstood, is today the most often visited monument in the U.S. Unlike Manet's or Duchamp's work, however, it was designed as public space. By observing the fate of art in public spaces, we can learn much about how and why we value public art.

Art, Politics and Public Space

When Congress established the National Endowment for the Arts (NEA) in 1967, their intent was to create a program that would bring the arts more fully into public spaces. Artists were asked to assume the role of educators, to educate the public about art. The Arts in Public Places program was initiated, followed by a number of state and local programs nationwide which funded public art by requiring that 1 percent of expenses for all new buildings be put aside to purchase art for those spaces. The Endowment's plan was to expose the communities to advanced art, and the Arts in Public Places program was conceived as an "art appreciation" course for the masses.

Alexander Calder's *La Grande Vitesse* (Fig. 72) in Grand Rapids, Michigan, was the first sculpture erected under the new program. Initially its praying mantis-like organic forms were rejected by the public, but eventually the work became a source of civic pride. The program was succeeding in teaching the public about the value of art for art's sake.

Three Public Sculptures

To value art for art's sake is to value it as an aesthetic object rather than for its practical function or its impact on social life. Public art, the Endowment believed, would make everyone's life better by making our environment more interesting and beautiful. Three sculptures, Carl Andre's *Stone Field Sculpture*, Richard Serra's *Tilted Arc*, and Michelangelo's *David* have all tested this theory.

Andre's *Stone Field Sculpture* (Figs. 73 and 74) echoes relationships between geological history and colonial history. The work, which consists of 36 unfinished boulders that range in size from 1000 lbs. to 11 tons, was thought by many not to be art at all. The boulders were placed in even rows in a public green in Hartford, CT., and the controversy started almost immediately. The debate over good or bad was vehement, and in the press constantly. It was described as "another slap in the face of the poor and the elderly."

But gradually, people came to realize Andre's intent. In part, Andre wished to create a quiet place that was a reference to the old grave stones in the church yard of Central Church across the street from the site. Furthermore, he wanted to contrast geologic and human time. Finally, Andre wanted an art that wasn't simply another disguised "man on horseback"—his expression for the thousands of seemingly generic bronze park statues. Andre's idea of public sculpture was that of "a road," a sort of moving causeway that entertains many points of view. Andre said you should make your way around or through his works, "but there should be no one place where you should be." Public consensus was positive for Andre, in part because his intentions became known and accepted.

Richard Serra's *Tilted Arc* (Fig. 75) was also highly controversial and raises new issues in comparison to Andre's work. When originally commissioned by the General Services Administration in 1981, it raised very little public controversy, but it became political. It started when the newly appointed head of the GSA sought its removal in 1985. When, eventually, it was removed, the artist announced that the work had been destroyed. Serra felt that the

work should be confrontational, that a site-specific work must engender a dialogue with its environment. His work was antagonistic in the sense that it challenged people to react to it, and also challenged the authority of those who commissioned it. In many regards, Serra's work could be seen as having fallen victim to politics, and many people felt that a negative consensus was created to justify its removal.

Michelangelo's *David* (Fig. 76) is considered a masterpiece of Renaissance art; however, it also met with disapproval when it was first unveiled in Florence, Italy, in 1504. The 26-year-old Michelangelo produced a sculptural triumph in carving the problematic piece of marble. Its subject, the David who stoned Goliath, signified Republican Florence, which had won freedom from both papal domination and the powerful ruling Medici family as well. After the work was placed on public display, supporters of the Medici hurled stones at it, and a second group of citizens objected to its nudity.

However, by the time that the Medici returned to power in 1512, the public had so completely accepted it that it was revered as a public shrine. Today, the sculpture is no longer valued for its politics, but rather its sheer aesthetic value, indicating that aesthetics remains a potent concern in public art.

═══════════

Works in Progress
Gómez-Peña's *Temple of Confessions*

The *Works in Progress* video series continues with a discussion of Guillermo Gómez-Peña, an activist performance artist from Mexico, whose work concentrates on

relations between Mexico and the United States. See the VIEWING GUIDE in this lesson.

========

The "Other" Public Art

The three examples of public art examined so far are not necessarily active agents of change in our lives. We now examine several artists whose intent is to do just that through "activist" artwork.

The artist Krzysztof Wodiczco, a Polish refugee artist, was appalled at the number of homeless in New York City, which during the winter of 1987-88 reached almost 70,000. Determined to do something about it, Wodiczco designed and created the *Homeless Vehicle* (Fig. 77), a portable sleeping living shelter designed to provide a level of safety and creature comforts on the streets. The vehicles are visually interesting, but more importantly, force us to see a situation (homelessness) that most of us would rather ignore.

In Mourning and in Rage (Fig. 78) was a collaborative piece created by Suzanne Lacy and Leslie Labowitz. The work protested the violence against women in America's major cities. It was an elaborately staged event intended to generate media coverage. Ten women (representing the ten victims of the Hillside Strangler), dressed in black, stepped from a hearse and lined up in a single row. They wore black veiled headdresses that made their total height over seven feet tall, and each one individually addressed the media. Lacy's and Labowitz's involvement in the media illustrated that violent crimes such as those committed by the Strangler become sensationalized events because of the media.

THE CRITICAL PROCESS
Thinking about the Value of Art

For Group Material, a collaborative artist team, the AIDS crisis is the central problem of our day. For a 1989 exhibition they created a ten-year timeline (Fig. 82) in an attempt to make visible the course of an epidemic from which we too easily, and at our peril, avert our eves. Sayre asks, "What role or roles do these artists assume—experiencer, reporter, analyst, or activist?"

Works of art can possess aesthetic or social value—they can attempt to make our world a better place in which to live. Could Group Material define their work as having an aesthetic as well as a social value? How does their work compare to the famous AIDS Quilt (Fig. 83), organized by the Names Project in order to give the disease what might be called a personal identity? How does the AIDS Quilt compare to Maya Lin's *Vietnam Memorial*? What would it mean for the AIDS Quilt and the Timeline to come to conclusion? What does it mean that they cannot be completed?

VIEWING GUIDE
to *Works in Progress: Guillermo Gómez-Peña*

Guillermo Gómez-Peña
Biographical Sketch

Performance artist Guillermo Gómez-Peña was born and raised in Mexico City in 1955. He came to the United States in 1978 and has been exploring cross-cultural issues and North-South relations ever since. He works in a wide variety of media, including performance art, bilingual poetry, journalism, radio, television and video, and installation art. From 1983 until the mid-1990s, Gómez-Peña lived in San Diego/Tijuana, where he was a catalyst for the reinterpretation of American culture from the point of view of the contested terrain along the border between the United States and Mexico. His art focuses, on the one hand, on the exotic and folkloric stereotypes of Mexico still popular in the United States, and on the other, the cultural nationalism often associated with politically charged Chicano art. He currently lives in San Francisco.

He was a founding member of the *Border Art Workshop/Taller de Arte Fronterizo* and the editor of the experimental arts magazine *The Broken Line/la Linea Quebrada*. He has been a contributor to the national radio magazine *Crossroads* and the radio program *Latino USA*, and a contributing editor to *High Performance* magazine and *The Drama Review*, two of the leading magazines dealing with performance art. In 1991 he was the recipient of the prestigious John D. and Catherine T. MacArthur Fellowship.

Summary and Introduction

The Temple of Confessions, the performance we see Guillermo Gómez-Peña and his collaborator Roberto Sifuentes perform in this *Works in Progress* episode, has been in process since its first performance at the Scottsdale, Arizona, Center for the Arts in 1994. Half performance and half installation, the piece is described by Gómez-Peña as follows:

> *We combined the format of the pseudo-ethnographic "diorama" (as in my previous "living diorama projects [such as* Couple in a Cage, *performed with Coco Fusco, and described and illustrated in your text]) with that of the dramatic religious "dioramas" displayed in Mexican Catholic churches; and decided to exhibit ourselves inside Plexiglass boxes as both cultural "specimens" and "holy" creatures. Our objectives (at least, the conscious ones) were to create a melancholic ceremonial space for people to reflect on their own racist attitudes toward other cultures; and to investigate the complex dynamics of fear and desire which are at the core of the U.S.'s relation to its southern neighbor and its Latino other within [i.e., the Latino population living in the United States itself].*

In an early press release, Gómez-Peña described the piece as follows: "Two living *santos* from a pagan religion (allegedly banned in the Southwest) are searching for sanctuary across America. . . . People are invited to experience this bizarre pagan Temple and confess to the saints their intercultural fears and desires." (Southwestern santos are discussed in *A World of Art* on p. 263.)

A surprisingly large percentage of visitors to the performance/installation confess, either into microphones placed on the kneelers in front of the booths (in which case their voices are recorded, and later are altered in post-production to protect their anonymity), or, if they are shy, they can write their confessions down on a card and deposit them in an urn, or they can call a toll-free 800 number. After every installation, the most revealing confessions are edited and incorporated into the installation soundtrack for coming performances. As a general rule, Gómez-Peña and Sifuentes only appear live in the booths for three days, after which time they are replaced by life-size effigies. To stay any longer is simply too physically and emotionally exhausting.

Since its first performance, *The Temple of Confessions* has been performed at the Three Rivers Arts Festival in Pittsburgh, The Detroit Institute of Arts, The Templo de Equis Teresa La Antigua in Mexico City, and the Bannister Art Gallery in Providence, Rhode Island. Seen here is the performance at the Corcoran Art Gallery, Washington, D.C., in late October and early November 1996. Gómez-Peña was particularly keen on performing the piece in the charged political atmosphere of Washington in the weeks just prior to the 1996 Presidential election.

Ideas to Consider

1. Very often in his work Gómez-Peña utilizes Spanish instead of English, even when it is clear to him that his audience is largely English-speaking. What is the political purpose of this decision? How did you react to the Spanish?

2. At the end of Chapter 14, Other Three-Dimensional Media, there is a segment on performance art (pp. 302-07). You will find it useful to read this section at some point in connection with the Gómez-Peña *Works in Progress*, but before you do, what is it about Gómez-Peña's project that makes it more "art" than, say, theater? What makes it more theater than art? If performance art is something of a mixture of both art and theater, how is its hybrid status particularly appropriate to Gómez-Peña's work?

3. In notes for the performance of *The Temple of Confessions*, Gómez-Peña has utilized this epigraph, "Performance, like religion, is about faith . . . and deception." Without getting involved in the question of whether or not religion is about deception, consider how performance is about faith.

 • In what ways is faith, both religious and otherwise, important to Gómez-Peña's "work"?

 • In what ways does activist art require faith?

 • How can faith and deception coexist in the work?

5. Obviously, Gómez-Peña could have created a single Plexiglass booth and performed a version of *The Temple of Confessions* by himself. But he chose to collaborate with Sifuentes. What does the collaboration contribute to the piece?

 • Furthermore, how does the idea of collaboration itself relate to the meaning of the work?

 • How does the audience collaborate in its making? And how does the idea of collaboration fit into Gómez-Peña's larger project?

6. Gómez-Peña likes to ask a single, telling question: "Have you ever heard of a Mexican tourist?" What are the implications of the question?

Frequently Asked Questions

How can we learn more about Gómez-Peña? Two collections of Gómez-Peña's writings are available. The first, published by Graywolf Press in 1993, is *Warrior for Gringostroika: Essays, Performance Texts, and Poetry.* The second is *The New World Border: Prophecies, Poems, and Loqueras for the End of the Century*, published by City Lights Books in 1996. Gómez-Peña is also an occasional contributor to National Public Radio's *All Things Considered.*

Are some of Gómez-Peña's other works available for us to see? Yes, but, like all video art tapes, they are comparatively expensive. It might be best for your media center to order them. The least expensive, one of the best, and one that can often be found in the bookstores of larger museums at normal retail video prices, is the documentary *The Couple in a Cage: A Guatinaui Odyssey.* Archive versions of *Couple in a Cage* are available from

> Video Data Bank
> 37 South Wabash Avenue
> Chicago, IL 60603
>
> Tel: (312) 345-3550
> Fax: (312) 541-8073

The Video Data Bank also rents *Couple in a Cage* for $75. Another tape entitled *El Naftazteca (Cyber-Aztec TV for 2000 AD)*, in which Gómez-Peña pretends to take over a real television station in a guerilla action, was produced at iEAR Studios on the campus of Rensselaer Polytechnic Institute in Troy, New York. Call 518-276-4778 for more information. Finally a two-CD set of Gómez-Peña's radio productions entitled *Borderless Radio* is available from

> Word of Mouth
> Vocal Art on CD and Cassette
> PO Box 429
> Station P
> Toronto, Ontario M5S 2S9
> CANADA

REVIEW QUESTIONS

Answers to the following questions appear in the APPENDIX: ANSWER KEY at the end of the *Study Guide*.

1. In defending photographer Robert Mapplethorpe as an artist, curator Robert Sobieszek compared him to Vincent van Gogh. On what grounds?

2. What are the four possible roles of an artist according to Suzanne Lacy?

3. Edouard Manet's *Déjeuner sur l'herbe* (*Luncheon on the Grass*) (Fig. 57) is based on a sixteenth-century engraving. What is the name of the engraving and how does its title inform the meaning of Manet's painting?

4. The work of Eadweard Murbridge and Etienne-Jules Marey led to
 a) a greater understanding of human and animal movement.
 b) Marcel Duchamp's *Nude Descending a Staircase* (Fig. 59).
 c) the motion picture.
 d) all of the above.

5. Which of the following is the best example of art for art's sake?
 a) Albert Bierstadt's *Rocky Mountains* (Fig. 3)
 b) Alexander Calder's *La Grande Vitesse* (Fig. 64)
 c) Michelangelo's *David* (Fig. 69)
 d) Edouard Manet's *Déjeuner sur l'herbe* (*Luncheon on the Grass*) (Fig. 57)

6. Which of the above is the best example of a work produced by an artist in the role of analyst?

7. Which of the following sculptures was destroyed?
 a) Alexander Calder's *La Grand Vitesse* (Fig. 64)
 b) Carl Andre's *Stone Field Sculpture* (Figs. 65 and 66)
 c) Richard Serra's *Tilted Arc* (Figs. 67 and 68)
 d) Michelangelo's *David* (Fig. 69)

SUPPLEMENTAL ACTIVITIES AND WRITING ASSIGNMENTS

Supplemental Activities: Examples of public art can be found in almost every community. And in most communities this art is loved by some, hated by others, and a matter of indifference to still others. Several activities can help you discover just how varied the feelings are about public art in your community:

• See if you can discover when and how a given example of public art was commisioned. Go to your local library and see if it was the subject of any controversy by checking old newspaper and other resources that your reference librarian might lead you to. (You might find it useful in fact to begin by asking people in the community who might know something about the piece—the artist, city leaders, even the local historical society.)

• Station yourself near the piece. Ask passersby what they think. Try to get an informal cross-section of the community.

• Survey your friends. See if there is any consensus. Do people think the piece is "worth" having in the community? What is its worth?

The Website: Go to the *World of Art* website (**www.prenhall.com/sayre**). Proceed through the Chapter 4 materials. Consider your command of the objectives as stated in the website. Take the multiple choice and fill-in-the-blanks self-tests. Briefly respond to both the critical analysis and the compare and contrast questions, either formally or informally. Visit the related sites linked in both the Modern Artists and Galleries and Museums areas. A hands-on project related to the course material is suggested. Even if you are not assigned the Project, think about how you might approach it. Finally, consider participating in the Message Board or Chat Discussions.

Writing about the Value of Art: At the end of Chapter 1, we considered a work almost as controversial as Robert Mapplethorpe's, Scott Tyler's *What Is the Proper Way to Display the American Flag?* (Fig. 14). Discuss the *value* of Tyler's work, comparing it to Mapplethorpe's.

Writing to Explore New Ideas: The National Endowment for the Humanties is under constant political pressure as the Robert Mapplethorpe story makes clear. Even though its budget is less than that supporting military marching bands, many people do not feel that the government should have any role in supporting the arts. What is your position? What should be the relation between government and the arts? Should they be separate, like church and state? Or do the arts serve an important social function that should be supported? Or is there a middle ground?

Suggested Further Reading: A complete documentary survey of events surrounding the Mapplethorpe controversy has been collected in *Culture Wars: Documents from the Recent Controversies in the Arts*, ed. Richard Bolton (New York: New Press, 1992).

An extraordinary history of the work of Jules-Etienne Marey is Marta Braun's *Picturing Time* (Chicago: University of Chicago Press, 1992).

Suzanne Lacy's *Mapping the Terrain: New Genre Public Art* (Seattle: Bay Press, 1995), surveys activist art in the United States, as does *Art in the Public Interest,* ed. Arlene Raven (New York: Da Capo Press, 1993).

Chapter 5

LINE

LEARNING OBJECTIVES

This lesson will help you understand the ways in which artists use and manipulate line as a formal element. At the end of this chapter you should be able to:

1) List the different varieties of line.

2) Name and appreciate the different qualities of line.

3) Discuss the ways in which line embodies certain cultural conventions.

4) Appreciate line's role as perhaps the most basic formal element.

KEY CONCEPTS

Varieties of line:
 Outline
 Contour line
 Implied line
 Line of sight
 Kinetic line

Qualities of line:
 Expressive line
 Autographic line
 Analytic line
 Classical line

the grid

the Romantic vs. the Classical

Cultural conventions associated with expressive and analytic line

STUDY PLAN

Step 1: Read Chapter 5, "Line," in your text, *A World of Art,* pp. 70–89.

Step 2: Attempt to answer the questions posed in the CRITICAL PROCESS section at the end of the chapter. Don't worry if you find that you have a difficult time. Proceed to the next step.

Step 3: Read the OVERVIEW of Chapter 5 in this study guide lesson. When a specific work of art that is illustrated in the text is discussed, try to visualize it. If you are unable to remember it, open the text to that illustration and refresh your memory.

Step 4: Read the VIEWING GUIDE to *Works in Progress: Hung Liu* in this study guide lesson.

Step 5: View the video *Works in Progress: Hung Liu,* following the VIEWING GUIDE as you watch. Take notes and jot down ideas in response to the VIEWING GUIDE. Your instructor may require you to hand in written responses, formal or informal, to some or all of the topics that the VIEWING GUIDE sets out for your consideration. View the video a second time if necessary.

Step 6: Return to the LEARNING OBJECTIVES and KEY CONCEPTS sections at the beginning of this study guide lesson. Demonstrate your mastery of each of the learning objectives. Define each of the concepts—each is discussed in the text and each appears in the glossary at the end of your text as well.

Step 7: Return to the CRITICAL PROCESS section at the end of the chapter. Having reviewed the material, attempt to answer the questions again. Turn to the back of the text, p. 513, and compare your answers to those provided by the author.

Step 8: Answer the REVIEW QUESTIONS. Complete the assigned SUPPLEMENTAL ACTIVITIES and WRITING ASSIGNMENTS in this study guide lesson.

Step 9: Pursue any title from the SUGGESTED FURTHER READING that is assigned or that interests you.

OVERVIEW
of Chapter 5 - "Line"
A World of Art

The subject matter of Paul Cézanne's *Still Life with Basket of Apples* (Fig. 84) is an arrangement of fruits and objects. The composition formally is a complex organization of lines, shapes, light, and color. To the casual eye the work appears full of mistakes, but it is deliberately arranged to "reanimate" or give life back to the "still life." Cézanne has taken liberties with the composition that cause it to become dynamic, rather than remain static.

Varieties of Line

Line is one of the most fundamental elements of art and is present in every aspect of our visual environment. By placing pencil to paper, one can create all varieties. Straight lines can be vertical, horizontal, or diagonal. Curved lines can be circular, organic, or fragmented. Lines possess direction, rise and fall, are thick and thin, and connect things together. They can be long or short, smooth, or agitated. Almost all types of line are present in Jean Tinguely's drawing from *La Vittoria* (Fig. 85).

Outline and Contour Line

Another important feature of line is that it indicates the edge of two- and three-dimensional forms. An **outline** can indicate an edge directly, as in Picasso's *Pitcher, Candle and Casserole* (Fig. 86), or indirectly, as in Diebenkorn's *Untitled* drawing (Fig. 87). In the latter case, the lines surround and define volumes or mass. Their weight (thickness or thinness) seems to move from front to back of the various body parts, giving them a sense of three-dimensional form. We call these lines **contour** lines.

Implied Line

Implied line is another variety of line that relies upon perception. We might follow the line suggested by a pointing finger, or see a line implied by a body in motion. The photographs of Etienne-Jules Marey and Eadweard Muybridge, discussed in Chapter 4, illustrate this idea.

Keith Haring drew actual lines to indicate implied lines—the motion of waving hands or jumping dogs, in the work *Untitled* (Fig. 88) from 1982. Likewise, just as the kinesis of dance is followed by tracking implied lines, so is the motion of kinetic sculptures, as in Alexander Calder's mobile *Dots and Dashes* (Fig. 89).

One of the most powerful forms of implied line is the line of sight. The three separate horizontal areas of Titian's *Assumption and Consecration of the Virgin* (Fig. 91) are tied together with two implied triangles (Fig. 92) created by line of sight and hand gesture.

Qualities of Line

Line can also possess certain intellectual, emotional, and/or expressive qualities. Pat Steir created a "dictionary of marks," derived from the ways in which artists she admires employ lines. One panel of *The Drawing Lesson* (Fig. 93) refers to Rembrandt, and the effects he achieves in

etchings such as *The Three Crosses* (Fig. 94). Steir's piece is a "blow up" of Rembrandt's basic line. Both Steir and Rembrandt employ "crosshatching," parallel lines intersected by other sets of parallel lines running in a different direction so that areas of light and dark result. In the Rembrandt, the crosshatched line seems to envelop the scene, enshrouding it in darkness. Steir's work of the single line on the white square seems two-dimensional, and flat, but the cross-hatching behind it creates three-dimensional depth. This effect imparts a type of psychological depth to the work.

A second panel of *The Drawing Lesson* (Fig. 95) makes use of the "dripping line," often employed by contemporary painters, which makes a reference to the activity of painting. In this panel, Steir is trying to evoke the expressive gestures of Vincent van Gogh. Steir willingly submitted herself to van Gogh's emotion and style.

Expressive Line

Many people feel van Gogh's work is some of the most personally expressive in the history of art. In *The Starry Night* (Fig. 96), life and death, the town and the heavens, collide and are connected both by the church spire and the cypress. The expressive line of van Gogh is loose and gestural, so much that it seems out of control. Yet it is consistently recognizable as van Gogh's to the point of being **autographic.**

Works in Progress
Vincent van Gogh's *Sower*

We know more about van Gogh's *The Sower* (Fig. 98) than almost all of his other paintings. This is because he documented his struggles with the work through numerous letters written to the painters John Russell and Emile Bernard, and his brother Theo.

Chief among his concerns were the disharmonious color clashes that he was constantly trying to resolve. After struggling for a period of eight days he finally found the combination of colors that worked. *The Sower* seemed to be a symbol of van Gogh's own "longing for the infinite," as he wrote to Bernard. He eventually began to see the painting as a study for a drawing. In the drawing (Fig. 99), van Gogh enlarges the wheat, the sun, and the sower, while eliminating the house and tree. What is most "astonishing" however is the tremendous variety of line employed by van Gogh. It is as if, wanting to represent his longing for the infinite, as it is contained at the moment of the genesis of life sowing the field, van Gogh himself returns to the most fundamental element in art—line itself.

Analytic or Classical Line

In his *Lines from Four Corners to Points on a Grid* (Fig. 100), Sol LeWitt employs a line that is as autographic as van Gogh's, but one that reveals a very different personality. LeWitt's line is **analytical**—precise and controlled— while Van Gogh's line is expressive, imprecise, and emotionally charged. Very often, LeWitt does not even draw his own lines. If a museum owns a LeWitt drawing, they own the instructions that explain how to create it.

One of the strongest elements in LeWitt's drawing is the resultant **grid** that occurs as the lines cross one another. The grid's geometry can lend a certain orderliness to even the most expressive composi-

tions. In Jasper Johns's *Numbers in Color* (Fig. 101), the expressive brushstrokes are held in rational control by the grid that organizes the entire surface.

Analytic line is closely related to "classical" line. **Classical** refers to Greek art of the fifth century BCE, but by association has come to refer to any art based on logical, rational principles. In his *Study for the Death of Socrates* (Fig. 102), Jacques Louis David portrays Socrates about to drink deadly hemlock. He has arranged the figure and the composition with a mathematical grid. By contrast, Romantic painter Eugene Delacroix has used a much more expressive line in his *Study for the Death of Sardanapalus* (Fig. 104). Delacroix's line is quick, imprecise, and fluid, and his final painting is emotional, almost violent, while David's painting is very calm.

═══════════

Works in Progress
Hung Liu's *Three Fujins*

The *Works in Progress* video series continues with a discussion of Hung Liu, a painter born and raised in China, who was "re-educated" as a teenager during Chairman Mao's Cultural Revolution, and who emigrated to the United States in 1984. See the VIEWING GUIDE in this lesson.

═══════════

Line and Cultural Convention

A comparison of analytic and/or classical lines is difficult because it can never be limited to formal concerns. Line carries a certain cultural burden, often reflecting questionable cultural values. Historically, the "logical, rational" classical line has been associated with the male. The "less logical, emotional or intuitive" line is often associated with the female form.

In the male figure of Zeus (Fig. 108), the sculpture is submitted to almost the same rigid grid as David's *Socrates* (Fig. 102). The female *Aphrodite of Knidos* (Fig. 109), by comparison, is softened and rounded, her body seems to echo the gentle folds of the drapery. In Ingres's giant *Jupiter and Thetis* (Fig. 110), the grand and indifferent Jupiter is the personification of male reason and power, while the female is the embodiment of sensuality and submissiveness. These conventional representations carry recognizably sexist implications, but nonetheless they enable us to better understand much of Western art. It should come as no surprise that cultural bias is reflected in art, and in something as basic as line.

THE CRITICAL PROCESS
Thinking about Line

Line is clearly a very versatile element. Here the reader is asked to consider how line defines our environment, and consider its properties of defining volume, movement, and direction. Line is "the artist's most basic tool."

In Robert Mapplethorpe's 1982 photograph of Lisa Lyon (Fig. 111), the first world women's body building champion, Lyons assumes a pose of extreme rigidity and angularity, suggesting both classical line and masculine line. As you consider questions such as "Is Lyon closer to Ingres's Jupiter or his Thetis?" you should realize that Mapplethorpe is defying cultural con-

vention and bringing new meaning to the work.

━━━━━━━━━━

Works in Progress
J.-A.-D. Ingres's *Turkish Bath*

Probably no painter more thoroughly explored the expressive qualities of the curve as it relates to the female body than Jean-Auguste-Dominique Ingres. Starting with the *Valpinçon Bather* (Fig. 112) in 1808, and culminating with *The Turkish Bath* (Fig. 113), Ingres inaugurated a series of studies and finished paintings on the theme of women alone, which can be seen as a career-long work in progress.

Ingres took many liberties with the female anatomy, and the *Valpinçon Bather* is no exception. His works were highly criticized as reflecting incompetence. The right leg seems oddly disengaged from the body proper. Ingres apparently preferred to sub- mit the body to the demands of his compo- sition.

In *The Turkish Bath*, the oddity of this leg has been cured. The woman playing the guitar with her back to the viewer is clearly modeled on the earlier painting. The paint- ing, which consists of a series of circles within circles, leaves the rectilinear frame of the earlier works behind. As Ingres sacri- fices, or controls, female anatomy to meet the demands of his circular design, the sex- ist implications of his work become clear. The painting celebrates the five senses— touch (the two women fondling each other in the foreground), smell (the perfume held by the standing figure on the right), taste (the tray of food in the foreground), hearing (the guitar), but above all, sight. For though women are freed, in these works, from the world of men, they are thoroughly submitted to the male gaze, not least of all Ingres's own.

━━━━━━━━━━

VIEWING GUIDE
to *Works in Progress: Hung Liu*



Hung Liu
Biographical Sketch

Hung Liu was born in Changchun, Manchuria, in northeastern China, in 1948, the year Mao Tse-tung drove the Nationalist forces of Chiang Kai-shek out of China to exile on the island of Taiwan in a Civil War that we think of today as the Chinese Communist Revolution. Soon after her birth, her father, an officer in Chiang Kai-shek's Nationalist army, was arrested, and her mother was forced to divorce him in order to protect herself and her newborn child.

As a young girl, Hung excelled as a student, and her high grades earned her a place in a prestigious Beijing middle and high school. But with the coming of the Cultural Revolution in the mid-1960s, Liu was sent to the countryside to work in the fields for four years—to be "re-educated" as a working member of the proletariat. "We were city girls in the country, treated as aliens. We worked in the fields



very, very hard, and went home when the sun went down. There were no holidays and we didn't have any family there." She earned the respect of the villagers by carrying heavy sacks of grain and by swimming long distances. She also photographed many of the villagers.

Part of Liu's fascination with photography can be traced to the fact that during the Cultural Revolution many people destroyed their family photo albums in order to hide their non-proletariat origins. Liu herself burned all of her diaries and journals. But in the village, she says, "I was like a journalist who went to their door, took their pictures and gave the photos to them free."

After the Cultural Revolution, she was admitted to Beijing Teachers College, where she earned a Bachelor of Fine Arts degree in 1975. Then subsequently she received a graduate degree in Mural Painting from the Central Academy of Fine Art in Beijing in 1981. Her training was strictly in the Russian Social Realist tradition. A highly developed form of propaganda, Social Realism advocates art as a vehicle for the education of the proletariat. Liu rebeled against the strict rules her training formulated for her. She constructed a secret painting pad, with tiny brushes and paints, and daily went off by herself to paint landscape in a fluid, Western style.

Her desire for artistic freedom led her to seek permission to study in the United States, and in 1984 she was allowed to leave China to study at the University of California at San Diego. She arrived with little English and only twenty dollars. A recipient of numerous grants and fellowhips at UCSD, she received her MFA in painting in 1986. She has since been awarded two fellowships in painting from the National Endowment for the Arts, as well as other grants and awards. Today she is married to art critic Jeff Kelly, whom she met at UCSD, and the two live in Oakland, California, where she teaches at Mills College.

Hung Liu has returned to China on several occasions, the first time in 1991. On that trip, she discovered that, though many private archives of photographs were destroyed during the Cultural Revolution, public collections still existed. She became fascinated with images of prostitutes. The photos mixed documentary truth with the artificiality of the pose, and Liu was fascinated by the questions of freedom and constraint that the images provoked.

A later trip home was prompted when she asked some friends to see if they could locate the grave of her father so that she could sweep it, a custom in China. To everyone's amazement, her father was found still living in the prison (though he was technically free, he knew no other place to go) where he had been incarcerated in the early years of the Revolution. She was able to see him again—though at first he pretended not to know that he had ever had a daughter, fearing that his guards would punish her—and her mother, who still lives in China and who never remarried, was able to meet him again as well. Today she hopes to bring her father to the United States for medical care, though his health may be too fragile to allow it. Her mother remains in China.

Summary and Introduction

Works in Progress: Hung Liu outlines the process of painter Hung Liu as she creates a series of works entitled *The Last Dynasty* for an exhibition at the Steinbaum/Krauss Gallery in New York in the autumn of 1995.

Her subject matter is the court of Cixi, the Empress Dowager of China, who effectively ruled China from 1861 until her death in November 1908, just three years before the 1911 revolution led by Sun Yat-sen. Hers was a court of 3000 eunuchs, of whom she demanded fierce loyalty in return for the riches that were the benefit of their position. As the widow of the Emperor, Cixi ruled by manipulating the appointment of a series of child emperors, promising, in each case, that as soon as the child should have completed his education, "we shall immediately hand over to him the affairs of government." For this exhibition, Hung Liu has painted court eunuchs, concubines of the court (the emperor and princes could have but one wife, but many concubines), the famous Last Emperor, Pu Yi, and his young wife, as well as the Empress Dowager herself. Pu Yi and his empress were both seventeen years old when the photographs upon which Hung Liu has based her paintings of them were taken. A year later, in 1924, Pu Yi was driven from the Imperial Palace in Beijing, where he had lived since abdicating the throne, at age 6, in 1912. He took refuge in the Japanese quarter of Tianjin, and throughout his life was subjugated to various abuses, depending upon who was in power. He died in October 1967, a clerk in the People's Republic of China.

Works in Progress: Hung Liu concentrates on Hung Liu at work on the painting of the *Three Fujins*, concubines to the Prince Yi Huan, a high-placed official in Cixi's court, as well as on her painting of the last empress, which she turns to in order to relieve herself for a while from the larger painting of the three concubines. The *Three Fujins* seemed to us like an excellent entry to the "Principles of Design" chapter, since it utilizes virtually all the major principles of design and addresses the question of unity and variety not only in compositional but also thematic terms. If Hung Liu's work can be said to focus on a single theme, it is the theme of freedom and subjugation—both her own freedom and subjugation as a painter and the freedom and subjugation of others.

Ideas to Consider

1. One of the challenges of viewing the Hung Liu episode is to come to an understanding of how Hung Liu's technical means support and contribute to the themes she addresses in her work. If, as we have said, one of her main themes is freedom and subjugation, consider the following questions:

- What does a photograph "capture"? As she has said, "The people being photographed . . . [are] arranged almost like abstract elements in a formal composition. These are relationships of power, and I want to dissolve them in my paint-

ings." She insists that she does not merely copy her photographic source. How does she free herself from her sources? How does she dissolve the "relationships of power"?

- To what degree is Hung Liu trapped by representation? How does this relate to her training in China?

- How does she escape the confines of representation? (Consider here the "freedom" of her drip technique.)

2. The French philosopher and critic, Roland Barthes, wrote in an essay on photography: "In front of the [camera] lens, I am at the same time: the one I think I am, the one I want others to think I am, the one the photographer thinks I am, the one he makes use of to exhibit his art." How does this inform Hung Liu's paintings?

- Consider in this context the painting seen in the gallery at the film's end that shows a traditional acupuncture chart. These diagrams, which date from the Ming Dynasty (1368-1644), map the human body. Acupuncture is an attempt to control the human body by puncturing its surface and manipulating its underlying currents. Is the acupuncturist in any way like the photographer?

3. In the video, Hung Liu refers to her Chinese tradition, to the "wild" painters and poets of yesteryear. Turn in your text to Figures 616 and 617, in Chapter 18 in the Timeline, "The Renaissance through the Baroque." Here are reproduced fourteenth-century paintings by Wu Chen and Cheng Sixiao. Can you relate these works to Hung Liu's painting style?

4. Hung Liu's paintings, as you can see in the video, are very large. Her figures are larger than lifesize. What effect does this shift in scale have on the viewer?

5. Fundamental to Hung Liu's art is her coming to the United States in 1984. In what ways does the video show that her emigration has made a difference to her and her work?

Frequently Asked Questions

How can I learn more about the themes dealt with by Hung Liu in her paintings, particularly the transformation of Chinese society? Two contemporary films are dedicated to the rule of the Chinese monarchy before and during its demise: Bernardo Bertolucci's *The Last Emperor* (winner of nine Academy Awards in 1987, including Best Picture and Best Director), and Chen Kaige's *Farewell My Concubine* (winner of the Palme d'Or at the Cannes Film Festival and nominated for an Academy Award as Best Foreign Film in 1993). Both are readily available at most video rental outlets.

REVIEW QUESTIONS

Answers to the following questions appear in the APPENDIX: ANSWER KEY at the end of the *Study Guide*.

1. What is the difference between an outline and a contour line?

2. What is an implied line? Give two examples.

3. What quality of line dominates Robert Mapplethorpe's *Ajitto* (Fig. 63)?

4. What quality of line dominates Marcel Duchamp's *Nude Descending a Staircase* (Fig. 67)?

5. What quality of line best describes Alesander Calder's *Grande Vitesse* (Fig. 72)? What association does this line quality evoke in the viewer?

6. What quality of line best describes Salvadore Dali's *The Persistence of Memory* (Fig. 53)? Why does this sort of line seem appropriate here?

SUPPLEMENTAL ACTIVITIES AND WRITING ASSIGNMENTS

Supplemental Activities: Experiment with your friends or acquaintances to determine whether the cultural conventions associated with line still hold true. Draw a straight line and a curved one:

Ask people to associate freely with these two lines. What words come to mind when you look at them? If, after a while, they have not actually said "male and female" or its equivalent, ask them if one line seems more male or more female? Does one seem more logical or rational?

SUPPLEMENTAL ACTIVITIES

The Website: Go to the *World of Art* website (**www.prenhall.com/sayre**). Proceed through the Chapter 5 materials. Consider your command of the objectives as stated in the website. Take the multiple choice and fill-in-the-blanks self-tests. Briefly respond to both the critical analysis and the compare and contrast questions, either formally or informally. Visit the related sites linked in both the Modern Artists and Galleries and Museums areas. A hands-on project related to the course material is suggested. Even if you are not assigned the Project, think about how you might approach it. Finally, consider participating in the Message Board or Chat Discussions.

Writing about Line: Consider the use of line in Robert Motherwell's *Elegy to the Spanish Republic #34* (Fig. 54), discussed in Chapter 3, p. 47. How does his use of line help, in formal terms, to underscore his thematic concern with "the struggle between life and death"? How does the drip inform his work? How does the work compare, in fact, to Hung Liu's *Three Fujins*?

Writing to Explore New Ideas: One of the most interesting uses of line in the modern world is its centrality to print culture. We read and write in lines. What is the standard structure of print in Western culture? That is, how does print look on the page? How is it organized? What are some of the implications of this structure? Can you find examples or instances where this standard structure is challenged or overturned? What is the result?

Suggested Further Reading: One of the most famous discussions of line in art occurs in a book written in the 1920s by the twentieth-century painter Wassily Kandinsky, *From Point to Line to Plane*, which has been reprinted by Dover Editions, New York.

"The Liberation of Line," Chapter 2 of Jean Clay's *Romanticism* (New York: Vendome Press, 1981), is a marvelously illustrated discussion of the Romantic's use of line.

Chapter 6
Space

LEARNING OBJECTIVES

This lesson will help you understand how artists manipulate space in their work. At the end of this chapter you should be able to:

1) Distinguish between shape and mass.

2) Appreciate the difficulty of representing three-dimensional space in two-dimensional terms, including the necessity of foreshortening.

3) Understand the principles of linear perspective.

4) Outline some of the means other than linear perspective that artists employ to represent space.

5) Appreciate why many modern artists have refused to represent three-dimensional space and have emphasized the two-dimensionality of the picture plane instead.

KEY CONCEPTS

shape and mass
two-dimensional space
three-dimensional space
figure-ground reversals
negative shapes or spaces
change in scale
overlap
picture plane
foreshortening

axonometric projection
isometric projection
dimetric projection
trimetric projection
oblique projection
cyberspace
hyperspace
virtual reality

Perspective

one-point linear perspective
two-point linear perspective
vanishing point

vantage point
frontal recession
diagonal recession

STUDY PLAN

Step 1: Read Chapter 6, "Space," in your text, *A World of Art,* pp. 90-108.

Step 2: Attempt to answer the questions posed in the CRITICAL PROCESS section at the end of the chapter. Don't worry if you find that you have a difficult time. Proceed to the next step.

Step 3: Read the OVERVIEW of Chapter 6 in this study guide lesson. When a specific work of art that is illustrated in the text is discussed, try to visualize it. If you are unable to remember it, open the text to that illustration and refresh your memory.

Step 4: Complete the suggested CD-ROM assignments for Chapter 6 outlined in this study guide lesson.

Step 5: Return to the LEARNING OBJECTIVES and KEY CONCEPTS sections at the beginning of this study guide lesson. Demonstrate your mastery of each of the learning objectives. Define each of the concepts—each is discussed in the text and each appears in the glossary at the end of your text as well.

Step 6: Return to the CRITICAL PROCESS section at the end of the chapter. Having reviewed the material, attempt to answer the questions again. Turn to the back of the text, p. 513, and compare your answers to those provided by the author.

Step 7: Answer the REVIEW QUESTIONS. Complete the assigned SUPPLEMENTAL ACTIVITIES and WRITING ASSIGNMENTS in this study guide lesson.

Step 8: Pursue any title from the SUGGESTED FURTHER READING that is assigned or that interests you.

OVERVIEW
of Chapter 6 - "Space"
A World of Art

Space is all around us, all the time, and we are all at least superficially familiar with it. But the creation of space in a work of art presents special problems we need to think about, problems addressed in this chapter.

Shape and Mass

Paramount to an understanding of the formal elements is an understanding of the relationship of space to three-dimensional form (or mass) and two-dimensional shape. This is particulary important, given the new forms of "space" that seem to be developing such as cyberspace or virtual reality, or the electronic space of the World Wide Web (Internet).

Shape is a two-dimensional concept. A shape is flat and is measured in terms of height and width. When viewing a three-dimensional object, we are looking at an object's **mass,** or solid volume, measured in height, width, and depth. Thus, a "square" is a shape, while a "cube" is a mass.

The creation of a shape on a picture plane simultaneously creates space, as exhibited in Donald Sultan's *Lemons* (Fig. 115). By contrast, Martin Puryear's *Self* (Fig. 116) is a three-dimensional mass which exists in real or actual space. Both works define space through their creation. *Lemons* also succeeds in creating illusory space, a sense of depth, through the simple technique of overlapping. The higher lemon appears further away from the picture plane.

The *Rubin Vase* (Fig. 117) achieves a sense of depth as well, although without overlapping. At first, the vase appears to sit in front of the white ground, but when we recognize that we are looking at two white heads facing one another, the relationship between figure and ground is reversed. The heads are now in the foreground. This **figure-ground reversal** demonstrates how our perceptual experience relies upon our recognition of spatial relationships between an object and its background.

Three-dimensional Space

The world that we live in (our homes, streets, and cities) has been "carved" out of three-dimensional space. An architectural structure such as the Musée d'Orsay in Paris (Fig. 118) frames three-dimensional space inside its walls, and, in designing the remodel, architect Gae Aluenti further defined its framing, or partitioning of space, in a manner which lent new monumentality to the original building.

Barbara Hepworth's *Two Figures* (Fig. 119) are two standing vertical masses which occupy three-dimensional space like standing human forms. Hepworth has also carved out **negative shapes** or **spaces,** so called because they are empty spaces that acquire a sense of volume and form by means of the mass that surrounds them.

The negative space formed in the bowl of the African *Feast-making Spoon* (Fig. 120) serves both a utilitarian and symbolic function. It holds rice during the described festivals celebrating the generosity of the wunkirle, and is also a metaphor for a "belly pregnant with rice."

OVERVIEW

Two-dimensional Space

When we surround empty space so as to frame or outline it, the space inside the frame or outline can acquire a sense of volume or form. Such spaces are called negative spaces or shapes. In two-dimensional terms, this can be equated to the empty canvas or "open space" that painters encounter. A flat canvas is two-dimensional or "flat" space, and a sense of depth can only be achieved through illusion. In Diebenkorn's *Woman in Chaise* (Fig. 121) the white ground of the paper (also called the "reserve") is surrounded by ink so that it seems to stand forward from the paper itself to become the nude's body. We read this white space as illuminated flesh.

There are many ways to create the illusion of deep space on a flat surface, and often several are used simultaneously. Large objects appear to be closer to the picture plane, therefore, closer to the viewer. Objects will frequently overlap one another, indicating spatial depth. Friedrich's *Woman in Morning Light* (Fig. 122) is an example of both of these basic principles. The rays of the sun fan out surrounding her, in a manner that reestablishes the distance of the sun. Friedrich is keenly interested in creating three-dimensional space through elements of perspective, overlapping, and diminishing size.

Linear Perspective

Perspective was known to the Greeks and Romans but not mathematically codified until the Renaissance. It allows the picture plane to function as a window to a scene. In one-point linear perspective, all lines describing an object's depth recede to a single vanishing point on the horizon line. When the vanishing point is directly across from the viewer's vantage point, the recession is frontal. To understand the importance of perspective in painting, one can compare the painting of *St. Francis Renouncing His Earthly Possessions* (Fig. 124), with its chaotic lines of recession, to a work such as Leonardo da Vinci's *The Last Supper* (Fig. 126), where all primary architectural lines converge upon a point behind Christ's head. In addition to creating a system of one-point perspective, this also places emphasis on the figure of Christ Himself.

Gustave Caillebotte's *Place de l'Europe on a Rainy Day* (Figs. 128 and 129) is an example of two-point perspective. Here, two (and even more) vanishing points organize the complex array of parallel lines emanating from the intersection of five Paris streets.

Two paintings that demonstrate the striking differences between frontal and diagonal recession in perspective compositions are Pieter Bruegel the Elder's *The Wedding Dance* (Fig. 131) and Peter Paul Rubens's *Kermis* (Fig. 133). Bruegel's *Dance* places the vanishing point at the center of the horizon, and the dancers' positions and arms align along diagonal parallels that bring the work and the feeling of the dance itself, a central balance. In Rubens's *Kermis*, the diagonal recession sets up a feeling of imbalance, which seems to appropriately address the drunken ribald nature of the "festivity."

═══════════════════

Works in Progress
Peter Paul Rubens's *Kermis*

Rubens's *Kermis*—literally, the celebration of a saint's feast day—echoes themes

similar to a painting of a Peasant Dance by his contemporary, Adriaen Brouwer, and earlier works by Pieter Bruegel.

In examining the sets of drawings for the final painting, we learn much about Rubens's creative process. The first drawing (Fig. 135) delineates, in a strong diagonal, peasants seated at a table. Many of the elements of this early study survive in the final painting, but not without modification. At the far left of the drawing, at the near end of the table, two men appear to be exchanging a tankard of ale, as if the one is paying the other. In the final painting, the exchange between these two is far less amicable. Indeed, they seem to be fighting over their beer.

On the back side of this drawing is another set of studies for the dancing figures in the final painting (Fig. 136). In contrast to Pieter Bruegel's dancing couples (see Fig. 131), who only touch hands if they touch at all, these pairs coil around each other in a close embrace. Rubens is apparently searching for the right combination of dancelike movement and sexual embrace. This couple is highlighted in the right center of the painting (Fig. 137). Through these studies, we begin to see the social or moral complexities that define the times in which Rubens lived. His painting has been adjusted for both compositional and moralistic concerns.

Some Other Means of Representing Space

Axonometric projections are systems of projecting space frequently used by architects and engineers because they can translate the space into a single drawing, but maintain the basic scaled measurements within the drawing. In **axonometric projections** (Fig. 138), lines remain parallel, and all sides of an object are at an angle to the picture plane. There are three types of axonometric projection drawing:

> **isometric:** where all measurements—height, width, and depth—are drawn to the same scale;
>
> **dimetric:** where two measurements, often width and depth, maintain the same scale, but the third is reduced by half;
>
> **trimetric:** where all three measurements use different scales.

Another related type of projection (often found in Japanese art) is **oblique projection**. Here the sides of the object remain parallel, but one face of the object is parallel to the picture plane as well.

Distortions of Space and Foreshortening

The space created by means of linear perspective is similar to the space created by photography, the medium we accept as representing real space. The perspective drawing and the photograph both employ monocular vision, or a "one-eyed" point of view. Actual vision is binocular—we see with both eyes. In the nineteenth century, the stereoscope was invented to imitate binocular vision. Two pictures of the same object were taken from slightly different positions, then were viewed simultaneously through the stereoscope, creating a three-dimensional effect (Fig. 140).

OVERVIEW

A disadvantage in both the linear perspective system and photography is that close objects often appear distorted and out of proportion, as in the *Man with Big Shoes* stereograph (Fig. 141). Some artists, such as Phillip Pearlstein in his *Model on Dogon Chair, Legs Crossed* (Fig. 143), deliberately paint what they see, allowing the out of proportion foreground elements to play against similar shapes in the painting.

Other artists such as Andrea Mantegna in his *The Dead Christ* (Fig. 144) have made up for this problem by foreshortening, in which the dimensions of the closer extremities are "scaled down"in order to make up for the distortion created by point of view.

Modern Experiments and New Dimensions

In the "modern era," artists have often intentionally violated the principles of perspective or **verisimilitude** (apparent visual truth) in an effort to better equate the three-dimensional image to the two-dimensional surface. In Henri Matisse's *Harmony in Red* (Fig. 145), the artist has eliminated almost any sense of three-dimensionality by uniting the different spatial areas in one large field of unified color and design. The wall paper and the table cloth are the same fabric, objects appear overly large, shapes are repeated, and the tree trunks beyond the room repeat wall paper pattern within the room. In fact, the window can be viewed either as a window or a painting on the wall. In traditional painting, the frame functions as a window; now the window has been transformed into a frame.

Cezanne's *Mme. Cézanne in a Red Chair* (Fig. 146) is deliberate in its lack of three-dimensional depth. Cézanne has avoided certain conventions that would allow depth to be implied in favor of integrating ideas of pattern and flat space into the work. In doing so he suggests that accurate description of the scene is not as important as the design of the canvas and the activity of painting itself. We are not looking so much at a portrait of his wife as we are a play of pattern and color. Cézanne has used this approach to organize the composition into dynamic relationships. The painting is an animated image of a potentially static subject.

THE CRITICAL PROCESS
Thinking about Space

The history of modern art has often been summarized as the growing refusal of painters to represent three-dimensional space on the picture plane. However, while some modern art has denied the representation and actual space, recent technology in video and computer technology have made it possible to create artificial environments that a viewer experiences as real space. Cyberspace, hyperspace, or virtual reality, are becoming increasingly realistic. A viewer can seemingly navigate through a world of actual space that is completely computer generated. In this technology, our traditional notions of space are challenged. The vastness of the world is brought immediately closer through the "World Wide Web" of the Internet. Space becomes open for a redefinition as fundamental as when perspective was codified in the fifteenth century. Consider Michael Scroggins and Stewart Dickson's *Topological Slide* (Figs. 147 and 148). Think about how you might define this "new space." Is it two-dimensional? Is it three-dimensional? What are its possibilities?

NAVIGATING *A World of Art*: THE CD-ROM

The *World of Art* CD-ROM contains two doorways, both in Hands-on Exercises Room, that will help you to understand the material in Chapter 6, "Space."

Perspective: One entire interactive pathway is dedicated to perspective. Move the pointer to the directional arrow and hold down the mouse button as the room spins until the Perspective doorway appears. Stop, then double-click on the doorway, and the Perspective problem and activity area will open.

The first demonstration area explores one-point perspective. You can manipulate the space by changing the vanishing point along the horizon line. Then you can change the vantage point by moving it either left or right. Notice how the lines of recession change as you move the vantage point from a frontal position to a diagonal one. Now move the vantage point up and down. Finally, in this section you can see how round forms, such as a vase and a bottle, are affected as the vantage point changes.

In the second demonstration area you can explore two-point perspective in the same way that you explored one-point perspective in the first demonstration. Alter your vantage point in as many ways as you can.

The third demonstration area is related to *St. Francis Renouncing His Earthly Possessions*, Figs. 124 and 125 in your text, a fresco sometimes considered the work of Giotto. In the CD-ROM, we have reproduced Giotto's *The Birth of the Virgin*, one of Giotto's frescoes from the Arena Chapel in Padua, Italy. When you click on it, its perspective lines will appear. Notice they do not meet at a single vanishing point. Double-click and the painting will redraw itself so that the perspective is perfect. Triple click, and you will return to the original work. Repeat the process as often as needed until you understand where Giotto went wrong. Incidentally, many people prefer the imperfect perspective of the original. Can you guess why?

Key: This demonstration looks forward to Chapter 7, "Light and Color," but it is useful to consider it here as well. Move to the Key doorway by moving the pointer to the directional arrow, holding down the mouse button, and spinning through Room 1 until the Key doorway appears. Stop, then double-click on the doorway, and the Key problem and activity area will open. For now, we will explore only the first two problems.

In the middle of your screen is the outline of a piece of fruit. To the right are three boxes with a line drawing in each. Grab each box and drag it over to the outline of the fruit. You will see that as the lines fill the flat shape, the shape assumes dimension. Other examples follow.

Figure 115 in Chapter 6 of your text is Donald Sultan's *Lemons*. It illustrates the concept of shape. This demonstration is a more complex version of the first. It begins with the basic shape of Sultan's lemons. Again, there are three line drawings to the right. Grab each box one at a time and drag it over to the lemons. As in the first problem, you will see that as the lines fill the flat shape, the shape assumes dimension. We have not yet considered how the manipulation of light and dark contributes to the illusion of three-dimensional space—that is, partly, the subject of the next chapter—but you can clearly see the effect in these two exercises.

REVIEW QUESTIONS

Answers to the following questions appear in the APPENDIX: ANSWER KEY at the end of the *Study Guide*.

1. Which, if any, of the following statements about linear perspective are true?
 a) The vanishing point is always directly across from the vantage point.
 b) All lines of recession converge at a single vanishing point.
 c) A single composition may possess two or more vanishing points.
 d) Leonardo's *Last Supper* is an example of frontal recession.
 e) Linear perspective was perfected in the Renaissance.

2. What is the difference between a shape and a mass?

3. Why are Christ's feet smaller than normal in Mantegna's *The Dead Christ*?

4. Which of the following are ways of creating the illusion of deep space on a two-dimensional surface?
 a) axonometric projections
 b) overlapping
 c) creating a change in scale
 d) positioning an object higher on the picture plane
 e) linear measurement

5. Many modern artists ignore the rules of perspective because
 a) they don't know any better.
 b) they are more interested in the design of their canvas than the accuracy of their representation.
 c) since Einstein's Theory of Relativity, they have been unable to imagine depth.
 d) they believe that art should be bound by no rules.

6. Negative space is
 a) space that seems difficult or impossible to fill with a meaningful image.
 b) empty space that is surrounded and shaped so that it acquires a sense of form or volume.
 c) the background of a picture.
 d) the space we enter in virtual reality systems.

SUPPLEMENTAL ACTIVITIES AND WRITING ASSIGNMENTS

Supplemental Activities: A good way to test your understanding of perspective is to take tracing paper and, with a ruler, trace the perspective lines of several paintings in your text.

- Begin with Gustave Caillebotte's *Place de l'Europe on a Rainy Day* (Fig. 128). Many of the perspective lines are already indicated in the text, but see how many more you can add.
- Next, try William Merritt Chase's *The Nursery* (Fig. 221). Describe the perspective plan.
- Trace the perspective plan of Jacques-Louis David's *Oath of the Horatii* (Fig. 226). How does this help you understand how the artist *focuses* his composition?
- Finally, trace the perspective lines in Vincent van Gogh's *The Night Café* (Fig. 189). Notice that there seem to be two conflicting vanishing points, one straight through the room and out the doorway, the other higher, almost directly under the large light on the left. What effect does this conflicting perspective create?

The Website: Go to the *World of Art* website (**www.prenhall.com/sayre**). Proceed through the Chapter 6 materials. Consider your command of the objectives as stated in the website. Take the multiple choice and fill-in-the-blanks self-tests. Briefly respond to both the critical analysis and the compare and contrast questions, either formally or informally. Visit the related sites linked in both the Modern Artists and Galleries and Museums areas. A hands-on project related to the course material is suggested. Even if you are not assigned the Project, think about how you might approach it. Finally, consider participating in the Message Board or Chat Discussions.

Writing about Space: In Chapter 3, in the discussion "Representing the Beautiful," there is a Works in Progress spread on Pablo Picasso's *Les Demoiselles d'Avignon*. Even a cursory look at this painting reveals that its space is ambiguous and complex. Describe what you think is happening in it spatially, and see if you can explain what Picasso's intentions might have been. What is the point? It might help to consider the last section of Chapter 6, "Modern Experiments and New Dimensions."

Writing to Explore New Ideas: Look at the Albrecht Dürer's print in Chapter 6, *Draftsman Drawing a Reclining Nude* (Fig. 142). At the end of Chapter 5, "Line," we considered the cultural conventions of line that treat the male in geometric terms and the female in curvilinear terms. Here, Dürer's draftsman submits the female to the male gaze. Explore some of the cultural implications of this image. What does it suggest about the roles of both the male and the female?

Suggested Further Reading: A sophisticated but fascinating history of perspective is John White's *The Birth and Rebirth of Pictorial Space*, 3rd edition, Belknap Press of the Harvard University Press, Cambridge, Mass., 1987.

Chapter 7
Light and Color

LEARNING OBJECTIVES

This lesson will help you understand how artists manipulate light and color in their work. At the end of this chapter you should be able to:

1) Discuss the ways in which light is used to create space—through atmospheric perspective, chiaroscuro, and hatching and cross-hatching.

2) Describe the types of shading employed in a modeled form.

3) Recognize how key (or value) is employed in a work of art.

4) Utilize the basic vocabulary of color.

5) Describe both the traditional and Munsell's color wheels.

6) Describe the basic color schemes employed by artists.

7) Differentiate among local color, perceptual color, optical color mixing, and arbitrary color.

8) Describe some of the ways in which the symbolic use of color is relative and arbitrary.

KEY CONCEPTS

Light
atmospheric perspective
chiaroscuro
tenebrism
hatching
cross-hatching
key
tint
shade

Color
spectrum
primary colors
secondary colors
intermediate colors
subtractive process
additive process
intensity or saturation
palette
temperature
analogous color schemes
complementary color schemes

polychromatic color
schemes
local color
perceptual color
optical color mixing
arbitrary color
pointillism
divisionism
plein-air painting
symbolic color

STUDY PLAN

Step 1: Read Chapter 7, "Light and Color," in your text, *A World of Art*, pp. 109-138.

Step 2: Attempt to answer the questions posed in the CRITICAL PROCESS section at the end of the chapter. Don't worry if you find that you have a difficult time. Proceed to the next step.

Step 3: Read the OVERVIEW of Chapter 7 in this study guide lesson. When a specific work of art that is illustrated in the text is discussed, try to visualize it. If you are unable to remember it, open the text to that illustration and refresh your memory.

Step 4: Complete the suggested CD-ROM assignments for Chapter 7 outlined in this study guide lesson.

Step 5: Return to the LEARNING OBJECTIVES and KEY CONCEPTS sections at the beginning of this study guide lesson. Demonstrate your mastery of each of the learning objectives. Define each of the concepts—each is discussed in the text and each appears in the glossary at the end of your text as well.

Step 6: Return to the CRITICAL PROCESS section at the end of the chapter. Having reviewed the material, attempt to answer the questions again. Turn to the back of the text, p. 513, and compare your answers to those provided by the author.

Step 7: Answer the REVIEW QUESTIONS. Complete the assigned SUPPLEMENTAL ACTIVITIES and WRITING ASSIGNMENTS in this study guide lesson.

Step 8: Pursue any title from the SUGGESTED FURTHER READING that is assigned or that interests you.

OVERVIEW
of Chapter 7 - "Light and Color"
A World of Art

Perspective is just one way in which artists suggest space; another way is through the use of light. In 1666, Isaac Newton demonstrated that some surfaces appear to be certain colors because they absorb and reflect different wavelengths of light. An object that appears yellow-green has absorbed all other colors of light, and reflects only the yellow-green. Color is essential for defining shape and mass—we see the red object against the green one. People who are color blind often cannot differentiate between certain color wavelengths, and cannot read the numbers in the *Test for Colorblindness* (Fig. 149). Because they often read different colors of similar lightness or darkness as the same, they see things differently spatially. This demonstrates how color, and light, are important to our perception of space.

Light

Since natural light helps to define spatial relationships, it stands to reason that artists are interested in manipulating it. This is true of architects as well. One of the most dramatically lit spaces in all of architecture is Le Corbusier's church of Notre-Dame-du-Haut at Ronchamp in eastern France (Fig. 150). The light is admitted through narrow stained-glass windows on the exterior southern wall, but as the window boxes expand through the thick wall, the light broadens into wide shafts that possess an unmistakable spiritual quality.

Obviously, not all artists can utilize light like architects, but if they are interested in representing the world, they must learn to imitate the effects of light in their work.

Atmospheric Perspective

For Leonardo da Vinci, light was at least as important to the rendering of space as perspective. The effect of atmosphere on the appearance of elements in a landscape was of prime concern to him, and through painting he formulated the "rules" of **atmospheric** or **aerial perspective**. Atmospheric perspective takes into account the manner in which the quality of the atmosphere affects objects that are nearer or farther away. Objects farther away appear less distinct, cooler or bluer in color, with reduced contrast. In Leonardo's *Madonna on the Rocks* (Fig. 151) foreground objects are painted with clarity and definition, enabling us to separate them spatially from the hazier distant rock formations.

By the nineteenth century, atmospheric perspective had come to dominate the thinking of landscape painters. J.M.W. Turner was a leading expert in the field of linear perspective, yet he always insisted that atmospheric perspective was a much more important tool to the painter. In his work, *Rain, Steam, and Speed—The Great Western Railway* (Fig. 152), Turner has used paint in a manner that causes light and atmosphere to completely dominate the scene, overwhelming any references to linear perspective. In part, Turner felt that with linear perspective one could describe physical reality, but with atmospheric perspective, one could reveal a greater spirituality.

OVERVIEW

The dominance of light over line had begun to assert itself in painting as early as the Renaissance. Tintoretto's *The Last Supper* (Fig. 154) seems much more expressive than Leonardo's, which we saw in Chapter 6, due to the dramatic play of light and dark. Tintoretto's version also places Christ at the center of the composition, yet it is light, not one point perspective that focuses our attention on Christ.

Chiaroscuro

A primary tool of artists of the Renaissance to render the effects of light is **chiaroscuro**. In Italian, the word *chiaro* means light, and *oscuro* means dark. The light/dark phenomena, when carefully employed, produces the effect of a three-dimensional surface. This process is called **modeling**.

Chiaroscuro can be readily observed when an artist has worked on colored or gray paper, and exaggerates highlights with white chalk, in addition to using charcoal or graphite for the darker areas. An example of this is the Prud'hon *Study for la Source* (Fig. 155). Highlights, indicated by the white chalk, define the areas where the light source hits the subject directly. There are three basic areas of shadow. The **penumbra**, which is the transition to the **umbra**, or the core of the shadow, and **cast shadow**, the darkest area of the shadow. There are also areas of reflected light, sometimes called "back light," where light is reflected back into the areas of shadow.

Artemisia Gentileschi's *Judith and Maidservant with the Head of Holofernes* (Fig. 157) shows her mastery of the technique of chiaroscuro, taking it, in fact, to a new level called **tenebrism**, from the Italian *tenebroso*, meaning "murky." This is demonstrated through the dramatic spots of light that appear against the deep shadows of the painting. The impact is heightened through the use of light that seems almost as if it is from a spotlight, emphasizing a hushed silence.

Hatching and Crosshatching

Other techniques used to model figures include **hatching** and **cross-hatching**. Hatching is an area of closely spaced parallel lines, or hatches. The closer the spacing between the lines, the darker the area. Hatching can be seen in Prud'hon's *Study for La Source* (Fig. 155). Hatching can also be seen in Michelangelo's *Head of a Satyr* (Fig. 158). However, in Michelangelo's drawing the greatest sense of volume and form is attained through cross-hatching. In **cross-hatching**— a set of hatches crossed at an angle by a second set, or a third. The denser the lines, the darker the area.

Works in Progress
Mary Cassatt's *In the Loge*

Mary Cassatt's *In the Loge* (Fig. 160) is a study in the contrast between light and dark, as becomes evident when we compare the final work to a tiny sketch, a study perhaps made at the scene itself (Fig. 159). In the sketch, Cassatt divides the work diagonally into two broad zones, the top left bathed in light, the lower right dominated by the woman's black dress. This diagonal design is softened by Cassatt's decision to fit her figure into the architectural curve of the loge itself, so that the line running along the railing, then up her arm, continues around the line created by her hat and its strap in a giant compositional arch. Thus the woman's face falls into the zone of light, highlighted by her single diamond earring, and cradled, as it were, in black.

In the final painting, the strict division between light and dark has been modified by the revelation of the woman's neck and her collar, creating two strong light and dark diagonals. This angularity emphasizes the horizontal quality of her profile and gaze as she stares out at the other loges through her binoculars. Across the way, a gentleman leans forward out of his box to stare through his own binoculars at the woman in black. He is in the zone of light, and the dramatic division between light and dark defines itself as a division between male and female spaces. But Cassatt's woman, in a bold painterly statement, enters the male world. Both her face and her hand holding the binoculars enter the space of light. Giving up the female role as the passive recipient of his gaze, she becomes as active a spectator as the male across the way.

Key

The gradual shift from light to dark that characterizes both chiaroscuro and atmospheric perspective is illustrated by the gray scale in the text (Fig. 161). The lighter an area is, or, the more "light filled," the higher its **key** (or **value**). The darker it is, the lower its key (or value).

Colors, too, change in key similarly. Light pink is high in key and dark maroon is low in key. Each is derived from the color red. The addition of white to a hue creates a **tint** (pink) and the addition of black to a hue creates a **shade** (maroon). Pat Stier's *Pink Chrysanthemum* (Fig. 162) and *Night Chrysanthemum* (Fig. 163) both employ change in key to heighten their expressive impact. In the lighter painting, the change from higher to lower key becomes increasingly energetic and alive, while in the darker painting (*Night Chrysanthemum*) the mood becomes somber and threatening.

Light and dark have always had symbolic meaning in Western culture, beginning with the book of Genesis from the Bible— ". . . the earth was without form and void; and darkness was upon the face of the deep. . . . And God saw the light, that it was good." This association of light with good and darkness with evil was first fully developed by J. W. von Goethe in the eighteenth century. Goethe felt that colors, which existed between pure light and pure dark, held moral and religious significance. Heaven, which many feel consists of pure light, sheds its light upon the darkness, inspiring a hope for salvation.

J.M.W. Turner was impressed with some elements of Goethe's color theory and illustrated it in a pair of paintings, *Shade and Darkness* (Fig. 164), consisting of blues, grays, and browns, and *Light and Colour* (Fig. 165), consisting of reds and yellows. The first seems passive and "sleeping," the second comes alive with brilliant light that illuminates the figure of Moses writing the words from Genesis quoted above.

Although the opposition between dark and light is taken for granted in our culture, for many people of color, this thinking is often offensive, and with reason. The term "value" serves as a descriptive term that describes gradations between light and dark to artists and historians. It becomes offensive when the words "low" and "high" are added to connote darkness as "low in value" and lightness (or "whiteness") as "high in value." For this reason, this text uses the expression "key" in place of value, a term used historically far longer than "value" anyway.

Goethe's sense of blackness as the absence of color is the antithesis to how African Americans view blackness. In Ted Wilson's poem the sound of African drums

is the sound of life, and blackness, as he eloquently points out, is "the presence of all colors."

The Nigerian Funeral Cloth (Fig. 166) further illustrates the limitations of Western assumptions about the meaning of white and dark, black and white. The dominant colors of the cloth—red, black, and white have different connotations than in western culture. The cloth's black signifies life and the ancestral spirit, the color white signifies death, and red is meant to inspire the warrior's valorous deeds.

Color

Of all the formal elements, color is perhaps the most complex. Individually, we might be able to distinguish between as many as ten million different colors. The Maoris of New Zealand regularly employ over one hundred different words for what most of us would call "red." Different cultures emphasize different colors.

Basic Color Vocabulary

Color is a direct function of light. Sunlight passed through a prism breaks into bands of different colors like a rainbow. This is called a **spectrum** (Fig. 167). By organizing the visible spectrum into a circle, we have the conventional color wheel (Fig. 168). The three **primary colors**—red, yellow, and blue—are those that theoretically cannot be made by mixing any other colors. The **secondary colors**—orange, green, and violet—are made by mixing two primaries. In between each secondary and each primary are **intermediate colors**, combinations of the secondary and primary color on either side, such as yellow-green or blue-violet.

Each primary and secondary color of the visible spectrum is called a **hue**. Thus all shades and tints of red, from pink to maroon, are said to be of the same hue. One of the problems in understanding color is that the primaries and secondaries are different depending upon whether one is talking about refracted light or reflected pigment. The conventional color wheel is really only suited to discussion of pigments. When we mix pigments, we are involved in a **subtractive** process (Fig. 169). That is, mixing two primaries causes the resulting secondary to be of a lower key or is duller than the two original primaries, because each primary absorbs a different range of white light. When we combine red and yellow, the resulting orange absorbs twice the light of either red or yellow alone. Theoretically, if we mixed all the pigments, we would wind up with black.

Refracted light, on the other hand, works in a different manner. The primary colors of light are red-orange, green, and blue-violet. The secondaries are yellow, magenta, and cyan. When we mix light, we are involved with an **additive** process (Fig. 170). Two primaries of light mixed together create a secondary of higher key than either primary. Our usual exposure to this process is color television. On television, the color yellow can be seen resulting from the overlapping of many red and green dots. In the additive process of light, the more colors that are added together, the more the spectrum is represented, and the closer we get to white light.

Color is described first by its hue, then by its relative key (the addition of white or black), and finally by its **intensity** or **saturation**. Intensity is a function of a color's relative brightness or dullness. A hue can be lowered in intensity by adding either small amounts of its complement, or a similarly keyed gray. Intensity may also be reduced

by adding a medium, a vehicle for suspending the pigment which effectively "thins" it, reducing its intensity.

An excellent example of the impact of change in intensity can be seen in the newly restored Sistine Chapel ceiling painted by Michelangelo between 1508 and 1512 (Figs. 171 and 172). Restorers have discovered that the dull, somber tones always associated with Michelangelo were not the result of his **palette** (the range of colors he purposely selected), but rather, years of accumulated dust, smoke, grease (from candle tallow), and layers of varnish. The restoration has revealed colors more intense than previously realized. Some experts have said that the painting is now almost garish. As one observer put it, "It's not a controversy, it's culture shock."

Color Schemes

Colors can be employed in different ways to achieve a wide variety of effects. **Analogous** color schemes are those composed of hues that neighbor each other on the color wheel. Such color schemes are also organized on the principle of color **temperature**. The colors yellow through orange and red are usually considered warm colors, and greens through blue to violet are considered more cool in temperature. Sanford Gifford's *October in the Catskills* (Fig. 173), employs yellows and oranges to incite the feeling of warmth. Just as warm or cool palettes can elicit the physiological sensation of warm or cool, combining both palettes can create contrasting physical sensations. Romare Bearden's *She-ba* (Fig. 174) is dominated by cool blues and greens, surrounded by great blocks of red, yellow, and orange.

Color schemes composed of hues that lie opposite each other on the color wheel are called **complementary**. Orange/blue and red/green are examples of complements. When two complements appear in the same composition placed next to one another, they will appear brighter than if used alone. This effect, called **simultaneous contrast**, is due to the physiology of the eye. The eye supplies an **afterimage** of a given hue that is the color of its complement. This effect is evident in Leon Golub's *Mercenaries III* (Fig. 175). The clash of the green and red further emphasizes the explosiveness of the scene.

In *Sunday Afternoon on the Island of the Grande Jatte* (Fig. 176), Georges Seurat has attempted to harmonize complementary colors. Seurat painted thousands of tiny dots on the canvas in a process that became known as *Pointillism*. His paints were not mixed on the palette—instead he relied on **optical mixing**. He felt that by placing the complements orange and blue next to each other, the saturation of both would be enhanced. To his dismay, the result was "murky." This is because there is a rather limited zone in which the viewer can mix the pointillist dots. For most viewers, the painting works from about six feet away—closer, the painting looks like abstract dots, farther away, the colors become muddy.

A vexing issue that the study of color presents is that the traditional color wheel does not adequately describe true complementary color relationships. For example, the afterimage of red is blue-green, not green. In 1905, Albert Munsell created a color wheel based on five primary hues: yellow, green, blue, violet, and red. The complementary pairs are: yellow/blue-green; green/red-violet; blue/orange; violet/yellow-green; and red/blue-green. Munsell's color wheel accounts for many of the powerful complementary color relationships that can-

not be as well illustrated using the standard color wheel. An example of such a relationship is evidenced in the Cara Grande Brazilian feather mask (Fig. 178).

Works in Progress
Chuck Close's *Stanley*

Chuck Close's oil painting *Stanley* (Fig. 180) could be described as layered pointillism. Like all of Close's works, the piece is based on a photograph with a grid overlaid on top of it. Close then draws a grid on a prepared canvas, and begins to reproduce, as accurately as possible, the abstract design which appears in each grid. Close is not concerned with achieving the exact photographic likeness of the subject, but rather, the process of the abstraction. Viewed up close, the work is hard to see as anything but a collection of concentric circles that appear in each "micro" painting, or square of the grid (Fig. 179). As the viewer moves further away, the design in the squares dissolves, and the sitter's features become visible with greater and greater clarity.

Close relates the process of working on such a painting to playing golf, through the notion of moving "from the general to the specific." In *Stanley*, Close reveals a rare knowledge of optical effects and color mixing. He also, in effect, accomplishes two things—the work is fully representational when viewed from a distance, and fully abstract, almost nonobjective, when viewed up close.

Artists working with either analogous or complementary color schemes limit the range of their color selection by choice. In *Filàs for Sale* (Fig. 181), Charles Searles has rejected such a closed or restricted palette in favor of an open palette, in which he employs the entire range of hues in a wide variety of keys and intensities. Such a painting is called **polychromatic**.

Color in Representational Art

There are four different ways of using color in representational art. Artists can represent **local** color, **perceptual** color, create an **optical** mix like Seurat, or simply use color **arbitrarily**.

Stuart Davis's *Summer Landscape* (Fig. 182) provides examples of local color, the use of color that describes an object by the color we know it to be, such as the green leaves on the tree and the red bricks.

The Impressionists were concerned with perceptual color, that is, employing the colors that things appeared to be dependent upon light, time of season, and atmospheric conditions. Monet painted his subjects outdoors, inspiring the French term **plein-air** ("open air") painting. Monet did not simply paint a grainstack yellow (Fig. 183), the local color of straw, but rather combined the colors that he perceived to be rendered by the light.

Monet's use of perceptual color was quite different from Seurat's optical color. Monet mixed color on the canvas, whereas Seurat relied on the phenomena of the eye to blend separate colors together. Seurat's student, Paul Signac, recognized that Seurat's pointillist dots had been too small to read properly, so he began to paint in larger square mosaic-like brushstrokes. He called this approach, used in paintings like *The Mills at Owerschie* (Fig. 184), Divisionism, writing that the "painter does not paint with dots, he divides." Signac could attain a great range of effects depend-

ing upon the variables of each stroke's hue and intensity.

Artists sometimes choose to paint things in colors that are not "true" to either optical or local color. Bonnard's *Terrace at Vernon* (Fig. 185) is an example of the expressive use of arbitrary color. No tree is really violet, and no apple is actually orange.

━━━━━━━

Works in Progress
Sonia Delaunay's *Electric Prism*

Sonia Delaunay-Terk, along with her husband Robert Delaunay, was a founder of modern abstract painting, and in Paris, in the early twentieth century, they explored the colors of the modern world. For both artists, these colors assumed the shape of disks. Robert called these *Simultaneous Disks* (Fig. 186), based on his notions about the simultaneous contrast of colors. He sought, in the paintings, to balance complements in giant color wheels. Sonia was less scientific in her approach to design.

In 1913, Delaunay began to make what she called "simultaneous dresses" (Fig. 187)—reflecting her observations of halos of electric street light and their effect on color. Her dresses were soon lauded for their dynamic use of colors that "moved as the body moved."

The writer Blaise Cendrars was so inspired by Sonia's color sense that he asked her to illustrate his long prose poem *The Prose of the Transsiberian*. Illustrating the poem, Delaunay experimented with what she called her "simulataneous colors," and her discoveries led to *Electric Prism* (Fig. 188). The title of Cendrars's poem, and

other phrases, appear in the center left of the painting. In *Electric Prism*, she unifies the circular disks and color combinations she had seen in electric light and her husband's *Simultaneous Disks*, and the movement of color and flowing lines that she had designed into her dresses. After her first year of studying art in Paris, she had come to believe, as she put it, that "colors can heighten our sense of ourselves, of our union with the universe." In the colors of Electric Prism, she believed she had joined herself to the flux and flow, the energy and dynamism, of modernity itself.

━━━━━━━

Symbolic use of color

To different people color symbolizes different things. For instance, when we see a stop light, we assume that everyone understands that red means "stop" and that green means "go." In China, however, this distinction does not exist. In the context of war, the color red might very well represent blood, in the context of Valentine's Day the color red symbolizes love.

In *The Night Cafe* (Fig. 189), van Gogh employs red and green to his own expressive ends. In a letter to his brother Theo, he described how the complements work to create a sense of imbalance. "Everywhere there is a clash and contrast of the most alien reds and greens" he states, and these colors "suggest the emotion of an ardent temperament." Van Gogh's use of dissonant complementary schemes such as blue and orange creates a type of symbolic color usage.

Wassily Kandinsky's *Black Lines* (Fig. 190) creates a less imposing atmosphere. Color had specific meaning to Kandinsky.

Blue was the heavenly color, yellow the color of earth, and red stimulated the heart. "In the open air," he stated, "the harmony of red and green is very charming." This is a direct contrast to van Gogh, who saw the combination of red and green as a potential reference to the "powers of darkness."

THE CRITICAL PROCESS
Thinking about Light and Color

Chapter 7 concerns itself with the manner in which light and color define our visual world, and how artists can use light and color to imply spatiality or symbolic meaning within their works.

Tony Cragg's Newton's *Tones/New Stones* (Fig. 191) raises many questions regarding color. Cragg, a trained scientist, reinvents Newton's color spectrum as white light passes through the work. What can be made of the title? What are the stones? The piece employs plastic toys, kitchen implements and tools—all things Cragg collected from a Sussex, England, beach. If readers consider Cragg's work a prism, then what else besides light is passing through it?

NAVIGATING *A World of Art*: THE CD-ROM

The *World of Art* CD-ROM contains two doorways, both in the Hands-on Exercises Room, that will help you to understand the material in Chapter 7, "Light and Color."

Key: We introduced you to this demonstration in the last chapter when we looked at the ways in which hatching and cross-hatching help create a sense of space, lending a sense of volume to flat shapes. Quickly review the first two problems in this demonstration, then move on to the third and fourth.

1 In this problem, you are presented with a complex example of chiaroscuro. You are free to manipulate the modeling of the figure in order to explore how light and dark create believeable space. Lighten shaded areas and see how shapes are flattened as a result. Darkening light areas has the same effect.

2 This problem consists of a depiction of a piece of cloth with many folds in it. When you open the problem, the cloth is presented utilizing the standard gray scale. A color palette accompanies the drawing. By dragging colors over to the cloth, you can change its colors. Notice how tints and shades of the basic hue appear, mimicking the effects of the gray scale in color.

NAVIGATING *A World of Art*: THE CD-ROM

Color: The Color doorway of Hands-on Exercises Room contains the most extensive set of problems in the CD-ROM, and you can learn a great deal about the complex ways in which color works by spending a lot of time here.

You can probably learn the most about the difficulties color presents by studying the effects of simultaneous contrast. This first problem zone consists of a self-test. Two squares of different hues, shades or tints, and intensities are placed beside each other. In the center of each is a smaller square. You are simply asked to decide whether the squares in the center are the same color or different colors. They may *look* the same, or they may look different—depending on how they are affected by the colors surrounding them. When you make a decision, enter your answer, and you will be told whether you are right or wrong. The two small squares will also move from the center of the larger squares to meet in the center, showing you whether they are the same or different. (You don't have to take our word for it!) If you don't do very well, don't worry. Even practicing artists rarely get them all right. The point is, a color's context affects the way we see it. Imagine a painter innocently introducing a new color into a painting, a simple act that might change the way all the other colors in the painting appear to the eye.

This problem consists of a number of designs in which simultaneous contrast is at work. In this problem, you have the ability to manipulate the color in the designs. In order to satisfy yourself that a given color is the same despite whatever its background is, change the background colors to white. Then experiment freely with the color fields.

The final window in the simultaneous contrast section consists of shirt and striped tie with separate palettes available for the shirt and both stripes on the tie. As you choose color schemes, you can see for yourself, in a practical application, how color combinations change depending on their context. A good-looking tie will look good on one color shirt but not on another. Experiment freely. Have some fun—try to make not only the best looking combinations, but the ugliest as well.

This exercise takes us beyond the elements presented in the text to the question of color harmonies. In the previous problem, you may have noticed that some of the best color schemes form, if you plotted them on a color wheel, a triangular structure. This problem demonstrates such triadic color harmonies, as well as some more complexly polychromatic color schemes.

REVIEW QUESTIONS

Answers to the following questions appear in the APPENDIX: ANSWER KEY at the end of the *Study Guide*.

1. What is the darkest area of shadow in chiaroscuro, and what is the lightest area on a modeled form?

2. Atmospheric or aerial perspective

 a) was considered by Leonardo to be at least as important as linear perspective in creating space.
 b) is a type of perspective that utilizes a point of view high above the ground.
 c) relies on the clarity of distant objects.
 d) is all of the above.

3. Johann Wolfgang von Goethe

 a) first utilized a prism to see the color spectrum.
 b) believed that color has moral significance.
 c) rejected the proposition, put forth in Genesis, that light is good.
 d) first articulated the theory of atmospheric perspective.

4. Name the complement in pigment of each of the following:

 a) red
 b) violet
 c) blue

5. Name the complement in light of each of the following:

 a) yellow
 b) magenta
 c) cyan

6. What is the difference between Seurat's Pointillism and Signac's Divisionism?

SUPPLEMENTAL ACTIVITIES AND WRITING ASSIGNMENTS

Supplemental Activities: Using old magazines, see how many different varieties of blue you can find in print. Cut out small rectangles of each color and arrange them in as close an approximation as you can to the gray scale, from lightest to darkest. This exercise not only will increase your awareness of the wide variety of colors in print, but also will give you practical knowledge of the relationship between key and color.

The Website: Go to the *World of Art* website (**www.prenhall.com/sayre**). Proceed through the Chapter 7 materials. Consider your command of the objectives as stated in the website. Take the multiple choice and fill-in-the-blanks self-tests. Briefly respond to both the critical analysis and the compare and contrast questions, either formally or informally. Visit the related sites linked in both the Modern Artists and Galleries and Museums areas. A hands-on project related to the course material is suggested. Even if you are not assigned the Project, think about how you might approach it. Finally, consider participating in the Message Board or Chat Discussions.

Writing about Color: In Chapter 5, we considered Vincent van Gogh's *The Sower* (Fig. 98) in terms of line, but we also mentioned, in passing, some of the difficulties that van Gogh was having with color in the painting. Compare and contrast van Gogh's use of complementary color schemes in *The Sower* and in *The Night Café* (Fig. 189). What possibilities for complementary color schemes does this comparison reveal?

Writing to Explore New Ideas: One of the media that takes most advantage of the relationship between light and dark is photography, especially black-and-white photography. This is partly due to the fact that the medium is dependent on light itself (as you will see in Chapter 15, photography literally means *light* [photo] *writing* [graphy]). Consider the way in which Henri Cartier-Bresson utilizes the contrast between light and dark in his photograph of *Athens* (Fig. 433). Then consider how the contrast informs Margaret Bourke-White's *At the Time of the Louisville Flood* (Fig. 434). Can you draw any conclusions from these two examples?

Suggested Further Reading: The classic book on color relationships is painter Josef Albers's *The Interaction of Color*, now available on CD-ROM from Yale University Press, accompanied by a small paperback edition of the original book, which is now very rare and hard to find.

An excellent example of the rich possibilities for symbolic meaning that color presents can be found in the small book *On Being Blue: A Philosophical Inquiry*, written by the novelist William Gass (Boston: David R. Godine, 1976).

Chapter 8
Other Formal Elements

LEARNING OBJECTIVES

This lesson will help you understand how artists manipulate the remainder of the formal elements. At the end of this chapter you should be able to:

1) Distinguish between actual and visual texture.

2) Describe how patterns are created by repeating any of the formal elements—line. shape, mass, color, or texture.

3) State the difference between spatial and temporal media.

4) Describe the different ways in which paintings such as Sassetta's *Meeting of Saint Anthony and Saint Paul*, Monet's *Waterlilies*, Pollock's *No. 29*, and Riley's *Drift 2* utilize time and motion.

KEY CONCEPTS

actual texture	pattern	spatial media
visual texture	decoration	temporal media
frottage	illumination	
impasto	"femmage"	Op Art
		kinetic art

STUDY PLAN

Step 1: Read Chapter 8, "Other Formal Elements," in your text, *A World of Art,* pp. 139-53.

Step 2: Attempt to answer the questions posed in the CRITICAL PROCESS section at the end of the chapter. Don't worry if you find that you have a difficult time. Proceed to the next step.

Step 3: Read the OVERVIEW of Chapter 8 in this study guide lesson. When a specific work of art that is illustrated in the text is discussed, try to visualize it. If you are unable to remember it, open the text to that illustration and refresh your memory.

Step 4: Return to the LEARNING OBJECTIVES and KEY CONCEPTS sections at the beginning of this study guide lesson. Demonstrate your mastery of each of the learning objectives. Define each of the concepts—each is discussed in the text and each appears in the glossary at the end of your text as well.

Step 5: Return to the CRITICAL PROCESS section at the end of the chapter. Having reviewed the material, attempt to answer the questions again. Turn to the back of the text, p. 513, and compare your answers to those provided by the author.

Step 6: Answer the REVIEW QUESTIONS. Complete the assigned SUPPLEMENTAL ACTIVITIES and WRITING ASSIGNMENTS in this study guide lesson.

Step 7: Pursue any title from the SUGGESTED FURTHER READING that is assigned or that interests you.

OVERVIEW
of Chapter 8 - "Other Formal Elements"
A World of Art

To this point, we have discussed the most important of the visual elements, but there are several others that can contribute significantly to an effective work of art—namely, texture, pattern, and time and motion.

Texture

Texture is a word that describes a work of art's ability to affect us as a visual phenomenon but also to call forth certain tactile sensations and feelings—to make us want to touch it.

Actual Texture

Marble is one of the most tactile of all artistic media. In Michelangelo's *Pietà* (Fig. 192), we are compelled to reach out and touch Christ's dead body, so strong is our conviction that the masterfully carved marble is really soft flesh. Carved marble's similarity to skin does not correspond to its actual texture. Michelangelo, in fact, was able to imply or create a visual texture through his sheer skill.

When paint is applied in a thick, heavy manner so that it seems to have a body of its own, the effect is called **impasto**. Joan Snyder is known for the expressive impasto of her paintings of the late 1960s. *Sea Moons* (Fig. 193), for example, consists of canvas draped with a swath of black velvet. The thick impasto of the sea sweeps up from the canvas across the bottom of the hanging fabric. The shift in texture, from paint to velvet, serves to differentiate the space.

In Manuel Neri's *Mujer Pegada Series* (Fig. 194), the actual texture of the bronze is both smooth (to imply the texture of the skin) and rough to indicate the "unfinished" quality of the work. Neri has also applied enamel paint in broad gestural strokes to the bronze. The paint adds another texture (brushstrokes) to the work, which in turn, suggests a two-dimensional quality by making a reference to painting.

Visual Texture

Visual texture appears to be actual but is not. The work *Europe After the Rain* (Fig. 175) by Max Ernst seems to possess all sorts of visual textures, but they are actually flat paper that has been affected by the process called "frottage." **Frottage**, from the French *frotter* (to rub) was invented by Ernst. It is the technique of laying thin paper onto an actual texture, then rubbing over it with the soft lead of a pencil. The paper picks up the visual qualities of the surface.

William Garnett's aerial view of *Erosion and Strip Farms* (Fig. 176) is a study in visual texture. The plowed strips contrast dramatically with those left to fallow. The geometric textures of the farmed landscape also contrast with the irregular veins and valleys of the unfarmed and eroded landscape in the photograph's upper left.

Pattern

Any formal element that repeats itself in a composition—line, shape, mass, color, or texture—creates a pattern. The Turkish

carpet (Fig. 197) has a pattern of interlaced lines and shapes that was based on a widely available master plan that rarely varied.

In its systematic use of the same motif or design, pattern is an especially important *decorative* tool. Throughout history decorative patterns have been applied to utilitarian objects in order to make them more pleasing to the eye. Early manuscripts, such as the *Lindisfarne Gospels* (Fig. 198) were *illuminated*, or elaborately decorated with drawings, paintings, and large capital letters. The simple design of the Celtic Cross contrasts with the interlaced fighting beasts that surround it, the "animal" style which was widely prevalent throughout much of western Europe.

Because decorative pattern is associated with the beautifying of utilitarian objects in the crafts, with folk art, or with "women's work" such as quilt-making, it has not been esteemed among artists. However, since the 1980s, the value of "women's work" and folk art have been reassessed. Miriam Schapiro has done much to legitimize pattern's importance in the arts. Schapiro creates works which she calls "femmages" (from the French *femme* and *homage*) that explore "a part of my life which I had always dismissed—my home-making, my nesting." In *Night Shade* (Fig. 199), Shapiro has chosen an explicitly feminine image, the fan.

Because of the associations with home decoration—wallpaper, upholstery, etc.— pattern symbolizes for many the home itself. For Kim McConnel, born soon after World War II, the prints and patterns of his childhood combine to create a nostalgic and ironic tribute to American family life in a work entitled *Miracle* (Fig. 200).

Time and Motion

Anyone who has ever stared at a wall-paper pattern knows how the eyes move to follow it. However, a distinction made between the plastic arts, such as painting and sculpture, and the written arts, such as music and literature, is that the former are *spatial* and the latter are *temporal* media. We experience a painting all at once, but we experience music and literature over time, in a linear way. A temporal work possesses a beginning, middle, and end.

Still, temporal experience plays a greater role in the plastic arts than such a formulation might suggest. Even where the depiction of a given event might suggest that we are witness to a "frozen moment," such as in a photograph, that single image may be seen as part of a larger narrative sequence. It might even be a mnemonic device, designed to trigger our memory of a certain passing of events.

A painting might also invite us to experience time in a temporal way. *The Meeting of St. Anthony and St. Paul* (Fig. 201) depicts Anthony at three different points in his travels on a winding road. In another circumstance, we can view a series of works as a progression of a temporal experience. Each of Monet's *Grainstacks* (Figs. 27 and 183), for instance, can be appreciated as an individual work. However, each is also one part of a series of *Grainstacks*, and, when seen with other variations of the same image together in a room, a sense of time, or the duration of the seasons, is imparted. The paintings are about time itself.

To appreciate large scale works of art it may be necessary to move around and view them from all sides—to view them over time. Monet's famous paintings of his pond

at Giverny are so large that they fully encircle two oval gallery rooms at the Musée de l'Orangerie in Paris (Figs. 202 and 203), causing viewers to move about in order to fully see them. According to Monet's friend Georges Clemenceau, the paintings serve as an example of "Brownian Motion," which stipulates that small solid particles suspended in a fluid will be buffeted by the water molecules that surround it and driven randomly throughout the solution. In the oval rooms of the Musée de l'Orangerie, the viewer's eye is driven randomly through the space of the huge works.

═══════════

Works in Progress
Jackson Pollock's *No. 29*

Jackson Pollock's large Abstract Expressionist paintings cause the eye to travel in what one critic called "galactic space," following first one line, then another. Work such as this has been labeled "Action Painting," not only because the lines prompt the eye of the viewer to follow the action, but also because the work as a whole serves to document the action or movement of the artist.

The photograph of Hans Namuth (Fig. 204) demonstrates how completely involved Pollock was in the painting process. Pollock (whose canvases were typically painted on the floor) said, "On the floor I am more at ease. I feel nearer, more a part of the painting, since this way I can walk around it, work from the four sides and literally be *in* the painting." According to Namuth, when Pollock was painting, his movements, slow at first, gradually became faster and more dancelike. Namuth's next step was to move into film. He eventually made two films of Pollock, one shot from below looking up through a sheet of glass (Figs. 205 and 206), vividly capturing the motion embodied in Pollock's work.

Namuth never showed the photographs to Pollock because of their blurred nature. Years later, he realized their importance, marveling at "Pollock's method of working, the dance around the canvas, the continuous movement, the drama."

═══════════

Some works are created to give the illusion of movement. In Optical ("Op Art") painting, certain formal elements, line and color in particular, are manipulated to stimulate the nervous system into thinking it perceives movement. Bridget Riley's *Drift 2* (Fig. 207) literally seems to wave and roll before our eyes.

Other works of art do actually move. Often driven by motors, these works are examples of **kinetic** art. Jean Tinguely dedicated his career to making large machines out of the refuse of machine culture. *Homage to New York* (Fig. 208), activated in the sculpture garden at the Museum of Modern Art in 1960, performed numerous kinetic actions, inflating a large balloon, playing a piano that had been incorporated, even discharging a small burning machine on wheels that headed for the audience before finally being doused by a fire fighter!

Spatial and temporal arts have been most successfully integrated in the twentieth century through the mediums of film and video. In 1903, Edwin S. Porter made *The Great Train Robbery* (Fig. 209), the first narrative action chase scene in the history of the cinema, which ended with the shocking-

ly direct act of the bandit turning to the audience and firing his gun. By the late 1920s Walt Disney had perfected the animated cartoon, and by 1936 Hollywood was putting out 450 movies per year.

After World War II the thirst for moving images was satisfied more and more by television. The directness, immediacy, and realism of the television image (most early shows were taped live) have made it, seemingly, the most realistic media. Although the images are constantly manipulated, we accept them as real. When 400 million people watched Neil Armstrong step on the moon (Fig. 211), very few people mistrusted the image.

THE CRITICAL PROCESS
Thinking about the Formal Elements

Bill Viola's *Room for St. John at the Cross* (Figs. 212 and 213) demonstrates how time and motion in television are very different from time and motion in video art. The work consists of a color television monitor displaying a videotaped image of a snow covered mountain. On the tape, the poems of St. John are being read and are just barely audible. The only movement is evidenced by the wind rustling leaves and branches. On a screen behind the monitor, Viola has projected a black and white video image of snow covered mountains shot with an unstable hand-held camera.

Neither of these two images could be shown on television. They would not be entertaining. In order to experience them, however, we must move within the installation, and in doing so, we experience a broad contrast of many formal elements all at once. Compare the architecture of the cell with the images on the large screen. Consider the conflicting senses of space. How are contrasts between light and dark, or color and black-and-white exploited? How does time enter into the experience?

REVIEW QUESTIONS

Answers to the following questions appear in the APPENDIX: ANSWER KEY at the end of the *Study Guide*.

1. Define visual as opposed to actual texture.

2. An illuminated manuscript is one that

 a) provides illumination to the viewer.
 b) is richly decorated with drawings, paintings, and large capital letters.
 c) is lighted by an outside source.
 d) shines forth with the sacred wisdom.

3. Define temporal as opposed to spatial media.

4. Op Art is

 a) art that seems to move before the eye.
 b) is short for "Optical Art."
 c) is a kind of kinetic art.
 d) is short for "Optimal Art."

5. In what ways can a work of art incorporate time and motion?

SUPPLEMENTAL ACTIVITIES AND WRITING ASSIGNMENTS

Supplemental Activities: A good way to test your understanding of visual texture is to take paper and, with a pencil, create your own *frottage* drawings in the manner of Max Ernst. Find as many different actual textures as you can in your enironment—walls, rough wool panels, leaves, and so on. Rub them through the paper with your pencil in order to create various designs.

The Website: Go to the *World of Art* website (**www.prenhall.com/sayre**). Proceed through the Chapter 8 materials. Consider your command of the objectives as stated in the website. Take the multiple choice and fill-in-the-blanks self-tests. Briefly respond to both the critical analysis and the compare and contrast questions, either formally or informally. Visit the related sites linked in both the Modern Artists and Galleries and Museums areas. A hands-on project related to the course material is suggested. Even if you are not assigned the Project, think about how you might approach it. Finally, consider participating in the Message Board or Chat Discussions.

Writing about Time and Motion: Jackson Pollock's paintings, as we have seen, have been described by Pollock himself as "energy and motion / made visible." In these terms, they might seem to have very little in common with still life paintings. But look at Paul Cézanne's *Still Life with Basket of Apples* (Fig. 84). In what ways are energy and motion made visible in Cézanne's painting as well?

Writing to Explore New Ideas: As we have seen, Joan Snyder has painted *Sea Moons* (Fig. 193) on velvet. We normally think of paintings on velvet as something less than "high" art—paintings of Elvis, and so on. The word for this sort of art is *kitsch*. Similarly, Miriam Schapiro, in works such as her *Night Shade* (Fig. 199), has elevated materials normally associated with homemaking into the world of art. Another complex example is Marcel Duchamp's *Fountain*, a common urinal that he "recognized" as sculpture, which is reproduced in Chapter 22 (Fig. 714). The question all these works raise is just what makes something art? Is art inherent in the object? That is, must the object give rise to aesthetic feelings? And how do we define the aesthetic anyway? Is it who makes it—or, in the case of Duchamp, who designates it—art? In other words, if the artist says it's art, then is it art? Find an object that normally would not be considered "art," and make a case for our considering it as art.

Suggested Further Reading: An excellent biography is B. H. Friedman's *Jackson Pollock: Energy Made Visible* (McGraw-Hill, 1972).

The philosopher and art critic Arthur Danto has made something of a career of asking many of the sorts of questions posed above in "Writing to Explore New Ideas." The basic work is *The Transfiguration of the Commonplace: A Philosophy of Art* (Cambridge, Mass.: Harvard University Press, 1981). The first chapter is especially interesting and useful.

Study Guide Lesson for

Chapter 9
The Principles of Design

LEARNING OBJECTIVES

This lesson will help you understand how artists compose the formal elements they employ by means of the principles of design. At the end of this chapter you should be able to:

1) Recognize the various types of balance and symmetry employed by artists.

2) Describe some of the ways in which artists employ emphasis in a composition.

3) Define scale and proportion and differentiate one from the other.

4) Recognize the use of repetition and rhythm in a work of art.

5) Understand the interplay between unity and variety in works of art.

KEY CONCEPTS

actual weight	scale
visual weight	proportion
absolute symmetry	Golden Section
bilateral symmetry	
asymmetrical balance	repetition
radial balance	visual rhythm
emphasis	visual unity
focal point	visual variety
afocal art	postmodernism

STUDY PLAN

Step 1: Read Chapter 9, "The Principles of Design," in your text, *A World of Art*, pp. 154-81.

Step 2: Attempt to answer the questions posed in the CRITICAL PROCESS section at the end of the chapter. Don't worry if you find that you have a difficult time. Proceed to the next step.

Step 3: Read the OVERVIEW of Chapter 9 in this study guide lesson. When a specific work of art that is illustrated in the text is discussed, try to visualize it. If you are unable to remember it, open the text to that illustration and refresh your memory.

Step 4: Read the VIEWING GUIDE to *Works in Progress: Judith F. Baca* in this study guide lesson.

Step 5: View the video *Works in Progress: Judith F. Baca*, following the VIEWING GUIDE as you watch. Take notes and jot down ideas in response to the VIEWING GUIDE. Your instructor may require you to hand in written responses, formal or informal, to some or all of the topics that the VIEWING GUIDE sets out for your consideration. View the video a second time if necessary.

Step 6: Complete the suggested CD-ROM assignments for Chapter 9 outlined in this study guide lesson.

Step 7: Return to the LEARNING OBJECTIVES and KEY CONCEPTS sections at the beginning of this study guide lesson. Demonstrate your mastery of each of the learning objectives. Define each of the concepts—each is discussed in the text and each appears in the glossary at the end of your text as well.

Step 8: Return to the CRITICAL PROCESS section at the end of the chapter. Having reviewed the material, attempt to answer the questions again. Turn to the back of the text, p. 513, and compare your answers to those provided by the author.

Step 9: Answer the REVIEW QUESTIONS. Complete the assigned SUPPLEMENTAL ACTIVITIES and WRITING ASSIGNMENTS in this study guide lesson.

Step 10: Pursue any title from the SUGGESTED FURTHER READING that is assigned or that interests you.

OVERVIEW
of Chapter 9 - "The Principles of Design"
A World of Art

The word design is both a verb and a noun, a process and a product. To design something is to organize its parts into a unified whole. We are able to see, in that totality, something we call its "design."

The principles of design are usually thought of in terms of balance, emphasis, proportion and scale, rhythm and repetition, unity and variety, but artists unite them all. Leonardo's *Illustration of Proportions of the Human Figure* (Fig. 214) is in many ways a compendium of all of them. The figure is perfectly balanced, its focal point (the navel) represents the source of life itself, and each limb is repeated once to fit into the square (the symbol of the finite earthly world) and once to fit into the circle (the symbol of the heavenly world).

When architect Frank Gehry remodeled his home in California in 1976, he surrounded the original with an outer shell constructed of plywood, concrete blocks, corrugated metal and chain link fence (Figs. 215 an 216). His neighbors felt that he had destroyed a perfectly good house. Gehry, however, values common materials, and he was interested in establishing a sense of discontinuity between the original house and the addition. The remodeled house is completely "out of sync" with the other houses in the neighborhood—almost "gleefully so."

Gehry deliberately violated certain principles of design, causing us to acknowledge that a certain set of rules or "principles" of design exists. Gehry's work demonstrates how the rules are meant to be broken. Artists can create visual interest by purposefully breaking with conventions such as the traditional rules of perspective; likewise, an artist can stimulate our interest by manipulating the principles of design.

Balance

Balance is something that we control in part through sight. Seeing the actual space around us helps us to maintain our own physical balance.

Sculpture and architecture deal with **actual weight**, but all art deals with **visual weight**—the apparent lightness or heaviness of the shapes and forms that exist in a composition. When both sides of a composition have the same visual weight, we say the work is balanced. There are three primary types of balance—symmetrical balance, asymmetrical balance, and radial balance.

Symmetrical Balance

If you draw a line down the middle of your body, each side would be, more or less, a mirror reflection of the other. When each side is exactly the same, we have **absolute symmetry**. Even when they are not identical, which is true of most human bodies, the overall effect will still be symmetrical, or what we would call **bilateral symmetry**. The scales depicted in Vermeer's *Woman Holding a Balance* (Fig. 217) demonstrate bilateral symmetry, even though one scale is larger than the other.

One of the dominant images of symmetry in Western art is the crucifix. In

Quarton's *Coronation of the Virgin* (Fig. 218), the crucifix is a small detail in the total composition, yet all formal elements within the composition are organized around it. Each element balances the other out, describing a perfectly unified theological universe.

Asymmetrical Balance

Compositions that have two apparently balanced halves that nevertheless are not reflections of one another are **asymmetrically** balanced. Nancy Graves's sculpture *Zeeg* (Fig. 219) is not symmetrically balanced, and were it not counterweighted in its base, would surely topple over.

The change in actual weight that allows three-dimensional sculpture to achieve equilibrium has a number of visual equivalents in two-dimensional terms. Just as children of different weights must sit in different places on either side of a seesaw, visual balance can be seen as a system of similar "counterweighting." Several examples (Fig. 220) are shown that demonstrate how various elements in a composition can be "visually balanced." However, there are no specific rules to attaining balance. Artists trust their eyes, and when a work looks balanced, it's balanced.

Chase's *The Nursery* (Fig. 221) is a perfect example of asymmetrical balance. The left side of this painting is much heavier than the right. The larger right side is predominantly green, with only two hints of red. But the smaller left hand side of the painting is dominated by a red that tints even the young woman's cheeks. If we visualize a fulcrum beneath the painting that would balance the composition, it would, in effect, divide the red from the green. It would be placed exactly below the vanishing point established by the building and the lines of planting frames. Instinctively, we place ourselves at this fulcrum, which is the painter's point of view as well.

Radial Balance

A final type of balance is **radial balance**, in which everything radiates outward from a central point. An example is the large round "rose window" from the south portal of Chartres Cathedral in France (Fig. 222). At its center is Jesus, surrounded by the symbols of Matthew, Mark, Luke, and John, the writers of the Gospels. Additional scenes form outer rings.

Emphasis and Focal Point

Artists can employ emphasis to draw attention to one area of the work, called the **focal point**. Often the focal point of a composition will be at, or near, the point or line around which it is balanced. Examples are the center of the rose window of Chartres Cathedral, or the vanishing point of Chase's *Nursery*.

Another means of establishing focal point is through the skillful use of light and color. Anna Valayer-Coster focuses our attention in her *Still Life* (Fig. 223) on the red lobster in the foreground by painting everything else in the composition green.

Elisabeth-Louis Vegee-Lebrun's *Portrait of Marie Antoinette with her Children* (Fig. 224) emphasizes its subject by means of the same color contrast—the queen's red dress against the green shades of her surroundings. In Tintoretto's *Last Supper* (Fig. 154), we saw how light could function like a spot light to draw attention away from perspective lines in a scene. The (Divine) light in George La Tour's *Joseph the Carpenter* (Fig. 225) draws our attention away from the painting's apparent subject, Joseph, to illu-

minate the young child Jesus holding the candle.

Sometimes emphasis can be achieved by its absence. In Jacques Louis David's *The Oath of the Horatii* (Fig. 226), all the male figures are focused on a compositional "X" created by the central figure's outstretched right arm and the three swords he holds in his left hand. This is the subject of the painting—the oath being taken by the three Horatii brothers. The women weep, as one of them is engaged to a soldier selected to do battle against her brothers on that day. The loss of at least one loved one is inevitable. Such sacrifice, the painting suggests, is the necessary price of patriotism.

David did not arrive at the focal point in his painting quickly. The first sketch for the project (Fig. 227) was different both in subject and organization. The battle is over, and Horatius stands at the top of the stairs, restraining a group of men rushing up the stairs to arrest his eldest son for the murder of Camilla. Horatius and his son are the focal point, or apex, as it were, beside the mound of bodies.

It is also possible to make a work of art that is **afocal**. An afocal composition not only deletes a specific point of emphasis, but provides no place for our eyes to rest. An example is Pollock's *No. 29* (Fig. 206) or Larry Poons's painting *Orange Crush* (Fig. 228).

———

Works in Progress
Diego Veláquez's *Las Meninas*

In *Las Meninas* (Fig. 231), Velázquez creates competing points of emphasis. The most obvious focal point of the composition is the young princess, the *infanta* Margarita,

emphasized by her central position in the painting and the gazes of the two maids who bracket her. The gazes outside of this central group (the dwarf on the right and the painter on the left) seem to focus to a point beyond and in front of the picture plane. In fact, one could assume that they are focused on the couple reflected in the mirror on the back wall of the room—the king and queen themselves, whom we recognize from earlier portraits (Figs. 229 and 230). They might well be the subject of the portrait that Velázquez is painting, and the infanta Margarita and her maids seem to be watching them.

The portrayal of Velázquez himself actively painting makes this an actual work in progress, although we will never know if he is painting the king and queen, *Las Meninas*, or another painting altogether. The presence of the royal family in his work, however, indicates that they are more than just his patrons—they are the measure of nobility in his art.

———

Scale and Proportion

Scale is a word we use to describe the dimensions of an art object in relation to the original object that it depicts or in relation to the objects around it. Scale is an issue that is always subtly at work in any textbook with illustrations. The reproductions we look at do not usually give us much sense of the actual work.

Both Joel Shapiro's *Untitled (Chair)* (Fig. 233) and Claes Oldenburg's *Giant Trowel* (Fig. 234) are intentional manipulations of scale. Shapiro's chair would be an appropriate scale if it were in a room in a doll house. Oldenburg's *Trowel* monumentalizes the common object it depicts, and

also makes a humorous comment on garden sculpture.

John Singer Sargeant's *The Daughters of Edward Darley Boit* (Fig. 235) seemingly shrinks the young ladies depicted to the size of a Chinese vase. The scale of the vases seems wrong. They appear to be too large. In this case, Sargeant's use of scale imparts a psychological condition upon the subject, cited by novelist Henry James, who felt that the work implied "assimilated secrets."

By manipulating scale an artist can achieve startling effects. Charles Simonds constructed over 300 miniature structures and dwellings (Figs. 236 and 237) that implied the existence of a race of little people who once inhabited them. Simonds's work seems to mimic civilization itself, a culture that once flourished, now vanished, leaving only artifacts behind.

Artists also manipulate scale by the way they depict the relative size of objects. One way to represent recessional space is to depict a thing closer to us as larger than a thing the same size farther away. When a mountain fills a small percentage of the space of a painting, as in Hokusai's *The Great Wave Off Kanagawa* (Fig. 238), we know that it lies somewhere in the distance.

Works in Progress
Judith F. Baca's
La Memoria de Nuestra Terra

The *Works in Progress* video series continues with a discussion of Judith F. Baca, a Chicana painter from Los Angeles who follows the rich tradition of muralism that can be linked to the Mexican muralists David Alfaro Siqueiros, José Orosco, and Diego Rivera. Like them, she sees her work as giving a political voice to the people. See the VIEWING GUIDE in this lesson.

Artists can also manipulate proportion to interesting ends. Picasso's *Woman with Stiletto* (Fig. 241) depicts the assassination of Jean-Paul Marat by Charlotte Corday. Marat lies in his bath with a tiny head and tiny left arm holding a pen. Corday stretches out above him like a praying mantis, threatening his very existence. Her stiletto pierces his heart. Her body is hugely distorted, seemingly monstrous, and through distortion, Picasso is able to imbue the scene with convincing horror.

When the proportions of the figure seem normal, the representation is more likely to seem harmonious and balanced. The classical Greeks believed that beauty was itself a function of proper proportion. Polykleitos, the great Greek sculptor, described the human body's perfect proportions in a textbook called the *Canon*. Polykleitos used the *Doryphoros* (Fig. 242) to illustrate his ideas of proportion as put forward in the Canon.

Mathematical harmony was also employed by the Greeks in architecture. The Parthenon (Fig. 243) was constructed so that the height vs. the width of the facade would equal the **Golden Section,** a rectangle whose sides measure 1 to 1.618, or roughly 5 by 8. Plato regarded this proportion as a key to understanding the universe. Later, this relationship was proven by the mathematician Fibonacci to be represented through an infinite sequence of integers—1, 2, 3, 5, 8, 13, 21, 34...etc. Each number in the sequence is the sum of the two numbers that precede it. It was fitting that the

Parthenon would be constructed according to this ratio, as it was a temple to Athena, the goddess of wisdom, and the golden ratio represented the wisdom of the universe.

Repetition and Rhythm

"Sameness" can breed monotony and conformity. Frank Gohlke's photograph *Housing Development South of Fort Worth* (Fig. 244) depicts an endless vista of sidewalk and repetitive identical houses, mailboxes, and driveways. There is order, but no beauty, nothing that sparks the imagination or creates a sense of visual delight. When the same or similar elements (shapes, colors, etc.) are repeated over and over, a type of visual rhythm is created. Jacob Lawrence's *Barber Shop* (Fig. 221) establishes rhythm through both shape and color. A visual rhythm takes place as our eyes move from one shape to the next, mimicking a sort of temporal "beat."

Conversely, apparently different things can reveal themselves to be the same. *The Gates of Hell* (Fig. 244) by Auguste Rodin, based on Dante's *Inferno*, is comprised of almost 200 figures throughout its composition, including his famous Thinker, located toward the top of the door panels. At the top are the *Three Shades* who are the guardians of the dark inferno below. Rodin has placed the figures facing into a semicircle, which causes each of them to be viewed from a different angle, implying that they are different. What is startling is that the *Three Shades* are not at all different, but rather, the identical figure cast three times.

Unity and Variety

Jacob Lawrence creates repetition and rhythm in *The Barber Shop* (Fig. 245) by repeating shapes and colors. These shapes also give the work a sense of coherence or unity. The figures, with their huge clumsy hands and oversimplified features are uniform throughout, and the painting feels complete.

James Lavadour's *The Seven Valleys and the Five Valleys* (Fig. 247) is a composition of 12 separate landscape views. They constantly negotiate the boundaries between realism and abstraction. In contrast, the *Untitled* painting by Jean-Michel Basquiat (Fig. 248) seems to purposefully avoid any sense of unity. His loose, expressive brush work is painted over a body of scrawled notations, the content of which is willfully arbitrary. Trying to make sense out of his random marks causes us to feel lost and confused. However, Basquiat's painting is distinguished by the energy of its style and the vitality of the color, and the sense of freedom that his brush work seems to embody.

This sense of disjunction, the sense that the parts can never form a unified whole, is what we have come to identify as **Postmodernism**. In architecture, the discontinuity between the old and the new that marks Frank Gehry's house (Figs. 215 and 216) is an example of Postmodern sensibility. In his book *Learning from Las Vegas*, Robert Venturi asserts that the collision of signs, styles, and symbols that mark the "American Strip," in particular Las Vegas (Fig. 249), could be seen as a new form of unity. "Disorder," Venturi writes, "[is] an order we cannot see. . . ."

Elizabeth Murray's shaped canvas *Just in Time* (Fig. 250) announces its postmodernity. The construction is actually a gigantic teacup, with a cloud of pink steam rising above it, which evokes a certain refer-

ence to work like Claes Oldenburg's *Giant Trowel* (Fig. 234) and also employs certain references to banal subject matter. But it is a serious work, the lightheartedness of the image embodied in lines from a poem by W. H. Auden that Murray feels explain the crack running up the center of the work:

The desert sighs in the cupboard
The glacier knocks in the bed
And a crack in the tea-cup opens
A lane to the land of the dead.

THE CRITICAL PROCESS
Thinking about the Principles of Design

Consider how all the principles of design are employed in a single work—Claude Monet's *Railroad Bridge at Argenteuil* (Fig. 251). First, line comes into play through the perspective of the bridge and the gridded geometry that occurs as the piers cross the horizon line. The bridge and the near bank create two strong diagonals, echoed in the wooden grid structure beneath the bridge. Countering all this is the single curve of the sail, echoed in the edge of the bushes at top right.

Monet has contrasted alternating rhythms of light and dark, and complementary colors of orange and blue to further activate the work. Consider how this contrast works thematically at work—the sailboat, a naturally powered traditional vessel, versus the modern locomotive, the symbol of the ever-encroaching industrial age.

VIEWING GUIDE
to *Works in Progress: Judith F. Baca*

Judith F. Baca
Biographical Sketch

As a visual artist, Judy Baca is best known for her large-scale murals, which involve extensive community organization and participation and address multicultural audiences. In the internationally known *Great Wall of Los Angeles* in the Tujunga Wash Flood Control Channel, Baca designed a work which incorporated 40 ethnic scholars, over 400 multicultural neighborhood youths, 40 assisting artists, and over 100 support staff to paint a half-mile long pictorial representation of the ethnic history of California. Along with many other mural projects, Baca has employed her community organizing techniques to make the *World Wall: A Vision of the Future without Fear*, seven dual-sided 10 x 30 foot portable mural panels on canvas. The 210-foot mural in seven parts addresses contemporary issues of global importance: war, peace, cooperation, interdependence, and spiritual growth. As the World Wall tours the world, additional panels by artists from seven countries will be added to complete this visual tribute to the "Global Village."

As an arts activist, Baca founded the first City of Los Angeles mural program in 1974, which produced over 250 murals and hired over 2,000 participants in its ten years of operation. In 1976, she founded the Social and Public Arts Resource Center (SPARC) in Venice, California, where she still serves as Artistic Director. In 1988, at the request of then Mayor Tom Bradley, she developed another Los Angeles Mural program based on the model of the Great Wall. Entitled Great Walls Unlimited: Neighborhood Pride, it operated under contract with the City's Cultural Affairs Department and has produced 73 murals in almost every ethnic community in Los Angeles.

She is a founding faculty member of the new California State University, Monterey Bay, and serves as a senior faculty member at UCLA's Cesar Chavez Institute. She lives and works in Venice, California.

Summary and Introduction

In *Works in Progress: Judith F. Baca,* we follow Baca as she creates two public art projects—a miraflage mural for the student center at the University of Southern California, and a grouping of large portraits that are part of a "re-visioning" of Fort Ord, the military base that was, in the 1960s and early 1970s, the largest single staging area for the Vietnam War, into the California State University, Monterey Bay. Both projects illustrate Baca's unique process, which is designed to unite the participants in producing a work of art based on shared discoveries, understanding, vision, and dreams—art that is inclusive rather than exclusive. The creation of each work begins with a group effort to research the historical events that have taken place around the site. This "excavation of the land" is the foundation for all of Baca's collaborations. Layers of information and historical data in the form of photographs, newspaper clippings, and old letters are gathered by students. Like layers of paint, the information is blended to become the imagery of the art—an imagery that will express, she hopes, the truth of the place where the work will be housed.

The project at USC is, by Baca's standards, relatively small, and yet its scale is still impressive. Entitled *La Memoria de Nuestra Tierra (The Memory of Our Land)*, it is designed to embody Latino presence and symbolize a long struggle for the young people who have felt they have not been able to articulate their presence at USC's campus and somehow gain acknowledgment. The imagery in the 9 x 23 foot mural, commissioned by the USC Administration, was developed by students, and their working process is remarkably close to Baca's work 20 years earlier on *The Great Wall of Los Angeles*, including all the controversy generated in the process.

At Fort Ord, Baca envisions a long-term art project that will see the boarded-up windows of the deserted barracks blossom into colorful portraits of the soldiers who passed through them on their way to war. The idea is to "re-vision" this environment, designed to prepare men for war, into an environment of learning that promotes peace.

The focus of the video is not so much the pieces themselves as Baca's collaborative process. "I use my gift," she says, "and give it away."

Ideas to Consider

1) In viewing this video, notice that Baca introduces her collaborators to a number of formal problems that they must consider. What are they? What political issues do they face?

2) How does Baca define the relationship of the mural to the viewer? How does scale help define this relationship? How does this scale define the emotional resonance of her work?

3) How would you define Baca as an "activist" artist? How does collaboration fit into her activist ideals?

4) In what ways is her painting style different from Hung Liu's, whose painting we studied in Chapter 5? How does its content differ from theirs?

NAVIGATING *A World of Art*: THE CD-ROM

The *World of Art* CD-ROM contains two doorways in the Hands-on Exercises Room that will help you to understand the material in Chapter 9, "The Principles of Design."

Balance: One entire interactive pathway is dedicated to balance. Move the pointer to the directional arrow and hold down the mouse button as the room spins until the Balance doorway appears. Stop, then double-click on the doorway, and the Balance problem and activity area will open.

In these demonstration areas you can explore absolute, bilateral, and asymmetrical designs by watching a series of shapes and designs mutate from one kind of symmetry to another. This last demonstration area is a playfield, consisting of the shapes and designs you observed earlier. You can make your own compositions here, symmetrical or asymmetrical, balanced or not, and compare them to compositions made by us.

Scale and Proportion: This pathway consists of two different areas, the first relating to scale and the second to proportion.

These two demonstrations are designed to give you a sense of the powerful effects manipulating scale can have on a work. In the first instance, you find yourself in a room. On the table is a vase. You can make it larger or smaller. The example should give you some practical sense of the emotional power of the vase in John Singer Sargent's *The Daughters of Edward Darley Boit* (Fig. 235). In the second instance, we have provided a rough sketch of Hokusai's *The Great Wave* (Fig. 238). See how its emotional content changes as you change the size of Mt. Fuji in the distance.

In this demonstration, you can observe how Polykleitos's *Doryphoros* changes dramatically as its relative proportions change.

In this demonstration, we have provided you with a range of examples of the Golden Section. Notice how it is particularly prevalent in architecture.

REVIEW QUESTIONS

Answers to the following questions appear in the APPENDIX: ANSWER KEY at the end of the *Study Guide*.

1. Name the basic principles of design.

2. Frank Gehry's Santa Monica home purposefully manipulates the principles of design, breaking with convention. His design is an example of

 a) symmetrical balance.
 b) a cruciform construction.
 c) postmodern design.
 d) the Golden Section.

3. Distinguish between proportion and scale.

4. In bilateral symmetry

 a) each side of the design is the mirror image of the other.
 b) even though each side is not the mirror image of the other, the effect is one of symmetry.
 c) each side balances the other, but not unilaterally.
 d) if one were to illustrate it with a teeter-totter or seesaw, one side would fall to the ground.

5. The Golden Section is

 a) a ratio of approximately 1: 1.618.
 b) the key to understanding the cosmos, according to Plato.
 c) part of the infinite sequence of numbers, 1, 2, 3, 5, 8, 13, 21, 34, 55, etc., in which each number is the sum of the two before it.
 d) all of the above.
 e) none of the above.

6. What is the particular feature of Rodin's *Three Shades*, guardians of the dark inferno of his *Gates of Hell*?

SUPPLEMENTAL ACTIVITIES AND WRITING ASSIGNMENTS

Supplemental Activities: So strong is its appeal in the Western world, the Golden Section is employed repeatedly by architects and designers almost without conscious deliberation. How many examples of its use can you find in your community? Consider windows, in themselves and as they relate to the rest of the building, doorways, facades of buildings, magazine page layouts, and so on, and so on.

The Website: Go to the *World of Art* website (**www.prenhall.com/sayre**). Proceed through the Chapter 9 materials. Consider your command of the objectives as stated in the website. Take the multiple choice and fill-in-the-blanks self-tests. Briefly respond to both the critical analysis and the compare and contrast questions, either formally or informally. Visit the related sites linked in both the Modern Artists and Galleries and Museums areas. A hands-on project related to the course material is suggested. Even if you are not assigned the Project, think about how you might approach it. Finally, consider participating in the Message Board or Chat Discussions.

Writing about the Principles of Design: In Armin Hofmann's poster for the ballet *Giselle* (Fig. 575), most of the formal elements so far discussed (except, obviously, color) come into play. How does Hofmann utilize line? space? light? texture? time and motion? Hofmann has, furthermore, composed these elements into a successful design. How does he utilize the various principles of design to bring the various formal elements together? What is emphasized? What balances with what? How does he take advantage of questions of scale? What about questions of rhythm and repetition? How does variety play a role in his composition? In what ways is it, finally, a unified composition?

Writing to Explore New Ideas: From *Gulliver's Travels* to *Alice in Wonderland,* the manipulation of scale has been a standard literary device. It has also proven immensely important to the art of cinema. Think about some of the ways in which motion pictures manipulate scale. To what end?

Suggested Further Reading: An extraodinary analysis of Velázquez's *Las Meninas* has been written by the French historian and theorist Michel Foucault. It serves as the first chapter to his book *The Order of Things* (*Les Mots et les choses*) (New York: Random House, 1994).

Robert Venturi's *Learning from Las Vegas* is available in a 1977 revised edition from the MIT Press in Cambridge, Massachusetts.

Chapter 10
Drawing

LEARNING OBJECTIVES

This lesson will help you understand the medium of drawing and how artists employ it. At the end of this chapter you should be able to:

1) Discuss how drawing came to be regarded, in the Renaissance, as an art in its own right.

2) Name the various dry and liquid drawing media.

3) Outline the primary characteristics of each drawing medium.

4) Discuss some of the innovative drawing media utilized by modern artists.

KEY CONCEPTS

medium	metalpoint
pigment	chalk
binder	charcoal
fixative	graphite
tooth	Conté crayon
	pastel
cartoon	pen and ink
sketch	wash
sinopie	

STUDY PLAN

Step 1: Read Chapter 10, "Drawing," in your text, *A World of Art*, pp. 183-207.

Step 2: Attempt to answer the questions posed in the CRITICAL PROCESS section at the end of the chapter. Don't worry if you find that you have a difficult time. Proceed to the next step.

Step 3: Read the OVERVIEW of Chapter 10 in this study guide lesson. When a specific work of art that is illustrated in the text is discussed, try to visualize it. If you are unable to remember it, open the text to that illustration and refresh your memory.

Step 4: Read the VIEWING GUIDE to *Works in Progress: Beverly Buchanan* in this study guide lesson.

Step 5: View the video *Works in Progress: Beverly Buchanan*, following the VIEWING GUIDE as you watch. Take notes and jot down ideas in response to the VIEWING GUIDE. Your instructor may require you to hand in written responses, formal or informal, to some or all of the topics that the VIEWING GUIDE sets out for your consideration. View the video a second time if necessary.

Step 6: Return to the LEARNING OBJECTIVES and KEY CONCEPTS sections at the beginning of this study guide lesson. Demonstrate your mastery of each of the learning objectives. Define each of the concepts—each is discussed in the text and each appears in the glossary at the end of your text as well.

Step 7: Return to the CRITICAL PROCESS section at the end of the chapter. Having reviewed the material, attempt to answer the questions again. Turn to the back of the text, p. 513, and compare your answers to those provided by the author.

Step 8: Answer the REVIEW QUESTIONS. Complete the assigned SUPPLEMENTAL ACTIVITIES and WRITING ASSIGNMENTS in this study guide lesson.

Step 9: Pursue any title from the SUGGESTED FURTHER READING that is assigned or that interests you.

OVERVIEW
of Chapter 10 - "Drawing"
A World of Art

Henri Matisse's painting *The Red Studio* (Fig. 252) serves as an inventory of the materials with which Matisse worked. Included are paintings, bronzes, plaster casts, and, one might presume, that beyond the frame of the picture, a variety of other media exists as well. Each material presented is called a **medium**. The history of media used to create art is the history of various **technologies** employed by artists. These technologies have helped artists both to achieve the ends they desire more readily and to discover new modes of creation and expression. A medium is a *techne*, from the Greek tekein, meaning "to make, prepare, or fabricate." A medium is, in this sense a *techne*, a means for making art. It is both the specific material and the process through which a given work of art is made. Part III will explore the various media of art, beginning with drawing.

Drawing as an Art

We think of drawing as a transient medium. We draw sketches on paper and often quickly throw them away and start over. Until the end of the fifteenth century, drawing was viewed as a "student medium." The young man in the illustration (Fig. 253) is drawing on a thin wood plank which could be planed down and used again. Paper was not readily available, and it was very expensive. Often drawing was done on parchment (prepared from animal skins), which was even more costly than paper. Usually a student would draw, with some temporary medium, a copy of a master's painting, and in this way the student learned the master's style.

However, by the end of the fifteenth century, drawing came into its own. It was recognized to embody the artist's personality and creative genius. The writer/artist Vasari saw in drawing the foundation of Renais-sance painting itself. He had a large personal collection of drawings by all the masters, and he suggested that these works were a dictionary of the styles of the artists who had come before him. Vasari writes in his book, *Lives of the Painters*, about how a **cartoon** (a full-scale drawing of a work intended to be executed in oil) of a *Virgin and Child* (Fig. 237) by Leonardo was exhibited for two days to the public, who flocked to it in "amazement at the marvels he had created." It is the first account of the public admiring a drawing.

Up to this time, a drawing was understood to simply be a sketch, usually not dated, signed, or preserved. Through the medium of drawing one could see an artist's ideas develop via a series of preparatory sketches, and this allowed one to learn about the creative process itself. In his *Study for a Sleeve* (Fig. 255), we witness the extraordinary fluidity and spontaneity of Leonardo's line, as well as his compulsion to portray drapery as if it were a whirlpool or vortex. The drawing might reveal the movements of the artist's own mind.

Motion fascinated Leonardo. He was obsessed by the movement of water, in particular the swirling forms of the Deluge, the great flood that would signify the end of the world. Because we can see a relationship between the Deluge described in *Hurricane over Horsemen and Trees* (Fig. 256) and the

swirling line depicted in the sleeve drawing, we not only know something of Leonardo's technique, but what drove his imagination. The record of creative drive and motivation is why drawings began to be collected in the sixteenth century.

Drawing Materials

Drawing materials are generally divided into two categories: dry media, which include metalpoint, chalk, charcoal, graphite, and pastel; and liquid media, which include pen and ink, oil paint, brush wash, water color, and acrylic. Typically, most media consist of **pigment** mixed with a **binder** which holds them together.

Works in Progress
Raphael's *Alba Madonna*

In a series of studies for the *Alba Madonna* (Fig. 259), Raphael demonstrates the ways in which artists use drawings in planning a work. In the studies illustrated, Raphael worked on both sides of a single sheet of paper. On one side (Fig. 257) he has drawn a model from life and posed him as the Madonna. His sketching continues to the other side of the paper (Fig. 258), where he has considered the composition with all the figures included. A circle frames the group, in an effort to visualize the composition's placement in the final circular panel.

The speed and fluency of the drawings are quite apparent, and they are able to quickly capture the pure gesture of the body. Raphael might well have taken the advice of Leonardo da Vinci, who suggested that artists should sketch quickly to capture the precise movements and gestures that will indicate the true emotional state of their subjects.

Dry Media

Metalpoint A common technique of the late fifteenth and early sixteenth centuries in Italy was metalpoint (often called silverpoint)—a stylus with a point of gold or silver is applied to a sheet of paper prepared with a mixture of powdered bone (or lead white) and gum-water. When the metal point is applied to this ground, a chemical reaction results, and a line is produced. It cannot be erased or redrawn, and, therefore, the process requires great patience and skill. Raphael's *Paul Rending his Garments* (Fig. 261) shows this skill. Shadow is rendered through hatching—carefully drawn parallel lines. The highlights in the composition are created by heightening, applying an opaque white to the design after the metalpoint lines have been drawn.

Chalk and Charcoal Metalpoint is concerned with **delineation**—the use of line. Softer media such as chalk and charcoal allow an artist to achieve a sense of the volumetric, or three-dimensional form, of an object, through modulations of light and dark. Bartolommeo uses chiaroscuro in *Study for a Prophet* (Fig. 262) to describe the three-dimensional form of the figure. An entire area can be produced by drawing with the edge of soft chalk, then blending the area with the hand or soft cloth.

By the middle of the sixteenth century, natural chalks derived from red, white, and black mineral deposits were fitted into holders and shaved to a point. With these chalks, it became possible to realize the most gradual transitions from light to dark just by adjusting the pressure of one's hand or by merging individual strokes through gentle rubbing.

In *Banana Flower* (Fig. 263), Georgia O'Keeffe has produced a study in light and

dark that seems comparable to a black-and-white photograph. Because of its tendency to smudge easily, charcoal was not widely used during the Renaissance except in **sinopie,** the outline of an image traced on a wall before applying a fresco. Modern artists have the advantage of using a **fixative,** or synthetic resin spray, which, when applied to a charcoal or soft medium drawing, "seals" the pigment in place, making it less likely to smudge.

In the hands of modern artists, charcoal has become very popular because of its immediacy and directness. In her *Self-Portrait* (Fig. 264), Käthe Kollwitz was able to reveal the tremendous expressive potential of the medium. Much of the drawing was done by dragging the charcoal on its side up and down across the paper. This area of raw drawing connects the drawing to her mind. In the final work, one can see Kollwitz holding the very charcoal used to create the work.

Graphite Graphite was discovered in 1564 in England, and as black chalk became increasingly difficult to find, the lead pencil (graphite encased in a cylinder of soft wood) became increasingly popular. During the Napoleonic wars, when English graphite was no longer available, Napoleon himself asked Frenchman Nicholas-Jacques Conté to find a substitute. The result was the **Conté crayon,** a mixture of refined graphite and clay, which resulted in a very soft point. By controlling the softness or hardness of the point, a great range of light and dark was possible. Seurat's Conté crayon work *Café Concert* (Fig. 265) indicates the range of tonal possibilities. As the artist presses more firmly down, the dark shadows of the orchestra pit are realized, and as he lightens the pressure, a lighter atmospheric quality is produced in the upper area. This "tonal"

approach of light and dark contrasts with Vija Celmins's photorealist drawing *Untitled (Ocean)* (Fig. 266). Here is one in a series of small photorealist Celmins created using different hardness of graphite pencil for each work, which further indicates the possibilities of the medium.

Graphite drawings, furthermore, can be erased, and the erasure itself can become an important element in the composition. Robert Rauschenberg created a work of art by completely erasing a drawing created by the more established Willem de Kooning. After weeks of diligent erasing, only a faint outline of the original remained. Larry Rivers's drawing of De Kooning (Fig. 267) is more of a traditional work, but it too employs erasure as an integral means of mark-making. De Kooning's own work, *Seated Woman* (Fig. 268), is a study in the potential means of exploiting graphite. The drawing has been smudged, erased, and redrawn. In fact, de Kooning takes the liberties of drawing even further, as this drawing is two separate drawings pasted together.

Pastel The color in de Kooning's drawing is the result of pastel, a chalk medium with colored pigment and a non-greasy binder added to it. The harder the stick, the less intense its color, which is why we associate the word "pastel" with pale color. The lack of binder in pastel drawings makes them extremely fragile. If the drawing is not "fixed," the marks can easily fall off the paper, despite the fact that special ribbed papers are produced specifically to help hold the medium to the surface.

Edgar Degas stands out as the most proficient and inventive artist to use pastel. He was attracted to the medium because of its immediacy and the fact that its unfin-

ished quality seemed better suited to capturing the reality of the contemporary scene. *After the Bath, Woman Drying Herself* (Fig. 269), like many of Degas's works, depicts a woman from a voyeuristic standpoint, and perhaps seems demeaning. Still, he is credited with disregarding the "academic" pose in favor of a more candid one. He also is credited with innovative approaches to the medium, including the invention of an early fixative (the formula now lost) that allowed him to build up pastel in successive layers without affecting the intensity of the color.

American painter Mary Cassatt learned to use pastel with an even greater freedom and looseness than Degas. In *Mother, Young Daughter, and Son* (Fig. 270), the gestures of her pastel line again and again exceed the boundaries of the forms that contain them.

Works in Progress
Beverly Buchanan's *Shackworks*

Beverly Buchanan is an artist from Athens, Georgia, who employs oil sticks—made of pigment and linseed oil and often bees' wax to hold the medium in stick form—to draw the shacks that dot the rural South. Her oilstick drawings and her sculptural shacks are featured in the video series, *Works in Progress*. See the VIEWING GUIDE in this study guide lesson.

Liquid Media

Pen and Ink During the Renaissance most drawings were made with iron-gall ink, a black ink that browned with age. The quill pen used by most Renaissance artists allowed for far greater variation in line and texture than was possible with metalpoint. In *The Holy Family with a Kneeling Monastic Saint* (Fig. 274), by Elisabetta Sirani, the ink quill line is thickened or thinned depending on the artist's manipulation of the stylus. Ink also provided a more fluid and expressive means to render light and shadow than the elaborate and tedious hatching process. Pen and ink was much faster and much more expressive.

In *Corps de Dames* (Fig. 275), by Jean Dubuffet, the artist has used the thick and thin line in a very spontaneous, almost frantic manner. Dubuffet's drawing, while seeming to derogate women, actually might be aimed more at attacking the academic notion of drawing. He is employing the modern artist's approaches of random or accidental scribbling, a type of *automatism*, very much like the art-making experiments the surrealists conducted.

Wash and Brush When ink is diluted with water and applied with a brush, the result is called a wash. In *Adoration of the Magi* (Fig. 276), Tiepolo has begun with a graphite sketch, drawn over it with pen and ink, then finished the work with a wash. The wash serves two purposes—it defines form and volume, and it makes the drawing much more dynamic than it would have been had it been left in pen and ink. Many artists prefer to draw with a brush. It affords a sense of immediacy and spontaneity, as in Rembrandt's *A Sleeping Woman* (Fig. 277).

Drawing with the brush has long been a tradition in the East, perhaps because it is used there as a writing instrument. In his drawing of the poet Li Bo (Fig. 278), Liang Kai contrasts the quick diluted strokes that form the poet's robe with the fine detailed work that defines his face.

Innovative Drawing Media

Drawing invites experiment. Matisse was inspired to cut out shapes of paper using scissors, and through this form of "sketching" he found what he considered to be the essence of form. Cutouts such as *Venus* (Fig. 279) dominated Matisse's work until his death in 1954.

Walter De Maria's *Las Vegas Piece* (Fig. 280) is a "drawing" made in 1969 in the Nevada desert with the six-foot blade of a bulldozer. The work is never entirely visible except from the air. It is reminiscent of the mysterious Nacza lines in Peru (Fig. 281). These mysterious lines, which date from the first century C.E., are of controversial significance, and De Maria's modern "earth drawing" seems to evoke similar mystery.

Increasingly, drawing is being accomplished by electronic means, especially with the aid of computers. Painter David Hockney created the work *Untitled* (Fig. 282) by "drawing" on a digitized "tablet" developed by a company called Quantel. The tablet functions as a digital sketchpad, and as the artist pulls the stylus across the pad, a line is produced on the monitor. The artist can choose a variety of colors, textures, and line widths all available on a software "menu." This opens up an immediate array of potential effects that the artist can easily manipulate and rearrange at will.

THE CRITICAL PROCESS
Thinking about Drawing

Drawing is one of the most basic and one of the most direct of all media. Initially, drawing was not considered an art in its own right, but only a tool for teaching and preliminary study. However, by the time of the Renaissance, at about the time Pietro da Cortona executed his *Study for a Figure Group in the Ceiling Fresco of the Palazzo Barberini* (Fig. 284), it was generally acknowledged that drawing possessed a vitality and immediacy that revealed significant details about the artist's personality and style.

What suggests that Pietro's drawing was thought of as a work of art in its own right? How did Pietro take advantage of pen and ink? Does the drawing reflect his temperament? The drawing was a cartoon for a ceiling fresco celebrating the life of the Barberini pope, Urban VIII. What are the differences between the drawing and the final work (Fig. 283)? Does this "first-idea" sketch have an exuberance that the final painting lacks?

VIEWING GUIDE
to *Works in Progress: Beverly Buchanan*

Beverly Buchanan
Biographical Sketch

Beverly Buchanan was born in 1940 in Fuquay, North Carolina. She grew up on the campus of South Carolina State College in Orangeburg, South Carolina, at that time the only state-supported school for blacks, where her father was dean of the School of Agriculture. When Beverly was seven or eight years old, the daughter of the school's first black president asked if she could borrow some twenty drawings of Beverly's. Soon after, she took Beverly to the YWCA building, and there was her work, hanging in an exhibition for university women. She first became interested in shacks as subject matter traveling in rural South Carolina with her father.

As she grew up, even as she was making art, she felt that, as an educated black woman, she needed to make "a contribution." She received a bachelor's degree in medical technology and a Masters of Public Health from Columbia University. Naturally, she thought that she would go on to medical school. Working as a health educator in the city of East Orange, New Jersey, in 1977, she realized one day that "I wanted to be an artist, not a doctor who paints. I had to do what I really wanted to do. It was hard and my mother continued to say 'Beverly's a health educator for the city of East Orange.' It wasn't until I got the Guggenheim [Fellowship] in 1980 that she said, 'My daughter is an artist.'"

She lives today in Athens, Georgia, where she works in a variety of media including sculpture, drawing, painting, and photography.

Summary and Introduction

In *Works in Progress: Beverly Buchanan,* we are introduced to a an artist whose chief imagery derives from the dwellings of the rural poor in the American South. She photographs shacks, draws them with pastel oilsticks, and constructs small models of them from scraps of wood and metal. Through her work, she reveals the lives of the people who made them, often attaching narratives to the individual pieces.

Shacks are examples of what we call *vernacular* architecture. In his book *African-American Gardens and Yards in the Rural South* (Knoxville: University of Tennessee Press, 1992), Richard Westmacott defines vernacular architecture as follows:

> *Vernacular architecture is sometimes characterized as being sensitive to local materials. "Available" materials might be more applicable. . . . The opportunistic use of materials such as railroad ties, granite blocks from local quarries, cable reels, auto tires, etc., and in the reuse of building materials . . . showed considerable resourcefulness. The use of recycled lumber often gave buildings and fences a weathered rustic appearance that is interpreted both positively as picturesque and harmonious, and negatively as being ramshackle and untidy.*

Buchanan obviously sees the shacks in a positive light. But she is also deeply sensitive to the importance of vernacular expression to Southern culture. It is worth pointing out that the word "vernacular" means, first, a slave who is born on his master's estate—that is, home-born—and second, an artform native or peculiar to a particular country or locality. It is, in essence, this ground that Buchanan's work explores. Her work reaches back to and touches upon Southern culture's roots in slavery, and it examines, in a way that is not without ambiguity, the conditions of freedom that have grown out of those roots.

We have included *Works in Progress: Beverly Buchanan* in the chapter on drawing because the segment of the video in which she constructs a pastel oilstick work from beginning to end seemed to us an almost perfect example of the drawing as a working process. But the material in this video dedicated to building a sculptural model of a shack is also relevant to Chapter 13, "Sculpture," especially the section on Assemblage. You might want to view it again later in the course.

Ideas to Consider

1. Beverly Buchanan teaches us to see what we would otherwise most likely ignore. She finds beauty in the most mundane subject matter. Be sure to note the ways in which she transforms the commonplace in her work—and honors it, as well, by recognizing its inherent beauty and dignity.

2. At the end of video, Buchanan is at work on a sculpture of a shack that seems to resist having a door. What, in the nature of shacks, demands a door? What, in the nature of art, frees Buchanan from the necessity of having a door?

3. Buchanan distinguishes between "making art" and "making things"—or, rather, she sees little distinction between the two. How does this inform her art?

4. Describe, as best you can, Buchanan's working process, both in sculpture and in drawing.

5. Buchanan has said that she considers her shacks "portraits"—"I'm interested in their shapes and how they're built and how they reflect the people who built them. . . . It's the[ir] spirit that comes through the forms." Think about the shack she builds in the video, and the drawing she executes—how do they reflect the people who built them? How are they "portraits"?

Frequently Asked Questions

Are the stories that Buchanan reads from her notebooks in the video true stories? Some are true, some are fiction. Many times, the stories are "myths" or "folktales"—that is, there is an element of truth in them, but over time the narratives have been embellished as they have been told again and again. Buchanan is also interested in capturing the "spirit" of a place—she is at least as interested in getting the "spirit" right as getting the story accurate. "I have written legends," Buchanan says, "that include the lives of people I met when I lived in Ohio, in New Jersey, etc.—not all of them were black people. These are not necessarily black or white structures." However, the story of Mary Lou Fucron, who single-handedly built her house, is a true story.

What kind of people live in these shacks? Almost all of the rural shack dwellers are fiercely proud and independent people. Although their means are slim, and although many would easily qualify for welfare, almost none accept any help from the state.

REVIEW QUESTIONS

Answers to the following questions appear in the APPENDIX: ANSWER KEY at the end of the *Study Guide*.

1. For Renaissance artists, a cartoon was

 a) a comic drawing.
 b) a caricature.
 c) a drawing done to scale for a painting or fresco.
 d) a rough sketch.

2. What did Giorgio Vasari see in drawing that led him to collect the drawings of Renaissance masters such as Michelangelo, Leonardo, and Raphael?

3. Metalpoint is distinguished by its

 a) heavy metallic line.
 b) a delicate, pale gray line that cannot be widened by increasing pressure upon the point.
 c) its similarity to chalk.
 d) its tendency to smudge, requiring the use of a fixative.

4. What are pigments and binders?

5. Charcoal is a medium favored especially by modern artists because

 a) it requires little preparation.
 b) it satisfies their love for texture.
 c) it satisfies their love for black and white contrasts.
 d) it is a particularly expressive medium.

6. Henri Matisse was an innovator in many ways. One of his most successful innovations was to use what tool as a drawing instrument?

SUPPLEMENTAL ACTIVITIES AND WRITING ASSIGNMENTS

Supplemental Activities: Some time in elementary school, most of us decide that we can't draw, and so we stop. But it's not exactly that we can't draw —we doodle throughout our lives—we just begin to realize that others, with greater hand/eye coordination perhaps, can imitate reality more closely than ourselves. Already in this book, you've probably come to realize that being able to copy nature, to represent things exactly, is not necessarily the goal of art. Still, for whatever reasons, we quit. The supplemental activity suggested here is not one that you can, in all likelihood, accomplish while you follow this course of study. But we would like to suggest that you consider taking a course in basic drawing. You will learn a lot, and you will learn most of all that you can be taught to draw. If you lack confidence, take the course pass/no pass. While you may lose something of your sense of the almost supernatural talent of artists—they work at what they do like all of us—you will learn to appreciate the fundamentals of their discipline to a far greater degree than you can just reading about it.

The Website: Go to the *World of Art* website (**www.prenhall.com/sayre**). Proceed through the Chapter 10 materials. Consider your command of the objectives as stated in the website. Take the multiple choice and fill-in-the-blanks self-tests. Briefly respond to both the critical analysis and the compare and contrast questions, either formally or informally. Visit the related sites linked in both the Modern Artists and Galleries and Museums areas. A hands-on project related to the course material is suggested. Even if you are not assigned the Project, think about how you might approach it. Finally, consider participating in the Message Board or Chat Discussions.

Writing about the Drawing: In Chapter 5, "Line," we encountered a great many drawings that utilized line in a variety of ways. As we noticed then, you can tell a lot about what the artist means to say in a drawing by analyzing line. Go to a gallery or museum on your campus or in your community. Analyze the use of line in a drawing. (If you can't find a drawing in your community, then go to the library. There you can find any number of drawings. Just look up drawing in the catalogue.)

Writing to Explore New Ideas: Drawing, it could be argued, is a way of thinking—the visual equivalent of thinking out loud. Go back through the *Works in Progress* spreads that you have read so far in *A World of Art* and look at those, particularly, where the artist has utilized drawing to think about the work at hand. What do these examples have in common? If drawing is a kind of critical thinking—a term much bandied about in higher education, but rarely adequately defined—how would you define critical thinking?

Suggested Further Reading: Bernard Chaet's *The Art of Drawing* (New York: Holt, Rinehart, and Winston, 1970) is the classic text on drawing.

One of the most important examinations of the vernacular in American culture is Houston Baker's *Blues, Ideology, and Afro-American Literature: A Vernacular Theory* (Chicago: University of Chicago Press, 1984).

Chapter 11
Printmaking

LEARNING OBJECTIVES

This lesson will help you understand the medium of printmaking and how artists employ it. At the end of this chapter you should be able to:

1) Define what a print is, including the concept of an "original" print.

2) Differentiate among and outline the basic steps involved in each of the basic printmaking processes—relief, intaglio, lithography, silkscreen, and monotypes.

3) Differentiate among and outline the basic steps involved in each of the relief processes—woodcut, wood engraving, and linocut.

4) Differentiate among and outline the basic steps involved in each of the intaglio processes—etching, engraving, drypoint, mezzotint, and aquatint.

5) Appreciate why many modern artists have been especially interested in lithography.

KEY CONCEPTS

impression
edition
matrix
proof
original print
registration

woodcut
wood engraving
linocut
ukiyo-e prints

engraving
etching
drypoint
mezzotint
aquatint

burin
ground
burr
rocker

lithography
tusche
silkscreen (serigraphy)
squeegee
monotypes

STUDY PLAN

Step 1: Read Chapter 11, "Printmaking," in your text, *A World of Art*, pp. 208-231.

Step 2: Attempt to answer the questions posed in the CRITICAL PROCESS section at the end of the chapter. Don't worry if you find that you have a difficult time. Proceed to the next step.

Step 3: Read the OVERVIEW of Chapter 11 in this study guide lesson. When a specific work of art that is illustrated in the text is discussed, try to visualize it. If you are unable to remember it, open the text to that illustration and refresh your memory.

Step 4: Read the VIEWING GUIDE to *Works in Progress: June Wayne* in this study guide lesson.

Step 5: View the video *Works in Progress: June Wayne*, following the VIEWING GUIDE as you watch. Take notes and jot down ideas in response to the VIEWING GUIDE. Your instructor may require you to hand in written responses, formal or informal, to some or all of the topics that the VIEWING GUIDE sets out for your consideration. View the video a second time if necessary.

Step 6: Complete the suggested CD-ROM assignments for Chapter 11 outlined in this study guide lesson.

Step 7: Return to the LEARNING OBJECTIVES and KEY CONCEPTS sections at the beginning of this study guide lesson. Demonstrate your mastery of each of the learning objectives. Define each of the concepts—each is discussed in the text and each appears in the glossary at the end of your text as well.

Step 8: Return to the CRITICAL PROCESS section at the end of the chapter. Having reviewed the material, attempt to answer the questions again. Turn to the back of the text, p. 513, and compare your answers to those provided by the author.

Step 9: Answer the REVIEW QUESTIONS. Complete the assigned SUPPLEMENTAL ACTIVITIES and WRITING ASSIGNMENTS in this study guide lesson.

Step 10: Pursue any title from the SUGGESTED FURTHER READING that is assigned or that interests you.

OVERVIEW
of Chapter 11 - "Printmaking"
A World of Art

Printmaking originated in the West very soon after the appearance of the first book printed with movable type—the Gutenberg Bible. In post-medieval Western culture, prints—the primary form of book illustration— were fundamental to the creation of our shared visual culture.

The Nuremberg Chronicle (Fig. 285) was published in 1493 by Anton Koberger, one of history's first professsional book publishers. Intended to be a history of the world, it included over 1800 illustrations, although only 654 actual blocks were used; in most cases, the same image would be repeated to represent a different person or place. Since the nineteenth century, and increasingly since World War II, there has been a resurgence of popularity for prints. The print has also provided contemporary artists with a ready medium with which to investigate the meaning of mechanically reproduced imagery itself. Prints are popular because original works of art (paintings or sculpture) are often too expensive for the average collector to afford. Prints are an avenue through which artists can gain greater exposure.

The **print** is a single **impression**, or example, of an **edition** of impressions, made on paper from the same **plate** or master image (sometimes called a **matrix**). As prints have become more and more collectible, the somewhat confusing concept of the "original" print has come into being. How can something produced in so many numbers be original? The original print consists of an image that the artist alone has created, and has been printed by the artist or under the artist's supervision. Each print is signed by the artist and numbered. For example, 3/35 means the third print produced in an edition of 35. Often the artist will reserve a number of additional "proofs," trial impressions usually marked "AP," meaning Artist's Proof. After an edition is printed, the original plate is then destroyed. There are five basic processes of printmaking—relief, intaglio, lithography, silkscreen, and monotype.

Relief Processes

Relief refers to any printmaking process in which the image to be printed is a raised surface which holds the ink. An example is the common rubber stamp. The letters are raised above the background, and once "inked" on the pad, the ink is transferred to paper through pressure (Fig. 286).

Woodcut

The first prints, such as the illustration for *The Nuremberg Chronicle* (Fig. 285), were woodcuts. A design was drawn on the surface of a wood block, and the parts of the print that were to remain white would be carved away with a knife or gouge. This left the areas to be black elevated, and these areas would be rolled with a viscous ink. The paper was then carefully placed on the block, and, under pressure, the ink easily transferred to the paper.

The woodcut print offers the artist a means of achieving great contrast between light and dark, and, as a result, dramatic

emotional effects. This expressive potential of the medium was recognized by the German Expressionists in the early twentieth century. Nolde's *Prophet* (Fig. 287) reveals the burden that prophecy.

Nineteenth-century European artists became particularly interested in woodcut processes through their introduction to the Japanese print (Fig. 290). This occurred after Japan reopened its doors to the rest of the world after 215 years of isolation. European artists were inspired by the colors, the subtle use of line, and the unique use of space evidenced in the Japanese prints. Vincent van Gogh was perhaps impressed the most by Japanese prints, often copying them directly as the basis of paintings, as in his *Japonaiserie: The Courtesan (after Kesai Eisen)* (Fig. 289).

Works in Progress
Utamaro's *Studio*

Most Japanese prints are examples of *ukiyo-e*, or "pictures of the transient world of everyday life." The subject matter often consists of common or shared experiences in contemporary life, such as arranging hairstyles, dressing, or theatrical entertainment. The creation of a *ukiyo-e* print was traditionally a team effort. The publisher, artist, carver, and printer, were all considered equal. Kitagawa Utamaro, one of the most famous of the nineteenth-century woodcut artists, has depicted the studio process in *A Fanciful Depiction of the Utamaro's Studio* (Fig. 291) The print is a *mitate*, or "fanciful picture," because all the members assisting Utamaro are attractive young women.

The print provides an insight into the process of the woodblock print. The left plate shows the workers preparing the paper for printing. The middle section shows the block being prepared, and the non-printing areas being carved away. The right print shows Utamaro himself showing a finished print to his publisher. Color prints were first printed as a black-and-white "proof," which the artist would approve, and indicate the areas of color to be printed. Each color had to be printed from a separate block.

Wood Engraving

By the late nineteenth century, woodcut illustration had become very sophisticated, evolving into wood engraving, which consisted of extremely fine lines cut into the end grain of wood blocks. As with true relief processes, the ink printed from the uncut, or raised portion of the block. The fine end grain of the block permitted the carver to cut in any direction without tearing across the grain, which made extremely fine detail possible. *Noon-day Rest in Marble Canyon* (Fig. 292) is an example of wood engraving.

The artist Paul Gauguin found this technique "loathsome," in essence removing from woodcut its potential primitive nature, the sense of wood with all its inherent nuances. He felt his own engravings were far more interesting with their bold wide cuts, which were purposefully coarse. In *Watched by the Spirit of the Dead* (Fig. 293), for instance, Gauguin opted to leave them in to print as large black areas rather than carving away portions of the block that would normally be left white or open.

Linocut

Color can be added to a print by creating a succession of different blocks, each

one printing a different color, and each one registered to line up with the others. Picasso, working with linoleum (called "linocut") instead of wood, simplified the process. He used the same block over and over for each color, and each time he printed a color, another portion of the image was carved away. In Picasso's *Luncheon on the Grass* (Fig. 294), the uncarved block was printed in yellow, then parts of the image were carved away so that they would not print again and blue was printed. This was followed by more carving, then violet printed, the process continuing until he added black.

Intaglio Processes

Relief processes like woodcuts print from a raised surface. With the intaglio process, the areas to be printed are below the surface of the plate. Intaglio is the Italian word for "engraving." In general, intaglio is any process in which cut, incised, or etched lines on a plate are filled with ink. The surface of the plate is then wiped clean, and a sheet of dampened paper is placed over it. In the press a powerful roller forces the paper against the plate causing it to pick up the ink in the depressed grooves (Figs. 295 and 296). Modeling and shading are achieved in the same way as in drawing, by hatching, cross-hatching, and often stippling, where instead of lines, dots are employed with greater and greater density.

Engraving

In engraving, the image is created on the plate by pushing a small V-shaped metal rod, called a **burin**, across a metal plate, usually of copper or zinc, forcing the metal up in slivers in front of the sharp tip. The slivers are then removed from the plate with a scraper, and the plate is ready to be inked and printed in the intaglio method. Line

engravings were often used to illustrate books before the advent of photography. Raphael's *Judgment of Paris* is known to us only through Raimondi's engraving (Fig. 66). Steel engravings, such as the one replicating J. M. W. Turner's *Snow Storm: Steamboat off a Harbor's Mouth* (Fig. 297), were more durable than copper or zinc, making them superior for book publishing. The Turner engraving is an example of the tremendous variety of line that can be accomplished through engraving.

Works in Progress
Albrecht Dürer's *Adam and Eve*

Albrecht Dürer was one of the great early masters of intaglio. His image of *Adam and Eve* (Fig. 300) is an example of the exceptional detail that can be achieved through engraving. Two of Dürer's early proofs (Figs. 298 and 299) survive and reveal the artist's process. These **states**, or stages, allowed Dürer to see how well his incised lines would hold and transfer ink, as well as show the image in its correct view, since the plate was incised in reverse or mirror image. Through the development of the image of Adam, one can see how Dürer employed hatching and cross-hatching to build an area of shadow.

The final print is rich in iconographical information. While the snake is the creature most typically associated with this "event," there are many other animals depicted that would have been immediately understood by a sixteenth-century audience. The cat is present as a symbol of deceit, and perhaps sexuality. The fact that it is about to pounce on a mouse suggests Adam's susceptibility to the female's wiles. The parrot over Adam's right shoulder is the embodi-

ment of wisdom and language. Other animals shown represent the four humors, or the bodily fluids that make up human constitution. The elk represents melancholy (black bile), the cat anger and cruelty (yellow bile), the rabbit sensuality (blood), and the ox laziness or sluggishness (phlegm). The engraving technique itself made it possible for Dürer to reveal this much detail.

Etching

Another intaglio process, etching is a much more fluid and free process than engraving and is capable of capturing some of the same spontaneity as exists in a sketch. The process is essentially twofold, consisting of a drawing stage and an etching stage. Since the areas or lines that print are made by eating the metal plate away with acid, the plate is coated with an acid resistant ground, which is then scratched or drawn through with an etching needle to expose the metal. A "hard ground" is very tough and requires such a tool. A "soft ground" is gel-like, and can be removed by drawing with a pencil, or even a finger tip. Regardless of the ground employed, the drawn plate is then placed in a bath of acid, and the drawn areas become eaten away, or etched. The undrawn areas, protected by the ground, remain unaffected by the acid. When the plate is etched and ready for printing, all the ground is removed with solvent, and the plate is inked and printed in the intaglio method. *The Angel Appearing to the Shepherds* (Fig. 301) provides evidence that Rembrandt was perhaps the first master of this medium.

The dynamic play between light and dark that Rembrandt achieved would be used to great expressive effect by German Expressionist Käthe Kollwitz. Deliberately avoiding the use of color in her work, she preferred the sense of emotional conflict and opposition that could be realized in black and white. In *Death and a Woman Struggling for a Child* (Fig. 302), the heavily inked shadow created where the mother presses her face against her child's forehead creates a depth of feeling and compassion.

Drypoint

A third form of intaglio printing is drypoint. The drypoint line is scratched into a copper plate with a metal point that is pulled across the surface. A ridge of metal called a burr is pushed up along each side of the line, and this gives a rich, velvety soft texture to the print, as in Mary Cassatt's *The Map* (Fig. 303). Because this burr quickly wears off during the printing process, drypoint editions are usually limited to no more than 25, and the earlier numbers in the edition are often the finest.

Mezzotint and Aquatint

Two other intaglio techniques are mezzotint and aquatint. Mezzotint is a "negative" process. The metal plate is first ground all over using a sharp curved tool called a **rocker**, which leaves a burr over the entire surface that, if inked, would produce a deep solid black. Areas intended to print light are produced by scraping or burnishing the surface of the plate smooth again. Prince Rupert's *Standard Bearer* (Fig. 304) is an example.

Like mezzotint, aquatint is a process that does not rely on line for its effect, but rather on tonal areas of light and dark. The method involves coating the surface of the plate with a porous ground through which acid can penetrate. Traditionally, powdered resin is used, and when the plate is heated, the resin melts and adheres to the plate. The acid bites around each particle, creating a sandpaper-like texture. Line is often added

later, usually by means of etching or dry-point. Jane Dickson's *Stairwell* (Fig. 305), an aquatint printed in three colors, employs the roughness of the plate's surface to heighten the emotional power of the subject.

Lithography

Lithography, meaning literally "stone writing," is a *planographic* printmaking process, meaning that the printing surface is flat. There are no raised or depressed surfaces on the plate to hold ink. Rather, the process relies on the principle that grease and water don't mix.

Lithography was discovered accidentally by a German playwright named Alois Senefelder, who was attempting to publish his own plays. Planning initially to print them from a plate, he was practicing writing backwards on a smooth piece of limestone. Through a series of accidents, he learned that the stone surface could hold an ink image in areas drawn on with a greasy crayon, but that the other areas, if kept wet, would resist the ink. Recognizing a commercial potential, he abandoned playwriting and proceeded to develop the process until he had essentially refined it to its present level. Because it is so direct a process, it has been the favorite printmaking medium of nineteenth- and twentieth-century artists, who appreciate its spontaneity and immediacy. Manet's *The Races* (Fig. 306) takes advantage of both spontaneity and immediacy, using a swirling dynamic line that is the essence of "the race" itself.

For Honoré Daumier, the immediacy of lithography made it an appropriate means for relaying current events. Daumier was employed by the French press for many years as both an illustrator and a political caricaturist. His famous print *Rue Transnonain* (Fig. 307) is a direct reportage of the outrages committed by government troops during an insurrection on the Parisian workers' quarters.

While lithography flourished as a medium in the twentieth century, it has increased in popularity since the 1950s. In 1957, Tatyana Grosman established Universal Limited Art Editions in West Islip, N. Y., and three years later, June Wayne founded the Tamarind Lithography Workshop in Los Angeles. The Mount Holyoke Printmaking Workshop was founded by Nancy Campbell in 1984. Elaine de Kooning was the first resident artist at the workshop. One of her prints, *Lascaux #4* (Fig. 308), inspired by the cave paintings at Lascaux, allows de Kooning to work with the same broad painterly gesture that typified her abstract expressionist paintings.

═══════════

Works in Progress
June Wayne's *Knockout*

June Wayne, founder of the Tamarind Lithography Workshop, is the subject of another installment in the Works in Progress video series. See the VIEWING GUIDE in this lesson for more information.

═══════════

Robert Rauschenberg's *Accident* (Fig. 312) represents the spirit of innovation and experiment found in much contemporary printmaking. Rauschenberg began by applying all sorts of materials down onto the stone to see if their natural oils would leave an imprint that would hold ink. When the stone actually broke in the press, he printed it anyway.

OVERVIEW

Silkscreen Printing

Silkscreens are formally known as "serigraphs" from the Greek *graphos* (to write) and the Latin *seri* (silk). The principles used are essentially the same as those employed in stenciling. Silk fabric is stretched tightly on a frame, and a stencil is made by painting a substance such as glue across the fabric where the artist does not want the image to print. Ink is then forced through the uncoated mesh of the silk fabric (today polyester is commonly used in place of silk) by the means of pressure provided by a *squeegee*. Alternately, special stencil films are available which can be cut and adhered to the silk, and there are also light sensitive films available that accommodate photographic processes. Serigraphy is the newest form of printmaking, although similar stencil techniques were used as early as 550 C.E. in China and Japan.

Silkscreen had been primarily a commercial printing process used most often by the advertising industry. In 1935, the term serigraphy was coined to differentiate artists' prints utilizing the medium from commercially printed products. In the 1960s, serigraphs became a popular medium for Pop artists. Warhol's *Thirty Are Better Than One* (Fig. 315) and Claes Oldenburg's *Design for a Colossal Clothes Pin* (Fig. 2313) take advantage of the fact that photographic processes can be applied to the medium. In reproducing Leonardo's *Mona Lisa* thirty times, Warhol emphasizes its status as an artistic cliché and a commodity comparable to his Campbell's Soup Cans. Oldenburg compares his clothes pin to Brancusi's famous *The Kiss*, both to demonstrate the formal similarity and deliberately suggest the irony of how art critics often tend to evaluate works of art on a formal basis.

Monotypes

The last form of printmaking to consider combines techniques of printmaking and painting. Unlike other types of prints, once a monotype has been printed, it can never be printed again. In monotype, the artist creates an image on the plate with printer's inks or paints, lays paper over it, and runs it through the press in order to transfer the image. The plate serves as the vehicle for transferring the paint to the paper.

A challenge with monoprint is that the first (bottom) layer of ink applied to the plate often becomes the top layer when transferred to the paper. The process requires considerable planning. Native American artist Fritz Scholder is a master of the medium. Scholder often works in a series, and his *Dream Horse* G (Fig. 314) is an example. After the inked plate passes through the press and transfers its image to paper, a ghost remains on the plate. Scholder often reworks the ghost, revising and making it a new image. Scholder's process, in a sense, is a summation of the possibilities available in print—the process often contributes surprises that result in new discoveries allowing for a new freedom of creativity. The visual effects of printmaking become virtually unlimited.

THE CRITICAL PROCESS
Thinking about Printmaking

Andy Warhol's *Thirty Are Better than One* (Fig. 315) raises fundamental questions about the manner in which "production" affects the originality of both work and image. Warhol, for instance, also made multiple image prints of Marilyn Monroe, suggesting that both Marilyn and Mona Lisa are cultural icons. What does it mean to be an icon? an image?

VIEWING GUIDE
to *Works in Progress: June Wayne*



June Wayne
Biographical Sketch

June Wayne was born in 1918 in Chicago. From the outset, she was interested in art and keenly observant. At the age of 5, she recognized that the dots of color in the comic strips, when fused by vision, produced secondary hues and began to make drawings composed entirely of colored dots, a sort of self-taught French Post-Impressionist in the manner of Seurat and Signac. At the age of 9 she began a project that would occupy her into her late teens, illustrating the *Rubáiyat of Omar Khayyam*. Her dedication to a single project would inform her work for the rest of her life.

Bored with high school, she dropped out. In 1934, when she was 16, in order to prove to her mother that she was nonetheless an educated person, she took and passed the entrance examinations to the University of Chicago. But she did not enter school. Within a year she had a one-person show of paintings at the Boulevard Gallery in Chicago. As a result of this show, she was invited by the Mexican Government to paint in Mexico. The invitation resulted in a well-received 1936 exhibition at the Palacio de Bellas Artes in Mexico City. She was 18 years old.

Over the course of the next five years, she worked, first, in the art galleries of Marshall Field and Company in Chicago, then on the easel painting project of President Roosevelt's WPA Art Project, then as a costume jewelry designer and stylist in New York City, and then as a writer for WGN radio in Chicago. But by 1950 she was working virtually full time as an artist.

By the time she acquired her Tamarind Avenue studio in Los Angeles in 1958, she was one of the most respected artists in the United States. In 1952, the *Los Angeles Times* had named her Woman of the Year for Meritorious Achievement in Modern Art,



and her work was in most of the major collections in the United States. Worried about the moribund condition of lithography in this country, she wrote a proposal to the Ford Foundation in 1959 requesting support to restore lithography by training master-printers to work with U.S. artists. At first cautious, the Ford Foundation granted her $165,000 in 1960 to test her plan. In 1962, it awarded her $400,000 more, and in 1965 another $700,000 to maintain the workshop through 1970.

Under her direction, Tamarind Lithography Workshop became one of the most important focal points of a general revival of printmaking in the United States. In 1969, as she prepared for the transfer of Tamarind to the University of New Mexico, she began collaborating with French tapestry weavers. Ever since she has continued to push the limits of almost all art media, constantly creating new techniques and forms. She was spurred on particularly by the feminist movement, which she anticipated to an extraordinary degree, and which validated her own career path. But her art was stimulated especially by discoveries in modern science, especially space exploration, the intellectual excitement of which has driven Wayne to remain one of the most innovative artists of the day.

Summary and Introduction

Works in Progress: June Wayne follows the artist as she makes a new series of prints with master-printer Judith Solodkin in New York City in the fall of 1995 and focuses particularly on Wayne's interest in science and space exploration.

Wayne's interest in science can be traced back to her early years, but it became particularly acute after the explosion of the atomic bomb in World War II, when she naturally became interested in atomic structure and radiation. She was using black and white dots on the surface of the picture, which seemed to her to "irradiate" the picture plane, revealing the molecular nature of matter. She had also been working on creating a visual equivalent to Proust's technique, in his novel *Remembrances of Things Past*, of changing his characters from one time frame to another. She wanted to move a theme in a picture through the space of the painting. Thus, she explains, "the elements of time, space, and matter moved me into galactic space."

In this emphasis on space and time, she shares much conceptually with Jackson Pollock, who is her contemporary and whose work we considered in our discussion of "Time and Motion" in Chapter 8. But in many ways her model is Leonardo da Vinci, whose drawings, she points out, track an "invisible *energy* that was shaping the trees and carving the waters into waves"—something we have already seen in Chapter 10, "Drawing." In other words, Wayne attempts to image what is not seen, to make visible the invisible forces of the universe. This effort is imaged dramatically in a work such as *The Tunnel*, the conceptual making of which we witness in the video.

The focus of the new series of prints executed by Wayne for the *Works in Progress* video series is the discovery of so-called "knockout" mice by research scientists at Johns Hopkins University in Baltimore. They found that male mice specifically bred to lack a gene essential for the production of nitric oxide, a molecule that allows nerve cells to communicate, are relentlessly aggressive against their fellow males, often to the point of killing them. The altered males also aggressively and repeatedly mount female mice, even when they are not in heat and screech vocally in apparent protest. Scientists were interested in blocking nitric oxide because evidence indicated that during a stroke the brain releases large quantities of the gaseous compound, increasing damage to the neural tissues. By blocking the enzyme responsible for making the gas, the incidence of stroke can be reduced by 70 percent. The Johns Hopkins mice were genetically manipulated to delete—or "knockout"—the gene that makes the nitric oxide-producing enzyme. While stroke incidence in the mice decreased, scientists soon found that when they checked the cages of male mice housed together overnight, one or two would be dead. At first they suspected natural causes, but soon realized that the mice were killing each other. When housed with females, the males became rather less violent but uncontrollably and unstoppably ardent. Scientists theorize that nitric oxide controls the sexual and aggressive appetites of the male mice (female mice lacking the nitric oxide-producing enzyme show no noticeable change in behavior). While scientists were cautious about extension of the findings to human behavior patterns, Johns Hopkins researchers planned to pursue the possibility that lack of the gene that produces nitric oxide, or some mechanism that inhibits its production, was involved in some percentage of human aggression.

As Wayne was preparing to make her prints for the *Works in Progress* series in November 1995, an article summarizing the Johns Hopkins study appeared in the *New York Times*. It provided her with the theme for her prints. Both formally and thematically, the pieces look back to work done with the atomic bomb forty years earlier and to a series of prints executed in the 1960s called *The Lemmings*. Lemmings are oversized field mice that have an instinct for morbid togetherness and for periodic migrations leading to mass suicide. In other words, they behave, in Wayne's opinion, a lot like people. The knockout mice in her new work are later versions of the lemmings. Like the lemmings, they behave a lot like people too.

VIEWING GUIDE

Ideas to Consider

1. June Wayne, as we know, is particularly interested in science. Note the various ways in which she utilizes scientific thinking in her work.

- How does it influence her subject matter?

- How does it influence her formal process?

2. At one point in the video she compares a color version of a print to a black-and-white one. What differences do you see? Which, to your eye, is the more powerful print? Or do they each have their attractions?

3. Consider some the ideas about space that we encountered in Chapter 6, "Space." Rarely does she employ linear perspective. Why? How is her space different than perspectival space?

4. Another issue that Wayne addresses in the video is scale. How do questions of scale come to play in her work?

5. Another formal element that is central to her work is texture. What role does texture play in her work?

6. Finally, consider the question of time and motion which Wayne addresses directly in her *Tunnel* works. How do time and motion inform some of the other pieces we see in the video?

NAVIGATING *A World of Art*: THE CD-ROM

The *World of Art* CD-ROM contains two doorways in Visual Demonstrations Room that will help you to understand the material in Chapter 11, "Printmaking."

Printmaking: Relief and Intaglio One entire interactive pathway is dedicated to QuickTime videos of relief and intaglio printmaking techniques. Move the pointer to the directional arrow and hold down the mouse button as the room spins until the Printmaking: Relief and Intaglio doorway appears. Stop, then double-click on the doorway, and the Printmaking demonstration area will open.

The first QuickTime video consists of a demonstration of the making of a traditional woodcut. Artist Yuji Hiratsuka makes his original drawing on rice paper, transfers it to a block, carves out the block, and then prints the image by hand. As you view the process, follow along in the accompanying text block.

The second QuickTime video consists of another demonstration of the making of a woodcut, but this time artist Yuji Hiratsuka utilizes a less conventional method. He paints the entire block with black ink, then draws directly onto the block, and finally carves out the block through the inked surface. In this way, he can see exactly what will print from the outset.

In this QuickTime video sequence we watch as Hiratsuka prints an etching. As you view the process, follow along in the accompanying text block.

Printmaking: Photo-Silkscreen Another entire interactive pathway is dedicated to a QuickTime video of the photo-silkscreen printmaking process. Move the pointer to the directional arrow and hold down the mouse button as the room spins until the Printmaking: Photo-Silkscreen doorway appears. Stop, then double-click on the doorway, and the Printmaking: Photo-Silkscreen demonstration area will open.

In the *Works in Progress* video that accompanied Chapter 2, we saw Lorna Simpson create a series of photo-silkscreen prints on felt. Here her printer, Jean Noblet, leads us step by step through the photo-silkscreen printmaking process. As you view the process, follow along in the accompanying text block.

REVIEW QUESTIONS

Answers to the following questions appear in the APPENDIX: ANSWER KEY at the end of the *Study Guide*.

1. Fill in the blanks in the following definition of a print:

 A print is defined as a single _____, or example, of a multiple _____ made on paper from the same _____, or master image. Often the artist reserves a small number of trial _____ for personal use.

2. What is the name of the printmaking process in which the image to be printed is raised off the background?

3. What is the name of the printmaking process in which the image to be printed is below the surface of the plate?

4. Which of the following is a relief process?

 a) wood engraving
 b) etching
 c) mezzotint
 d) serigraph

5. The acid-resistant suabstance used to coat the metal plate in etching is called a

 a) stipple.
 b) tusche.
 c) ground.
 d) reserve.

6. Which of the following is used in one or another of the intaglio processes?

 a) rocker
 b) burin
 c) squeegee
 d) linoleum

7. Why has lithography been a favorite printmaking medium of nineteenth- and twentieth-century artists?

SUPPLEMENTAL ACTIVITIES AND WRITING ASSIGNMENTS

Supplemental Activities: A good way to master conceptually the relief process is to print a block of your own making. You don't need a press or any fancy equipment to do this. At most art supply stores you can readily find a material called Safety Cut, a soft, white, rubberlike material that comes in various sizes up to one foot square. With an Exacto knife, cut out a design in the Safety Cut block. You can then print your design by utilizing a standard rubber stamp ink pad, or, if you are so inclined, felt-tip pens of various colors are available that are specifically designed for color printing from a hand-made block. Be sure to note how the printed image is the reverse of your original block.

The Website: Go to the *World of Art* website (**www.prenhall.com/sayre**). Proceed through the Chapter 11 materials. Consider your command of the objectives as stated in the website. Take the multiple choice and fill-in-the-blanks self-tests. Briefly respond to both the critical analysis and the compare and contrast questions, either formally or informally. Visit the related sites linked in both the Modern Artists and Galleries and Museums areas. A hands-on project related to the course material is suggested. Even if you are not assigned the Project, think about how you might approach it. Finally, consider participating in the Message Board or Chat Discussions.

Writing about Printmaking: One of the most confusing and potentially interesting aspects of printmaking is the way it calls into question the idea of "original" works of art. Not only do prints exist in multiple editions, but artists often rely on others, namely, master-printers, to make their prints. Pop artists such as Andy Warhol and Claes Oldenburg have particularly challenged the idea of artistic originality. Using the two silkscreen images by these artists reproduced in this chapter (Figs. 313 and 315) consider the idea of "originality." (It may prove useful, incidentally, to think about repetition and rhythm, as discussed in Chapter 9, "The Principles of Design.")

Writing to Explore New Ideas: At the beginning of the next chapter, we will consider the centrality of representation to the history of painting in Western culture. Building on the ideas you developed in the essay above, consider the Greek philosopher Plato's position that any representation is but a copy of an original.

Suggested Further Reading: An excellent essay on contemporary printmaking in general, and on Tatyana Grosman's Universal Limited Art Editions in particular, is Calvin Tomkins's "The Skin of the Stone," which appeared originally in *The New Yorker* and is reprinted in his collection entitled *The Scene: Reports on Post-Modern Art* (New York: Viking Press, 1976), pp. 55-83.

A very sophisticated but also extremely interesting essay dealing with the question of the original is Rosalind Krauss's "The Originality of the Avant-Garde," in *The Originality of the Avant-Garde and Other Modernist Myths* (Cambridge: MIT Press, 1985).

Study Guide Lesson for

Chapter 12
Painting

LEARNING OBJECTIVES

This lesson will help you understand the medium of painting and how artists employ it. At the end of this chapter you should be able to:

1) Define and differentiate among the basic painting processes—encaustic, fresco, tempera, oil painting, watercolor, gouache, and synthetic media.

2) Outline painting's development in terms of its desire to represent the world more and more faithfully, from encaustic and fresco, through tempera and oil painting.

3) Distinguish between painting's denotative and connotative aims.

4) Describe the basic composition of each medium in terms of its characteristic binder and, where appropriate, vehicle.

5) Outline the relative advantages and disadvantages of painting with oil and painting with synthetic media.

KEY CONCEPTS

imitation or *mimesis*	encaustic	watercolor
the denotative	fresco	gouache
the connotative	fresco secco	synthetic media
	buon fresco	Duco
pigment, binder	tempera	acrylic resins
support	gesso	
primer	oil painting	
ground	impasto	
solvent or vehicle	glazing	
	trompe l'oeil	
	scumbling	

STUDY PLAN

Step 1: Read Chapter 12, "Painting," in your text, *A World of Art,* pp. 232-58.

Step 2: Attempt to answer the questions posed in the CRITICAL PROCESS section at the end of the chapter. Don't worry if you find that you have a difficult time. Proceed to the next step.

Step 3: Read the OVERVIEW of Chapter 12 in this study guide lesson. When a specific work of art that is illustrated in the text is discussed, try to visualize it. If you are unable to remember it, open the text to that illustration and refresh your memory.

Step 4: Read the VIEWING GUIDE to *Works in Progress: Milton Resnick* in this study guide lesson.

Step 5: View the video *Works in Progress: Milton Resnick* following the VIEWING GUIDE as you watch. Take notes and jot down ideas in response to the VIEWING GUIDE. Your instructor may require you to hand in written responses, formal or informal, to some or all of the topics that the VIEW-ING GUIDE set sout for your consideration. View the video a second time if necessary.

Step 6: Complete the suggested CD-ROM assignments for Chapter 12 outlined in this study guide lesson.

Step 7: Return to the LEARNING OBJECTIVES and KEY CONCEPTS sections at the beginning of this study guide lesson. Demonstrate your mastery of each of the learning objectives. Define each of the concepts—each is discussed in the text and each appears in the glossary at the end of your text as well.

Step 8: Return to the CRITICAL PROCESS section at the end of the chapter. Having reviewed the material, attempt to answer the questions again. Turn to the back of the text, p. 513, and compare your answers to those provided by the author.

Step 9: Answer the REVIEW QUESTIONS. Complete the assigned SUPPLEMEN-TAL ACTIVITIES and WRITING ASSIGNMENTS in this study guide lesson.

Step 10: Pursue any title from the SUGGESTED FURTHER READING that is assigned or that interests you.

OVERVIEW
of Chapter 12 - "Painting"
A World of Art

Early in the fifteenth century a figure known as *La Pittura*, meaning "the Picture," was introduced. La Pittura, which was the personification of painting, conferred upon painting the new status as one of the liberal arts. It was to be taken as seriously as any of the other liberal arts, which included rhetoric, arithmetic, geometry, astrology, and music. These areas of knowledge were thought to develop greater intellectual capacity, although up until this time, painting was seen more as a craft.

The artist Artemisia Gentileschi presents herself as both a real person and as *La Pittura* in her *Self-Portrait as an Allegory of Painting* (Fig. 317). Gentileschi's portrait included an honest depiction of the artist's "unruly hair"—representing her creativity, her colored clothing indicating her skill as a painter, and finally a pendant around her neck symbolizing imitation, the act of painting nature. Gentileschi's statement is an early declaration of the increasing importance of women in the arts and society. Her image not only represents artistic genius— she is artistic genius.

One of the major concerns of painting in the Western world has always been representing the appearance of things. This tradition, wherein the painter's task is to rival the truth of nature, has survived to one degree or another to the present day. If we look at two examples of altar pieces— *Madonna Enthroned* by Cimabue (Fig. 318) and *Madonna and Child Enthroned* by Giotto (Fig. 319), we see that Giotto's is more realistic, and to early Renaissance eyes, it would have been seen as a significant advance over Cimabue's. In Giotto's work one senses the mass and three-dimensional form of the subjects, whereas Cimabue's work seems to be flatter.

By this measure, the more accurately it represents the real world, the greater the aesthetic value attached to it. If this were the case, abstraction in painting would have no value. In the Renaissance, the concept of imitation or *mimesis*, involved the creation of representations that transcended mere appearance, and implied a sacred or spiritual essence of things. Painting then, can outstrip physical reality. Even when it is fully representational, it need not be merely "indexial," pointing at what it represents. It can be *connotative* as well as *denotative*. What a painting denotes is its subject—in the case of Cimabue and Giotto, the Madonna and Child. However, both works connoted something else to early Renaissance Italian audiences—the ideal love between a mother and child, or a greater love for God and mankind. Giotto's painting has a *didactic* function, which is to teach and elevate the mind to the level of contemplation of salvation. In fact, there are many levels upon which the work can be interpreted.

From prehistoric times to modern day, principles of painting have remained essentially the same. Artists use **pigments**, or powdered colors, suspended in a medium or **binder** that holds the pigment particles

together. The binder enables the pigment to attach to the **support**, the surface on which the artist paints or draws. Binders all have different characteristics—some create transparent paint, some are very opaque. Most supports are too absorbent to take the binder and pigment directly, so they are **primed** with a paint which serves as a ground. Finally, the artist uses a **solvent** or **vehicle** that enables the paint to flow more readily and can also be used to clean brushes.

Encaustic

Encaustic, made by combining pigment with hot wax, is a very old medium. Its origins date back to classical and Hellenistic Greece. A large number of surviving encaustic paintings, such as the *Mummy Portrait of a Man* (Fig. 320) come from Faiyum in Egypt at the time of Roman colonialism in the second century C.E. These pieces are primarily funeral portraits painted with encaustic medium on wood panels which were then attached to the mummy cases. They demonstrate remarkable skill with a brush, as it was essential that the artist work very quickly in order for the wax to stay liquid.

Fresco

Wall painting was practiced by the Egyptians, Greeks, and Romans, and the preferred medium was fresco, in which pigment is mixed with limiter then applied to a lime plaster wall. In **buon fresco** (Italian for "good fresco"), the paint is applied to wet plaster that has not yet hardened. The plaster draws the pigment into its surface, and the painting literally becomes part of the wall. In **fresco secco** (dry fresco), the pigment is combined with a binder such as egg yolk, oil, or wax, and is applied to a dry wall. Fresco secco allows the artist to pro-

ceed at any pace they desire, while buon fresco demands that the artist only paint as much as they can complete before the wet plaster sets up. Dry frescoes often exhibit beautiful detail, *if* they survive—but moisture can get into the plaster behind the painting and cause it to peel. This was the sad fate of Leonardo's *Last Supper* (Fig. 126).

In the eighteenth century, frescoes such as the *Still Life with Eggs and Thrushes* (Fig. 321) were discovered at Pompeii and Herculaneum where they had been buried under volcanic ash since the eruption of Mt. Vesuvius in C.E. 79. An example is a wall-sized rendering of a garden found in the Villa of Livia, wife of Emperor Augustus (Fig. 322). The image would suggest the continuation of the room to an exterior garden, suggesting that one is looking out-of-doors. From the early Renaissance through the Baroque, this goal of creating the illusion of reality became dominant. The early fourteenth-century fresoes by Giotto in the Arena Chapel in Padua (Fig. 323) demonstrate this interest. A culminating example can be seen in Fra Andrea Pozzo's *Glorification of St. Ignatius* (Fig. 324) painted on the ceiling of the church of Sant' Ignazio in Rome. Looking upward, the congregation had the illusion that the roof of the church had been removed, revealing the glories of Heaven. Through masterful perspective and foreshortening, Pozzo has created an awe-inspiring illusion of St. Ignatius being transported on a cloud toward the waiting Christ.

Works in Progress
Michaelangelo's *Libyan Sibyl*

Michaelangelo's ambitious project—the fresco ceiling of the Sistine Chapel at the Vatican in Rome—consumed four and one-

half years of his life. Pope Julius, who commissioned the work, had originally envisioned a design in which the central part of the ceiling would be filled with a field of geometrical ornaments surrounded by the twelve apostles. Michelangelo protested, assuring Julius that it would be "a poor design" since the apostles were themselves "poor too." Apparently convinced, the pope then freed Michelangelo to paint anything he liked.

Michelangelo set to work preparing hundreds of drawings and cartoons for the ceiling. None of these cartoons, and surprisingly few drawings have survived. Of those that do, one of the finest is a study for the *Libyan Sibyl* (Fig. 325). The *Libyan Sibyl* (Fig. 326) is the last sibyl that Michelangelo would paint. The Sibyl herself turns to close her book and place it on the desk behind her. Even as she does so, she steps down from her throne, creating a stunning opposition of directional forces, an exaggerated, almost spiral contrapposto. She abandons her book of prophesy as she turns to participate in the celebration of the Eucharist on the altar below.

By comparing the drawing of the Sibyl to the final fresco, one can learn much of Michelangelo's process. In the drawing, the Sibyl's hands are balanced evenly, across an almost horizontal plane. But the idea of dropping the left hand, in order to emphasize more emphatically the Sibyl's downward movement, came almost immediately, for just below her left arm is a second variation matching the positions of the final painting. In the drawing, the Sibyl is nude, and apparently Michelangelo's model is male, his musculature more closely defined than in the final painting. Furthermore, in the drawing, the model's face is redone to the lower left, her lips made fuller and fem-

inized, the severity of the original model's brow and cheek softened. There are, in fact, several reworkings of the left foot, upon which, in the final painting, Michelangelo directs our attention, to the fulcrum upon which she turns from her pagan past to the Christian present.

━━━━━━

A revival of fresco painting occurred in the 1920s, when the new revolutionary Mexican government decided to support a public mural project that would teach and inform the public about revolutionary history. Diego Rivera's *Sugar Cane* (Fig. 327) is such an example, and shows the suppression of workers by the landowners on the one hand, and at the same time, the nobility of the suppressed.

Tempera

Until the end of the Middle Ages, most paintings were done in tempera, a medium made by combining pigment with water and a gummy material such as egg yolk. The paint was carefully applied with a fine brush and colors could not be readily blended because the paint dried too fast; thus, in order to create the effect of chiaroscuro, the artist had to carefully hatch or crosshatch the paint. The painting surface (often a wood panel) had to be prepared with a ground similar to plaster, and **gesso**, a mixture of glue and plaster of Paris or chalk, was often used. The gesso surface was very absorbent and the tempera paint would fuse with the surface to create a very durable and vibrant surface.

Botticelli's *Primavera* (Fig. 328) is an outstanding example of tempera painting. Tempera paint could be thinned to a transparent glaze, which enabled Botticelli to

effectively describe the sheer gowns worn by the subjects. Botticelli used undercoats of black for the trees and white for the figures, building the glaze colors upon them.

The type of detail that an artist can attain with tempera is readily apparent in Andrew Wyeth's *Braids* (Fig. 329). Seemingly each strand of the model's hair is revealed individually in the painting.

Oil Painting

Oil paint is a far more versatile medium than tempera. It can be blended on the painting surface to create a continuous scale of tones and hues, many of which were previously not possible. The painter was able to render extremely subtle changes in light and achieve the most realistic three-dimensional effects, rivaling sculpture. Oil paintings were slow to dry, so unlike fresco or tempera, artists could work almost endlessly to perfect their images.

The Master of Flémalle (probably Robert Campin) was the first to recognize the realistic effects that could be attained with the new medium. The *Merode Altarpiece* (Fig. 330) is an example of a fully realized Flemish interior executed in the oil medium. Campin's contemporary, Jan van Eyck, developed oil painting even further. In his *Madonna of Chancellor Rolin* (Fig. 331), van Eyck demonstrates his skill at both realizing the effects of atmospheric perspective (applying a haze-like softness to objects that recede from the viewer) and rendering the visible world in exact detail.

By the time the Netherlands freed itself from Spanish rule in 1608 it had become, through trade, the wealthiest nation in the world. Artists became extremely skillful at representing the new material riches through the medium of oil paint. Jan de Heem's *Still Life with Lobster* (Fig. 332) exemplifies this trait, showing us the remains of an extravagant meal. Van Heem uses the **glazing** technique, building up thin films of transparent color to give the entire work a luminous and extremely realistic quality.

The more real a painting appears to be the more it is said to be an example of *trompe l'oeil*, a French phrase meaning "deceit of the eye." René Magritte's *Euclidean Walks* (Fig. 333) depicts a "painting within a painting" set in front of a window so that it hides, but exactly duplicates, the scene outside. The painting confuses the interior of the room with the exterior landscape and, by analogy, the world of the mind with the physical world.

Since its inception, the expressive potential of the oil medium has also been explored. Oil paint allowed the artist more of a spontaneous approach to the image than did tempera or fresco, and often revealed the artist's actual touch or involvement in the painting much more readily. In Susan Rothenberg's *Biker* (Fig. 335), the expressive swirls and dashes of paint enable us to see a biker charging straight at us. This type of energy and movement seems best described by the expressive agitation of the brushstroke and the glimmering color.

Where Rothenberg begins with a source or "thing seen" for her painting, Pat Passlof begins with abstraction. She begins to paint without a plan. Her work *Dancing Shoes* (Fig. 335) came into being when she distributed paint left over from an earlier smaller work randomly over an 11-foot canvas. The result suggested a choreography of short leaps and intervals.

131

OVERVIEW

Many of Pasloff's attitudes about painting are a direct reflection of her association with New York painters such as Willem de Kooning. De Kooning's *Door to the River* (Fig. 336) has no reference to visual reality at all. He described the subject matter of his painting and others like it as a mixture of raw sensations.

=====

Works in Progress
Milton Resnick's *U + Me*

The development of a series of six large paintings executed by Resnick over the course of eight months in 1995 are the subject of another *Works in Progress* video. See the first VIEWING GUIDE of the two included in this study guide lesson.

=====

Watercolor

Of all the painting media, watercolor is potentially one of the most expressive. Watercolor paintings are made by applying pigments suspended in a solution of water and gum arabic to dampened paper. Working quickly, an artist can realize very spontaneous and gestural effects, similar to those attained with brush and ink. Winslow Homer's *A Wall, Nassau* (Fig. 339) is a work that illustrates the various effects that can be attained with watercolor. Homer has used both thin transparent washes and rich opaque areas of heavy pigment.

It is worth comparing Homer's work with John Marin's *Sunset* (Fig. 340). Marin's style is much more expressive. Homer's painting has fine delicate lines

which could only be attained with a fine tipped brush. Marin, by contrast, uses quick, energetic bold strokes. *Sunset* is painted in a modern style, reflecting the modern age speed and energy. Expressive energy is revealed in Georg Baselitz's *Untitled* work (Fig. 341) from 1981. Baselitz seems to have painted a sunset or landscape similar in style to Marin's painting, until we realize he has painted a man singing into a microphone—upside down. He wants us to see the painting as a painting, subject matter aside.

Gouache

Gouache is essentially watercolor mixed with white chalk. The medium is opaque, and while this quality results in a light-reflecting brilliance, it is difficult to blend brushstrokes together. For this reason gouaché lends itself to the painting of flat-colored forms. In Jacob Lawrence's *You can buy bootleg whiskey* (Fig. 342), the artist uses the medium to describe the figures in flat angular shapes, creating a sense of disorientation and drunken imbalance, while also emphasizing the flat two-dimensionality of the painting's space.

Synthetic Media

The first artists to experiment with synthetic media were a group of Mexican painters led by David Alfaro Siqueiros, whose goal was to create large-scale revolutionary art. Painting outdoors, Siqueiros, Diego Rivera, and José Clemente Orozco first worked in fresco, then oil paint, but found that the weather soon ruined their efforts. In 1937, Siqueiros organized a workshop in New York close to the chemical industry, expressly to develop and experiment with new synthetic paints. One of the

first media used at the workshop was pyroxylin, commonly known as Duco, a lacquer developed as an auto paint. Siqueiros's *Cuauhtémoc Against the Myth* (Fig. 343) is a huge 1000 square-foot panel using Duco.

In the early 1950s, Helen Frankenthaler gave up the gestural qualities of the brush loaded with oil paint and began to stain raw, unprimed canvas with thinned oil pigments, soaking color into the surface. The technique appealed to painters such as Morris Louis who was experimenting with Magna, a paint made from acrylic resins mixed with turpentine. The thinned oil mixture Frankenthaler used left a brownish "halo" around the painted areas on the canvas, which didn't occur with Magna.

Soon after, researchers in Mexico and the United States discovered how to mix acrylic resins with water, and by 1956 water-based acrylic paints were readily available. Louis's *Blue Veil* (Fig. 344) consists of multicolored translucent washes of acrylic thinned with water.

Frankenthaler quickly moved to staining canvases with water-based acrylic, and with this new medium she was able to create intensely atmospheric paintings such as *Flood* (Fig. 345). Placing the canvas on the floor and pouring the paint directly on from overhead, Frankenthaler was able to give a sense of spontaneity to even a large painting. According to Frankenthaler, "A really good picture looks as if it's happened all at once. . . . It looks as if it were born in a minute." This sense of spontaneity manifests itself as a sort of aggressive good humor in poured pieces such as *Contraband* (Fig. 346) by Lynda Benglis. Her liquid rubber materials find their own form as they spill directly onto the floor.

THE CRITICAL PROCESS
Thinking about Painting

Consider the different painting media that were used and why artists have favored them. One factor has been the desire to represent the world more faithfully, but accurate representation is not the only goal of painting. Some painting media—oil paint, watercolor, and acrylics—are better suited to expressive ends than others because they are more fluid or can be manipulated more easily.

Judith F. Baca, whose mural for the University of Southern California student center was discussed in Chapter 9, created the *Great Wall of Los Angeles* (Fig. 347), a mile-long mural in the concreted-over Tujunga Wash of the Los Angeles River. The river, as a result, seemed to Baca "a giant scar across the land which served to further divide an already divided city." She thought of her mural, which would depict the history of the indigenous peoples, as a healing gesture: "Just as young Chicanos tattoo battle scars on their bodies, *Great Wall of Los Angeles* is a tattoo on a scar where the river once ran." Baca worked with four hundred inner-city youths, many of them recruited through the juvenile justice system, who did the actual painting and design. They represented the divided city itself. "The thing about muralism," Baca says, "is that collaboration is a requirement... [The] focus is cooperation."

Consider why Baca chose acrylic paint as opposed to oil or fresco. How is it also expressive? What is denoted, and what are its connotative implications? How does Baca's collaborative working method relate to the work's connotative suggestiveness? Finally, in what ways does it share many of the same aims as Giotto's *Madonna and*

VIEWING GUIDE
to *Works in Progress: Milton Resnick*

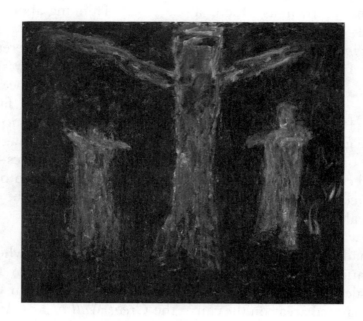



Milton Resnick
Biographical Sketch

Milton Resnick was born Rachmiel (nicknamed Milya) Resnick in Bratslav, Rodolia, Ukraine, on January 8, 1917. His family emigrated to the United States when Resnick was 5 years of age, landing on Ellis Island and settling in Brooklyn, New York. Rachmiel attended public school, where a teacher renamed him Milton, after his nickname Milya. When he was 14, he enrolled in the commercial art program at the Pratt Institute Evening School of Art in Brooklyn, but was advised by his teacher to transfer to fine arts. The next year, in 1933, he transferred to the American Artists' School in New York, where one of his classmates was Ad Reinhardt, who would later become an abstract expressionist painter like himself.

In 1934, when Resnick told his father that he wanted to be a painter, his father replied, "Not and live in my house." Resnick moved out, working as an elevator boy to support his studies at the American Artists' School, where he was given a small room to paint in, using materials left by night school students, since he could not afford to buy his own.

In 1938, he moved to a studio on West 21st Street, near Willem de Kooning, with whom he would maintain a close relationship through the 1960s. In 1940, at the outbreak of World War II, he was drafted into the Army and served in Iceland and Europe, and after the War he lived for three years in Paris, where he met Alberto Giacometti and Constantin Brancusi, among others. In 1948, he returned to New York, and with his remaining G.I. benefits enrolled in abstract expressionist painter Hans Hofmann's school. He rented a studio on East 8th Street, near



Jackson Pollock, de Kooning, and Franz Kline, and in September met Pat Passlof, whom he married in 1961, and who remains a close companion and deep influence to the present.

Throughout the 1950s and 1960s, Resnick gained recognition as an abstract painter, becoming one of the first New York painters to have a very large working space. In 1976, he purchased the abandoned synagogue where he still works and lives on Eldridge Street on New York's lower east side, around the corner from Pasloff's Forsyth Street studio, another abandoned synagogue which they purchased in 1963. Resnick's work is in most major American colletions, including the Metropolitan Museum of Art , the Museum of Modern Art, the Whitney Museum of American Art, the National Gallery of Art, the National Museum of American Art, and the Walker Art Center in Minneapolis.

Summary and Introduction

Works in Progress: Milton Resnick opens in February 1996, with Resnick entering the Robert Miller Gallery on East 57th Street in New York City during an exhibition of six new paintings, all entitled *U + Me*. Soon we flash back to eight months earlier, to the morning in June 1995, after Resnick first put paint to all six canvases. In the course of the video, we see the paintings at four different stages—on that first morning, then the next day, where we watch as Resnick paints on the canvas reproduced in **A World of Art** (Fig. 337) and are witness to the remarkable progress Resnick has made overnight on all six paintings, then to a point five months later, in November, where the paintings are very close to their final form, and finally to their appearance at the Robert Miller Gallery.

The theme of the paintings is Adam and Eve in the Garden of Eden. Feeling that the title "Adam and Eve" was too specific, Passlof suggested that the figures were really just "you and me." Resnick liked the way that the story of the Garden was extended in this manner to all of us, and so he retitled the series *U + Me*, changing the spelling, he said, "because it's easier." All six of the paintings include two figures and a tree, and all but two also include a serpent.

As an abstract painter, Resnick had ceased painting the figure in the late 1940s and was working hard to eliminate all referential aspects of his painting. Throughout the 1950s he painted large, deeply impastoed canvases in which any reference to figure or landscape was removed. Their surface was a continuous field of color and brushwork. Following the logic of this removal of content from his canvases, in 1963 his work became monochromatic, as a painting entitled *Leaving Color* announced. Throughout the 1960s, 1970s, and into the 1980s, as he pursued this direction, he was considered one of "the best pure painters around," an artist continuously exploring the possibilities of "paint as paint."

The figure reemerged in Resnick's work in the early 1990s. He was no longer able to stand in front of large canvases for long periods of time, and Pat Passlof suggested that he get a model and draw. These drawings soon led to a series of small paintings entitled *The Judgment of Paris*, which were in turn quickly followed by paintings with two figures in

them that he began to think of as Adam and Eve. The paintings remain largely abstract. Detail is not important, and as the figures lose their particularity, becoming as much distinctive shapes in the field of Resnick's brushwork as actual figures, they move not only to the very edge of complete abstraction but also toward the universality that Resnick's *U + Me* title implies. Because they are figures on a ground, nevertheless, they introduce a new element of tension into Resnick's work. They suggest three-dimensional depth, the space of landscape, even as, in their brushwork, they remain flat.

Ideas to Consider

1) An important aspect of Resnick's working process is one of layering. Between Day 1 and Day 2, we are witness to a remarkable change in all of Resnick's paintings, but the change in the canvas at the end of the studio is particularly marked. Can you describe that change?

2) Between Day 2 and the next time we see the canvas at the end of the studio, five months later, the canvas has changed remarkably again. Can you describe this change?

- How have the figures changed? Does this make the composition more or less static? Can you surmise why Resnick wants to push the canvas in this direction?

- Resnick calls it "stupid" to put a tree in the middle of the canvas. Why? How does this placement affect the symmetry of the composition? Does this make the canvas more or less static?

3) As we witness Resnick painting, we hear him talk about his working process, especially his physical relation to the canvas. Compare Resnick's attitudes to Jackson Pollock's as described in Chapter 8 on pp. 148-49.

4) Resnick, like Pollock and Willem de Kooning, is considered an abstract expressionist. In what ways is his work "expressive"? What does it express?

Frequently Asked Questions

How much was the Robert Miller Gallery asking for Resnick's U + Me *paintings?* The average price at the exhibition was $70,000. Artists usually receive approximately 50 percent of their gallery's proceeds from sales.

Resnick uses so much paint—how does he get it all? Because they were using so much paint, and because buying it by the tube was both expensive and inconvenient, in the 1950s, Resnick, Passlof, de Kooning, and others ground their own pigment and made paint together in a large industrial barrel grinder purchased by Resnick. Resnick later gave the grinder to Carl Plansky, founder of Williamsburg Paints in Virginia. In return, Plansky continues to provide Resnick with cases of finely ground handmade oil paints.

NAVIGATING *A World of Art*: THE CD-ROM

The *World of Art* CD-ROM contains two doorways in the Visual Demonstrations Room that will help you to understand the material in Chapter 12, "Painting."

Oil Painting: Pigment One entire interactive pathway is dedicated to a QuickTime video of the traditional technique of making paint. Move the pointer to the directional arrow and hold down the mouse button as the room spins until the Oil Painting: Pigment doorway appears. Stop, then double-click on the doorway, and the Oil Painting: Pigment demonstration area will open.

This QuickTime video consists of a demonstration of the traditional way of making paint. Obviously many artists simply buy their paint already made in tubes (Resnick, for instance, today buys his paint in tubes). But by making their own paint, artists can more thoroughly control not only the quality of their paint, but its color, intensity, and key.

Oil Painting: Color Mixing Another entire interactive pathway is dedicated to a QuickTime video of the process of mixing color. Move the pointer to the directional arrow and hold down the mouse button as the room spins until the Oil Painting: Color Mixing doorway appears. Stop, then double-click on the doorway, and the Oil Painting: Color Mixing demonstration area will open.

Here we watch as oil pigments are mixed both on the palette and on a canvas in another QuickTime video demonstration. It may help you to refer again to the color wheels in the chapter on color to understand the ways in which colors are created in this demonstration.

REVIEW QUESTIONS

1. In her *Self-Portrait*, Artemisia Gentileschi represents herself as

 a) a real woman.
 b) *La Pittura*.
 c) a copyist.
 d) the idealized personification of artistic genius.
 e) all of the above.

2. Fill in the blanks in the following description of painting with the appropriate words:

 In painting, artists use _____ , or powdered colors, suspended in _____ that holds the particles of pigment together, and, in turn, serves as an adhesive to anchor the paint to the _____, or the surface upon which the artist paints.

3. What is paint made by combining pigment with hot wax called?

4. What is paint made by suspending pigment in a solution of gum arabic and water called?

5. What is the solvent or vehicle utilized in oil painting?

6. There are two kinds of fresco: name them. Which was used by Leonardo to paint *The Last Supper*? What has turned out to be the disadvantage of his choice?

7. A smooth ground must be prepared for tempera painting. What is the most common ground used?

8. What is painting with thin films of transparent color in oil painting called?

9. Why did Mexican muralists turn to synthetic media, abandoning oil painting?

SUPPLEMENTAL ACTIVITIES AND WRITING ASSIGNMENTS

Supplemental Activities: Go to your local museum and study the painting collection. Without looking at the labels on the works, see if you can distinguish among the various painting media. Then look at the labels. Consider not only the "look" of the various works—the way that watercolor, for instance, is obviously different from oil painting—but the era in which the works were painted—you know, for instance, that oil painting wasn't invented until the early fifteenth century. You should pay particular attention to synthetic media—can you see anything that makes acrylic paintings look different than oil paintings? Are there any instances where acrylics, diluted heavily with water, look like watercolor?

The Website: Go to the *World of Art* website (**www.prenhall.com/sayre**). Proceed through the Chapter 12 materials. Consider your command of the objectives as stated in the website. Take the multiple choice and fill-in-the-blanks self-tests. Briefly respond to both the critical analysis and the compare and contrast questions, either formally or informally. Visit the related sites linked in both the Modern Artists and Galleries and Museums areas. A hands-on project related to the course material is suggested. Even if you are not assigned the Project, think about how you might approach it. Finally, consider participating in the Message Board or Chat Discussions.

Writing about Painting: In order to grasp some of the expressive and emotional power that abstract painters are able to muster, it is useful to compare and contrast Milton Resnick's *U + Me* (Fig. 338) and Albrect Dürer's *Adam and Eve* (Fig. 300). Consider not only the formal aspects of the two pieces—how does painting differ from engraving?—but what each artist chooses to portray in the Adam and Eve story (and be sure to consider the effect of Resnick's choice of a title).

Writing to Explore New Ideas: What implications does René Magritte's use of *trompe l'oeil* in his *Euclidean Walks* (Fig. 333) have for the question of representation and *mimesis*? That is, how does it undermine or question itself? How does Magritte's *This Is Not a Pipe* (Fig. 16), which we saw in Chapter 2, inform the painting? Be sure to consider the difference between two- and three-dimensional space.

Suggested Further Reading: Richard Wollheim's *Painting as an Art* (Princeton, N. J.: Princeton University Press, 1987) is the classic text on painting.

One of the most readable accounts of abstract expressionism is April Kingsley's *The Turning Point: The Abstract Expressionists and the Transformation of American Art* (New York: Simon & Schuster, 1992).

A fictionalized account of a day in the life of Claude Monet in 1900, which gives a compelling account of the painter's working process, is Eva Figes's novel *Light* (New York: Ballantine, 1983).

Study Guide Lesson for

Chapter 13
Sculpture

LEARNING OBJECTIVES

This lesson will help you understand the various three-dimensional media and how artists employ them. At the end of this chapter you should be able to:

1) Define the subtractive and additive sculptural processes.

2) Describe the lost-wax casting process.

3) Differentiate between low-relief, high-relief, and in-the-round sculpture.

4) Define what earthworks are.

KEY CONCEPTS

subtractive processes
additive processes
replacement processes

low (bas-) relief
high (haut-) relief
sculpture in-the-round

carving
modeling
casting
lost-wax process
 investment
assemblage
construction
earthworks

STUDY PLAN

Step 1: Read Chapter 13, "Sculpture," in your text, *A World of Art*, pp. 259-79.

Step 2: Attempt to answer the questions posed in the CRITICAL PROCESS section at the end of the chapter. Don't worry if you find that you have a difficult time. Proceed to the next step.

Step 3: Read the OVERVIEW of Chapter 13 in this study guide lesson. When a specific work of art that is illustrated in the text is discussed, try to visualize it. If you are unable to remember it, open the text to that illustration and refresh your memory.

Step 4: Complete the suggested CD-ROM assignment for Chapter 13 outlined in this study guide lesson.

Step 5: Return to the LEARNING OBJECTIVES and KEY CONCEPTS sections at the beginning of this study guide lesson. Demonstrate your mastery of each of the learning objectives. Define each of the concepts—each is discussed in the text and each appears in the glossary at the end of your text as well.

Step 6: Return to the CRITICAL PROCESS section at the end of the chapter. Having reviewed the material, attempt to answer the questions again. Turn to the back of the text, p. 513, and compare your answers to those provided by the author.

Step 7: Answer the REVIEW QUESTIONS. Complete the assigned SUPPLEMENTAL ACTIVITIES and WRITING ASSIGNMENTS in this study guide lesson.

Step 8: Pursue any title from the SUGGESTED FURTHER READING that is assigned or that interests you.

OVERVIEW
of Chapter 13 - "Sculpture"
A World of Art

Chapter 13 concerns itself with three-dimensional objects and the space they occupy. Central to this study is the oldest and most enduring of all the arts—sculpture. All of the sculpture considered in this chapter use one of two basic approaches—**subtractive**, where material is removed from an original block, as in carving; or **additive**, where the form is built up by adding material to the form, such as clay. Casting (or **replacement** process) is a separate process unto its own, and earthworks are often both additive and subtractive in nature.

The Greeks perfected **relief** sculpture, which is intended to be seen from one side only. Relief sculptures were often used on Greek buildings, particularly as friezes (decorative bands) or on the pediments (triangular gables) of their temples. Forms and figures carved in relief are done in either **low (bas-) relief** or **high (haut-) relief**. The *Maidens and the Stewards* (Fig. 348) from the Parthenon in Athens is an example of low relief. The figures project out very little from their background. By contrast, *Atlas Bringing Herakles the Golden Apples* (Fig. 349) from the Temple of Zeus, is an example of high relief—the figures project out more than half their circumference. The Parthenon frieze exhibits much greater naturalism than *Atlas*, and even though the work is low relief, the space seems deeper because the figures are shown in three-quarter view.

Perhaps because the human figure has always been a chief subject for sculpture, movement is one of the defining characteristics of the medium. Sculpture **in-the-round** literally demands movement. We must walk around it in order to see the form in its entirety. Giovanni da Bologna's *Rape of the Sabine Women* (Fig. 350) is impossible to represent from a single photograph. To see the sculpture, one must be able to move around it completely.

From different points of view, David Smith's *Blackburn: Song of an Irish Blacksmith* (Figs. 351 and 352) seems like two different works of art. By experiencing sculpture from many vantage points, one can begin to understand how sculpture might be considered a "kinetic" medium—the work takes on more meaning as one moves about it.

Carving

Carving is a subtractive process. In carving, material such as stone or wood is removed or subtracted from a block of raw material in order to reveal the form inside. Michelangelo wrote, "The best artist has no concept which some single marble does not enclose within its mass." Carving is a difficult process, and even Michelangelo would occasionally give up. The unfinished *Atlas* (Fig. 353) allows us to see the "subtractive" process as if it were still in progress.

Nativity, by Patrocinio Barela (Fig. 354), is carved out of juniper, and the forms are dependent upon the original shape of the wood itself. The lines of his figures follow the natural contours of the wood and its grain. The images of saints, carved from

local juniper wood by Barela, attempt to tie the local world into the universal realm of religion.

This desire to unify the material world and the spiritual world has been a goal of sculpture from the earliest time. Larger than life Egyptian funerary statues were intended to bear the *Ka*, or principal soul of the deceased. The permanence of the stone was thought to ensure eternal life. For the Greeks, what tied the world of the gods to humanity was beauty itself, and a premier example of this was the perfectly proportioned male body. While Greek sculpture was indebted to Egyptian sculpture, the Greeks quickly progressed to a much more naturalistic style.

Compared to the Egyptian *Menkaure and His Wife, Queen Khamerernebty* (Fig. 355), the Greek *Kouros* (Fig. 356) is much less rigid and more lifelike. The weight of his body is centered on his left leg, a principle called *ponderation*, or "weight shift." The resulting sense of movement created around the axis of the spine is **contrapposto**, meaning "counterpositioning." The *Kouros* seems capable of movement, but even more dynamic is the *Hermes and Dionysos* (Fig. 357), by Praxiteles.

The Kouros is an example of freestanding sculpture, or sculpture in-the-round. The crowning achievement of Greek naturalism is perhaps the *Three Goddesses* (Fig. 358), originally from the east pediment of the Parthenon. The drapery is so masterfully carved that it brings to life the human figures beneath.

Modeling

The manipulation of clay by hand—pinching, bending, kneading, rolling, and shaping—are the basic gestures of modeling. Clay, a natural material found worldwide, has been used by artists to make everything from pots to sculptures since the earliest times. The creation of objects from clay that are fired are called "ceramics." Robert Arneson's *Case of Bottles* (Fig. 359) is a ceramic sculpture.

Historically, the Chinese have excelled at ceramics, particularly porcelains of fine white clay—hence, we call our best dinnerware "China." The most masterful display of Chinese ceramic art, however, was discovered in 1974 when the tomb of Shih Huang Ti was uncovered accidentally. Shih was buried with over 6000 life-size ceramic figures of soldiers and horses (Fig. 360), serving as immortal bodyguards to the emperor.

Casting

When sculptor Henry Moore visited Greece, he was enthralled by the use of drapery in classical sculpture. He made several draped figures, seeking to capture the same essence he had witnessed in the Greek works.

Moore's *Draped Reclining Figure* (Fig. 361) is cast in bronze. Casting is an invention of the Bronze Age (beginning approx. 2500 B.C.E., where it was first used to make utensils by pouring liquid bronze into open-faced molds (very much like gelatin molds). The Greek *Girl Running* (Fig. 362) is an example of a bronze sculpture made by pouring bronze into a mold made from an original.

In the kingdom of Benin, in Nigeria, brass casting reached an extraordinary level of sophistication by the fourteenth century. The "Oba" head (Fig. 363) is an example of the intricate detail that is possible in one of the most enduring casting processes—**lost-wax,** or **cire-perdue,** which was perfected by the Greeks).

OVERVIEW

The Greek *Girl Running* (Fig. 362) is solid cast. This is fine for small works, but the weight and cost of the bronze made hollow, rather than solid, castings essential. The Greeks perfected hollow casting by the fifth century B.C.E. Text images depicting the basic process (Figs. 364-366) are from the *Encyclopedia of Trades and Industries*, published in the eighteenth century by Denis Didorot. A brief description follows:

1) The sculpture is first modeled from a pliable material such as clay, wax or plaster.

2) A mold is then made of the original, either in plaster or in a soft gel-like material such as synthetic rubber. When it is removed, a negative impression (mold) of the original is revealed.

3) Wax is then poured or brushed into the negative mold to the desired thickness of the bronze.

4) The space inside this hollow lining is filled with investment, a combination of water, plaster and ground-up pottery.

5) The outer mold is now removed, and rods of wax are attached to the wax, sticking out from it like "giant hairs."

6) The entire structure, including the wax rods, is then encased in investment material, with only the ends of the wax rods visible.

7) The investment is placed into a kiln, where the temperature is gradually brought up until the wax rods melt, leaving tunnels or vents that allow all the wax, including that of the sculpture, to "burn out" of the investment, hence "lost-wax."

8) The heated investment "mold," void of wax, is now removed from the kiln, and molten bronze is poured into the casting gate—the large opening in the top of the investment.

9) Once the investment mold has cooled, it is chipped away from the bronze structure, revealing the sculpture fully realized in bronze. The surface is ready to be cleaned up and finished.

Because lost-wax casting replaces the wax with bronze, it is often referred to as **replacement** process.

Large pieces such as Moore's *Draped Reclining Figure* (Fig. 361) are cast in several pieces and welded together. The Greeks took advantage of the malleability of the metal and pounded their sections together. When Moore saw the torso section of the reclining figure, he realized it had a completeness all of its own. He then had a wax copy made of it and reworked it into the *Draped Torso* (Fig. 367).

Assemblage

David Hammons's *Spade with Chains* (Fig. 368) is an example of **assemblage,** another additive sculptural process. Hammons has combined found materials — a garden spade and a set of chains—into a face that recalls an African mask. This transformation of common materials into art is one of the most defining characteristics of assemblage. The piece works effectively at a cultural level, as Hammons uses two symbols of slave labor, the shovel and the chain, to create the image of the mask, a reaffirmation of the American slave's African heritage.

Clyde Connell's sculpture *Swamp Ritual* (Fig. 369) is fabricated of parts of rusted tractors and machines, discarded building materials, logs, and papier-maché, which Connell found well suited to binding the wood and iron elements of her work together.

Connell was inspired by another assembler of nontraditional materials, Eva Hesse. Connell was impressed with Hesse's desire to make art in the face of all odds. Before the women's movement of the early

1970s, Hesse was a feminist. She strove to refute the stereotypical roles that society had placed on women. Although hopelessly ill with a brain tumor in 1969, Hesse was still producing works such as *Contingent*, a series of suspended floating "ethereal, sensitive, fragile" forms. Connell sensed in the work of Hesse an obstinate insistence on being: "No matter what it was" she said of Hesse's work, "it looked like it had life in it." While Hesse's and Connell's pieces are assembled from many parts, they seem unified and coherent wholes.

━━━━━━━━━

Works in Progress
Eva Hesse's *Contingent*

Contingent (Fig. 358) was one of the last four pieces made by Eva Hesse before her death in 1970. It reflects Hesse's enduring drive to succeed in the face of illness, as well as her feminist sensibilities. In 1965, she wrote, "A woman is sidetracked by all her feminine roles. She's at a disadvantage from the beginning. She also lacks the conviction that she has the 'right' to achievement."

Hesse first sketched the work in a drawing. Initially, she conceived of the work flat against the wall. By the time she did her test piece, she had turned it sideways, hanging out from the wall. The final work consists of eight cheesecloth and fiberglass panels that catch light in different ways, producing different colors. The panels seem to hang ponderously and yet feel as if they could float effortlessly away. In Hesse's own statement about the work she says, "They are tight and formal but very ethereal. sensitive. fragile. . . . I have learned that anything is possible. I know that. That vision or concept will come to

me through total risk, freedom, discipline. I will do it." *Contingent* embodies Hesse's personal strength.

━━━━━━━━━

Earthworks

Since the 1960s a focus of contemporary art has been large outdoor environments. Nancy Holt's *Sun Tunnels* (Figs. 373 and 374) consists of four 22-ton concrete tunnels aligned with the rising and setting sun during the solstices. The pattern of the holes cut into the tunnels duplicates constellations, and the size of each hole is based on the brightness of each star it represents. The work is designed to be experienced on site, imparting to viewers a sense of their own relationship to the cosmos.

Near Quevado, New Mexico, Walter de Maria created *The Lightning Field* (Fig. 375). Consisting of 400 large vertical steel poles, the work is activated by thunderstorms that frequent the region. During these times lightning jumps from pole to pole across the grid in a stunning display of pyrotechnics. Visitors may or may not experience the poles activated by lightning, but they still can experience the space and sense of the vastness and emptiness around them, a limitless freedom and time without end: a feeling of the sublime.

Work of this scale indicates that art can have much in common with landscape, and some artists, such as Beverly Pepper, are starting to design landscape. Pepper's *Cromlech Glen* (Fig. 376) consists of large mounds traversed by stone steps. Responses vary—from those who see it as an almost "religious" site, to children who climb up the hills as if they're playground equipment.

OVERVIEW

THE CRITICAL PROCESS
Thinking about Sculpture

Compare Anthony Caro's *Early One Morning* (Figs. 377 and 378) made of industrial materials, to Beverly Pepper's earthwork, *Cromlech Glen* (Fig. 376). *Early One Morning* boldly declares itself separate from the natural world, the exact opposite of a work like Pepper's. Consider how different objects relate to interior and exterior spaces. Caro did not think of this work in any context other than an interior room. Would *Early One Morning* lose its force in a sculpture garden? What do the two works have in common? What do you make of the title? Caro was influenced at the time by the work of David Smith. How does *Early One Morning* compare to Blackburn: *Song of the Irish Blacksmith* (Figs. 351 and 352)? How would you describe each of the two views of the piece as depicted here? If the work is an assemblage of disparate elements, what prevents them from becoming chaotic. What unifies the work?

How are Smith's and Caro's works fundamentally different? If Smith's is figurative, or at least anthropomorphic, how would you describe Caro's? Finally, what does Caro's work gain by resting on the ground instead of a base?

NAVIGATING *A World of Art*: THE CD-ROM

The *World of Art* CD-ROM contains one doorway in Visual Demonstrations Room that will help you to understand the material in Chapter 13, "Sculpture."

Lost-Wax Bronze Pour One entire interactive pathway is dedicated to a QuickTime video of what is probably the most difficult to describe of all sculpture-making techniques. Move the pointer to the directional arrow and hold down the mouse button as the room spins until the Lost-Wax Bronze Pour doorway appears. Stop, then double-click on the doorway, and the Lost-Wax demonstration video will open.

The QuickTime video consists of a demonstration of the making of part of sculptural installation by artist Tom Morandi. As you view the process, follow along in the accompanying text block.

REVIEW QUESTIONS

Answers to the following questions appear in the APPENDIX: ANSWER KEY at the end of the *Study Guide*.

1. What is the difference between low and high relief?

2. There is a marked difference between Egyptian sculpture and Greek sculpture. What is the primary difference?

3. In bronze casting, the outer mold that covers the wax cast before the burnout and into which the molten bronze is poured is called

 a) a casting urn.
 b) a burnout mold.
 c) the investment.
 d) the casting gate.

4. Casting is

 a) a subtractive process.
 b) an additive process.
 c) a modeling process.
 d) a replacement process.

5. How does a construction differ from an assemblage?

SUPPLEMENTAL ACTIVITIES AND WRITING ASSIGNMENTS

Supplemental Activities: Assemblage, as a means of working, requires recontextualizing found objects and pieces of objects. They are refashioned into a work of art. Marcel Duchamp's *Fountain* (Fig. 714) is an even clearer example. See if you can find an object or objects that you can redefine as art by manipulating the object(s) into a sculptural assemblage piece, or by simply calling your object(s) art and displaying your piece(s) as art. It is sometimes fun to mount an exhibition of such pieces collected by you and other friends or students.

The Website: Go to the *World of Art* website (**www.prenhall.com/sayre**). Proceed through the Chapter 13 materials. Consider your command of the objectives as stated in the website. Take the multiple choice and fill-in-the-blanks self-tests. Briefly respond to both the critical analysis and the compare and contrast questions, either formally or informally. Visit the related sites linked in both the Modern Artists and Galleries and Museums areas. A hands-on project related to the course material is suggested. Even if you are not assigned the Project, think about how you might approach it. Finally, consider participating in the Message Board or Chat Discussions.

Writing about Sculpture: Many aspects of our environment are sculptural—think, for instance, of everything from playgrounds to many homes and buildings. What, in your estimation, distinguished something that's *sculptural*—i.e., possessing some or all of the characteristics of sculpture—from sculpture proper? Give examples from your own environment. How does this distinction help us arrive at a definition of art itself?

Writing to Explore New Ideas: Earthworks such as Walter de Maria's *Lightning Field* (Fig. 375), *Las Vegas Piece* (Fig. 280), also by de Maria, and Robert Smithson's *Spiral Jetty* (Fig. 6), all raise serious ethical concerns. What does it mean to permanently (or semi-permanently) transform the landscape? How do you suppose environmentalists react to such work? How do they compare to other human endeavors to alter the landscape, such as golf courses, dams (such as Lake Powell), or even ecologically driven intrusions into the environment (such as stream diversions or habitat building)? What does it mean for art to have ethical ramifications?

Suggested Further Reading: The classic text on earthworks is John Beardsley's *Earthworks and Beyond: Contemporary Art in the Landscape* (New York: Abbeville, 1984).

Many of the themes of this chapter have been articulated by Rosalind Krauss in her book *Passages in Modern Sculpture* (New York: Viking Press, 1977).

Chapter 14
Other Three-Dimensional Media

LEARNING OBJECTIVES

This lesson will help you understand the various three-dimensional media and how artists employ them. At the end of this chapter you should be able to:

1) Distinguish between so-called "craft" media and traditional art media.

2) Describe the methods of ceramic construction and the three basic types of ceramics.

3) Describe the elements involved in weaving and embroidery.

4) Define the three major forms of mixed-media art—collage, installation, and performance art.

KEY CONCEPTS

craft media

ceramics
 firing
 glazing
 slab construction
 coiling
 throwing
 potter's wheel
 earthenware
 stoneware
 porcelain

glassblowing
metal
wood

fiber
 weaving
 warp and weft or woof
 tapestry
 embroidery

mixed media
 collage
 photomontage
 installation
 Happenings
 performance art

STUDY PLAN

Step 1: Read Chapter 14, "Other Three-Dimensional Media," in your text, *A World of Art*, pp. 280-308.

Step 2: Attempt to answer the questions posed in the CRITICAL PROCESS section at the end of the chapter. Don't worry if you find that you have a difficult time. Proceed to the next step.

Step 3: Read the OVERVIEW of Chapter 14 in this study guide lesson. When a specific work of art that is illustrated in the text is discussed, try to visualize it. If you are unable to remember it, open the text to that illustration and refresh your memory.

Step 3: Read the VIEWING GUIDE to *Works in Progress: Goat Island* in this study guide lesson.

Step 4: View the video *Works in Progress: Goat Island*, following the VIEWING GUIDE as you watch. Take notes and jot down ideas in response to the VIEWING GUIDE. Your instructor may require you to hand in written responses, formal or informal, to some or all of the topics that the VIEWING GUIDE sets out for your consideration. View the video a second time if necessary.

Step 5: Return to the LEARNING OBJECTIVES and KEY CONCEPTS sections at the beginning of this study guide lesson. Demonstrate your mastery of each of the learning objectives. Define each of the concepts—each is discussed in the text and each appears in the glossary at the end of your text as well.

Step 6: Return to the CRITICAL PROCESS section at the end of the chapter. Having reviewed the material, attempt to answer the questions again. Turn to the back of the text, p. 513, and compare your answers to those provided by the author.

Step 7: Answer the REVIEW QUESTIONS. Complete the assigned SUPPLEMENTAL ACTIVITIES and WRITING ASSIGNMENTS in this study guide lesson.

Step 8: Pursue any title from the SUGGESTED FURTHER READING that is assigned or that interests you.

OVERVIEW
of Chapter 14 - "Other Three-Dimensional Media"
A World of Art

Chapter 12 ended with a discussion of Lynda Benglis's work *Contraband* (Fig. 346), a "painting" which because of its three-dimensional nature, could be considered as sculpture. Marcia Gygli King's *Springs Upstate* (Fig. 379) is another example of a "crossover" painting-to-sculpture artwork. While largely consisting of two-dimensional painted elements, it spills out onto the floor and includes three-dimensional objects.

Craft Media

Often, artists elect to work in media more typically associated with "crafts" than fine arts. Robert Arneson's *Case of Bottles* (Fig. 359) is a good example, as is Eva Hesse's *Contingent* (Fig. 372). The line between the arts and crafts is a fine one. **Craft** refers to expert handiwork, yet artists produce their work by hand and don't call their work craft. One means of separating the two is to suggest that work made mainly for aesthetic purposes is art; and work made mainly for functional purposes is craft. But the distinction between the two in not that easy. Picasso's *Meed* (Fig. 380) although techinically a pitcher, would never be called a craft—it is a work of art. If you buy a functional object for its aesthetics, the maker's intent may be irrelevant—it is for you, a work of art.

Ceramics

Ceramics are objects that are formed from clay and hardened by firing in a kiln. Usually ceramic objects are flat and relief-like, or hollow, like cast sculpture. Some ceramic objects are slip cast, meaning the clay is liquidized and poured into a plaster form, where it sets up, dries, and is fired, but most ceramic objects are made by one of three methods—slab construction, coiling, or throwing (on a potter's wheel). Pieces are then **glazed**.

Koetsu's tea bowl *Amaguno* (*Rain Clouds*) (Fig. 381) is an example of slab construction. The clay is rolled out flat and then cut into pieces that are then assembled by hand. The bowl was wood fired at one of the "Six Ancient Kilns" in Japan. The early kilns, known as *anagama* were narrow underground tunnels dug into hillsides. A firebox was at the lower end, and a chimney was at the upper end. The firing lasted seven days, reaching temperatures of 2500 degrees.

Maria Martinez's black jar (Fig. 382) is an example of the coiling technique. In coiling, the clay is rolled out in long rope-like strands, then coiled around on top of one another, and finally smoothed. Coiling was the technique most often employed by Native American cultures.

Most cultures of the ancient world made use of throwing pots on potters' wheels—flat disks attached to a flywheel below that is either kicked so that it spins, or, in modern times, turned by means of an electric motor. As the disk spins, the potter carefully pinches the clay between fingers and thumb, gradually working the material upward to form both inside and outside simultaneously. Handles and spouts are added after the vessel form has partly set up. The Greek amphora known as *Revelers* (Fig. 384) was constructed in this way.

There are three basic types of ceramics. **Earthenware**, made of porous clay and fired at low temperature, must be glazed to hold water. **Stoneware** is impermeable to water, because it is fired at high temperatures. Finally, **porcelain** is fired at the highest temperature until it becomes almost translucent. The first true porcelain was made in China during the T'ang dynasty (C.E. 618-906). By the time of the Ming Dynasty (1368-1644), the official kilns at Chingtehchen had become a huge industrial export center of porcelain (Fig. 385). The export trade flourished even after the Manchus overran Ching, establishing the Ch'ing Dynasty. An example of the exceptional porcelain work of this period is the *famille verte* vase (Fig. 386), so called because of the distinctive greens used in its decoration.

―――――

Works in Progress
Peter Voulkos's *X-Neck*

In 1976, an American ceramic artist named Peter Callas built the first traditional *anagama*, or wood burning kiln, in the United States in Piermont, New York. One of the first ceramic artists he attracted to try the new "ancient kiln" was Peter Voulkos.

Voulkos's work was well suited to the wood firing process, as it causes an artist to give up a great deal of control and resign themselves to accidental effects. For Voulkos, this is a source of excitement in the work—"the expectancy of the unknown." The work *X-Neck* (Fig. 389) was fired in this way. The "x" is a reference to the Zen practice of *shoshin*, which means "beginner's mind." It is also Voulkos's way of keeping in touch with what the Zen master Shunryu Suzuki describes as "the limitless potential of the original mind, which is rich and sufficient to within itself. For in the beginner's mind there are many possibilities, in the expert's mind there are a few."

―――――

Glass

Glass is an ancient medium made by heating silica, or sand, until it melts and can be formed. The invention of glass blowing late in the first century B.C.E. so revolutionized the process that it soon became a major industry for the Romans. The mosaic glass bowl (Fig. 390) was produced near Rome during the second half of the first century C.E. before glass blowing really took hold, and was made by fuzing colored glass chips over a ceramic form.

One of the leading centers for glass blowing in the world is the Pilchuck Glass School in Washington State. Dale Chilhuly, one of Pilchuck's founders, has helped transform glass from a utilitarian medium to a sculptural medium. Chilhuly's *Alabaster Basket Set* (Fig. 392) sag, bulge, push against, and flow into each other as if still in their liquid state. Chilhuly is not so interested in baskets, but the interplay of line and space. The work also demonstrates how light can play an important role in animating glass.

Fiber

In the Middle Ages, tapestry hangings such as the *Unicorn in Captivity* (Fig. 393) were used to soften and warm the stone walls of mansions and castles. Because fiber is extremely textural, it has recently become a preferred medium for sculpture. All fiber arts, sculptural or not, trace their origin back to weaving, the interlacing of horizontal threads (the weft) and vertical threads (the warp). In **tapestry,** the weft is comprised of several colors of yarn that the weaver manipulates to create an intricate design.

In **embroidery**, a second traditional fiber art, the design is made by needle work. From the early eighteenth century onward, the town of Chamba was one of the centers of embroidery in India. It was particularly famous for its *rumals*—embroidered muslin textiles often used to wrap gifts (Fig. 394).

One of the most popular textile designers in this country was Anni Albers. The silk tapestry by Anni Albers (Fig. 395) reflects Albers's interest in geometry that is rooted in nature. Her reading of Johann Wolfgang von Goethe's *Metamorphosis in Plants* caused her to consider the way that a simple basic pattern could be generated in an infinite number of ways in nature.

Magdalena Abakanowicz is often considered the artist most responsible for freeing fiber from any utilitarian associations. Using traditional fiber materials such as burlap and string, Abakanowicz began to make figurative forms in the early 1970s. By pressing fiber into a plaster mold, she created a series of multiples that are uniform, yet thoroughly autonomous. In *Backs* (Fig. 396), the repetitive pieces form a pattern, which has traditionally been a characteristic of woven fabric. They also remind us of clothing, and its function to protect us from the elements. As her *Backs* seem to huddle together for protection, Abakanowicz reminds us that all living organisms are built from fiber.

Metal

Perhaps the most durable of all craft media is metal, which is why it has been used for food and drink vessels, tools, jewelry, and weapons of war. Over the years, silver and gold have been the most lavishly used in the creation of jewelry. The Persian *Griffin Bracelet* (Fig. 397) is thought to be one of the most beautiful works of jewelry ever made, and was originally inlaid with colored stones. Some of the finest work has been commissioned by royalty. In 1539, Benvenuto Cellini created the exquisite *Saltceller* (Fig. 398) for Francis I of France. Made of gold and enamel, it is actually a functioning salt and pepper shaker. The male figure of Neptune represents the sea—hence salt; and the female figure represents earth—the origin of pepper.

Wood

Because it is so easy to carve and widely available, wood has always been a popular material for artisans. However, wood is not long lasting—very few artifacts survive from ancient cultures. Cedar, native to the Northwest American coast, is a favorite of Native American artists in that region. Cedar is resistant to insects and weather. Chests such as the Tlingit example (Fig. 399) were designed to contain family heirlooms and serve as a bench or throne for the clan leader.

Wood has also been a favored media for furniture. Spanish architect Antoni Gaudí created curving organic architectural designs (Fig. 550), and felt that the furniture in these environments should match. His chair (Fig. 400) replicates the organic curving lines of the interior of the Casa Calvet.

Mixed Media

When various media are combined together in a single artwork, the result is called mixed media. In this chapter, three types of mixed media are covered: collage, installation, and performance art. One of the most important results of mixed media has been to extend "the space of art." If art was thought to be contained in the space of the picture frame, modern artists have extended it well beyond that boundary. Picasso and Braque were among the first artists to do this through collage.

Collage is the process of pasting or gluing fragments of printed matter, fabric, or anything relatively flat onto a two-dimensional surface. Collage creates a sort of low-relief assemblage. The way that collage rises off a two-dimensional surface soon led artists to discover the room or gallery space as the space of art. Thus they began to create **installations**—works designed to fill an interior architectural space. Finally, the work of art began to integrate human activity into its space, and this evolved to **performance art**.

Collage

The reasons that artists employ collage are many. One is that from the standpoint of traditional painting, collage violates the integrity of the medium. It introduces into the space of painting objects from the real world. Pablo Picasso purposely confuses the realm of painting with that of real life in *Bottle of Suze* (Fig. 401). The collaged image is that of a table with a bottle of aperitif sitting upon it—the perfect image of a life of ease. However, the newspaper article that is pasted into the work describes a gruesome war scene from the Balkans. Two worlds collide—the image of life, art, and leisure, and the world of death, misery, and war.

═══════════════

Works in Progress
Hannah Höch's
Cut with the Kitchen Knife

Collage's inclusiveness allows it to be a political medium. In Germany, after World War I, as the precursors to Hitler's Nazi party began to assert themselves, a number of artists, including Hannah Höch, began to protest the growing nationalism of the country. They saw in collage and photomontage (collage constructed of photographic fragments) a means of reflecting the kaleidoscopic pace, complexity, and fragmentation of everyday life. Höch, along with Raoul Hausmann and Richard Hulsenbeck and others, inaugurated a series of Dada evenings in Berlin in 1918. On June 20, 1920, they opened a Dada-Fair in a three-room apartment covered from floor to ceiling with a chaotic display of photomontages, Dada periodicals, drawings, and assemblages, and Hannah Höch's photomontage *Cut with the Kitchen Knife Dada through the Last Weimar Beer Belly Cultural Epoch of Germany* (Fig. 403).

Höch's preparatory drawing (Fig. 402) allows us to identify many of the figures in the final work. The top right-hand corner (the forces of repression) included a picture of recently deposed emperor Wilhelm II gazing out below the words "Die anti-dadistische Bewegung," or "the anti-Dada movement," what Höch calls in her title, "the Wiemar beer belly." Also included (as an exotic dancer) were General Field Marshall Friedrich von Hindenburg and other generals. Behind Wilhelm, is a photograph of people waiting in line at a Berlin employment office.

The upper left includes Albert Einstein, suggesting his Theory of Relativity might have been a proto-Dada event. Other figures include printmaker Käthe Kollwitz, Lenin, Karl Marx, Raoul Hausmann, and Höch herself—situated at the bottom right partially on the map of Europe that depicts the progress of women's enfranchisement. Included are several text passages: "Tretet Dada bei" ("Join Dada"), "Die grosse Welt dada" ("the great dada World"), and then, further down, "Dadaisten" ("Dadaists.")

The complexity of Höch's composition is obvious, but in its ability to capture both a sense of liberation and oppression, pleasure and pain, it is emotionally complex as

well. Finally, the title suggests that it is not just photographs that have been cut with the kitchen knife, but the self, the body politic.

━━━━━━━━

The movement of art from the two dimensional to the three dimensional is well illustrated in the work of Robert Rauschenberg. *Monogram* (Fig. 404) is a "combine painting," or high-relief painting that Rauschenberg worked on over a five-year period. Rauschenberg's *Monogram* is a kind of a collage, but more lenient than other collages in terms of what it admits into its space, which includes a full-sized stuffed Angora goat.

Rauschenberg found the goat in a sec-ond-hand office furniture store in Manhattan and was determined to put it into a painting. The first version has the goat mounted on a ledge at the top of a six foot high painting (Fig. 405). In this ver-sion, the goat is reasonably integrated into the two-dimensional surface. In a second version (Fig. 406), the goat is taken off its perch and set in front of another combine painting. At this point he added the auto-mobile tire around its midsection. Still, he was not satisfied. In the final version, Rauschenberg put the combine painting flat on the floor, creating what he called a "pas-ture" for the goat. The goat is now fully contained within the boundaries of the pic-ture plane, and totally liberated from the wall. Painting has become sculpture.

The connection between collage and sculpture is evidenced in Louise Nevelson's *Sky Cathedral* (Fig. 407). The piece is a giant assemblage of wooden boxes, wood-working remnants, scraps, and found objects. It functions like a giant altar, ele-vating its components to an almost spiritual dimension. Nevelson has made this work appear unified. This is accomplished by the grid structure formed by the boxes, her careful placement of the various shapes, and most importantly, the black paint.

Installation

Collage is an inclusive medium—it admits anything and everything into its world. An **installation** is a collage that moves from the two-dimensional space of the wall into the three-dimensional space of the world. Judy Pfaff's installation *Rock/Paper/Scissors* (Fig. 408) is also an environment. You can literally be inside the work. It insists upon its lack of unity, and transforms the architectural space of the gallery into an array of color, line, and form. Pfaff's assemblage disassembles the architecture in which it is located.

Installation art plays with the pre-dictable forms of interior architectural space. Gaho Taniguchi's *Plant Body* (Fig. 409) is inspired by *ikebana*, the ancient Japanese art of flower arranging. Ikebana stresses the notion of *mono no aware*, a sense of the poignancy of things, which can be traced back to Zen Buddhism. *Ikebana* seeks to capture the vanishing moment, while celebrating the cycle of birth, death, and renewel. In *Plant Body*, Taniguchi has covered the walls of the space with clay, and planted soybeans, rice, millet, straw, and rootlike rope which create a roomsized liv-ing ceramic sculpture. The installation embodies, in architectural space, the entire agricultural cycle.

More recently, installations have incor-porated film and video into the sculptural or architectural setting. Eleanor Antin's 1995 *Minetta Lane—A Ghost Story* (Figs. 410 and 411) recreates scenes from three buildings in New York that were artist com-

munities in the 1940s and 1950s. Antin prepared three narative films that are rear-projected onto windows in the installation. The films depict two lovers in a tub, a painter at work, and an old man putting away his birds for the night. A fifth character, a little girl, visible to us but not the subjects, paints a giant "x" across the images. She represents the destructive forces in us all, and the transient nature of nostalgic times to which we can never return.

Performance Art

Allan Kaprow invented an early form of performance art in the 1950s called the **Happening**. He defined happenings as "assemblages of events performed or perceived in more than one time and place. . . . A Happening is art but seems closer to life." The paintings of Jackson Pollock inspired Kaprow. Works such as *Full Fathom Five* (Fig. 412) with their added components of nails, tacks, coins, and matches buried into the paint caused Kaprow to realize that art could include everything, as well as real people acting in real time.

In the happening entitled *Household* (Fig. 413), there were no spectators, only participants, who were grouped by gender. Each group built a representative structure—a tower made by the men, and a nest made by the women—and each group wound up destroying the other group's structure. A symbolic catalyst in this destruction is a car covered with jam, which eventually is also destroyed toward the end of the performance. As both groups watch the demise of what might well have been the object of their aggression, their animosity toward each other wanes. They all leave quietly. *Household* was rehearsed ahead of time, but often performance takes on more of a free form or spontaneous nature.

One performance artist whose works were considered very powerful was Joseph Beuys, who referred to his works as "actions." Beuys was committed to teaching people to be creative so that through their actions they might effect change in society. He stated, "The key to changing things is to unlock the creativity in every man." In 1974, Beuys performed a three-day piece at the René Block Gallery in Manhattan entitled *I Like America and America Likes Me* (Fig. 392). This performance marked his first visit to the country. Placed in a fenced-in area within the gallery, Beuys's only companion was a live coyote who, for Beuys, was symbolic of the Native Americans victimized by the "expansion" of the west. He saw a similar imperialism in America's involvement in Vietnam. Throughout the course of the three day performance, Beuys and the coyote gradually developed a mutual respect for each other's presence in the space, underscoring Beuys's effort to demonstrate that different cultures could coexist in the same space.

───────────

Works in Progress
Goat Island's *How Dear to Me the Hour When Daylight Dies*

The performance art group Goat Island produces a collaborative work that is the subject of the *Works in Progress* video production. See the VIEWING GUIDE in this study lesson.

───────────

Performance art therefore exceeds the visual and, as a result, often becomes multidisciplinary, combining the arts of drama, dance, poetry, and music. One of the major advocates for this approach was a group of artists called "Fluxus." Beuys was associat-

ed with this group, as were La Monte Young, George Brecht, Yoko Ono, and, on occasion, John Lennon of the Beatles. The composer John Cage provided a springboard for the group. The classes he taught at The New School in New York inspired his students to experiment with unusual approaches to creating and composing. Jackson Mac Low created poetry of chance-derived nouns, and Dick Higgins's *Winter Carol* required everyone to go outside and listen to snowfall for a specified amount of time. These events became known as Fluxus "concerts." A collection of such works were organized together in an anthology by La Monte Young and designed by George Maciunas (Fig. 418). The innovative design of the six title pages reflect the movement's willingness to include virtually anything and everything as art.

Perhaps the most successful of the multimedia performance artists has been Laurie Anderson, who has not only performed successfully in front of audiences, but has also marketed film, videos, and recordings of her work. Her performances—the most ambitious of which is the seven-hour-long *United States* (Fig. 419)—involve a wide variety of technological effects, matched by equally sophisticated choreography, lighting, and a wealth of complex visual imagery. In one scene, Anderson says, "I mean my mouth is moving, but I don't really understand what I'm saying." It is as if she had no real voice of her own, only the voice of technology.

THE CRITICAL PROCESS
Thinking about Other Three-Dimensional Media

As a medium, sculpture is, by and large, more active than painting. We walk around sculpture—or through it, in the case of earthworks—and it changes with our point of view. When we work with clay or glass or fiber, we make things that we can physically use. Three-dimensional media engage our lives, just as collage engages the realities of the world around it by admitting such things as the news into the space of art. And as the space of art opens up, as room-size installations and then as performance, it literally comes to life.

Ann Hamilton's installation *'a round'* (Fig. 420) relates directly to its site, as do all her projects. It consisted of twelve hundred human-shaped cotton bags, wrestling dummies, cut and sewn industrially, and filled, manually, with sawdust, and piled around the walls, suggesting the transformation of the human into the commodity. The floor resembles a boxing ring, and at the top of two massive pillars are two mechanized leather punching bags which periodically burst into motion, disrupting the silence (hence the work's title). Between them, an extraordinary length of white yarn was stretched in a wide horizontal band, which during the course of the installation is gradually unraveled by a seated woman knitting a white shawl in isolation in the middle of the room. What is sculptural about this space? How does it relate to craft media, or performance? What is masculine or feminine about the work? Hamilton's education was in textile design and later, sculpture. "Cloth," Hamilton has said, "like human skin, is a membrane that divides an interior from an exterior. It both reveals and conceals. . . . In its making, individual threads of warp are crossed successively by individual threads of weft. Thus cloth is an accumulation of many gestures of crossing." The author asks what "crossings" can be detected in the work? What are the elements of ritualism, or the tension between "live" and mechanized activity? How does the wall of "dummies" function as a sort of skin in its own right?

VIEWING GUIDE
to *Works in Progress: Goat Island*

Lin Hixson, director of the performance group Goat Island, has led what Jacki Apple has described in a survey of her life that appeared in *The Drama Review* in 1991, as a "personal history [that] reads like fiction, movie fiction, a montage of American dreams and nightmares, from *The Magnificent Ambersons* to *The Deer Hunter*." Hixson was in fact raised in the same 50-room Tudor-style mansion in Lake Forest, Illinois, where two decades later they made the film *Ordinary People*. When she was 14 years of age, her mother tried to kill herself, but survived only to spend her remaining ten years in a state institution. In 1969, when her father, a Chicago coffee importer, died of cancer, Hixson, then a sophomore at Wittenberg College in Ohio and a former high school cheerleader and homecoming queen, married a recently returned Vietnam veteran. She moved twelve times in the next seven years, from Ohio to Colorado, Mexico, New Mexico, and Oregon, where she managed to graduate from the University of Oregon. In 1977, she left for Los Angeles to become an artist.

It was around Hixson that the new art of performance coalesced in Los Angeles in the early 1980s. In 1978, she enrolled in the Otis Art Institute's graduate program, began to take classes with Rachel Rosenthal, one of the innovators of performance art, and formed a collaborative performance group called Hangers. The group stayed together for two and one-half years. With the breakup of the group, as people were debating whether her work was art or theater, Hixson gave up performing herself and began to concentrate on directing. Because she was interested in increasing her theater vocabulary, she began to spend her summers working at

the Padua Hills Playwrights' Festival in Los Angeles. There, in the summer of 1984, she met Matthew Goulish, who received his undergraduate degree in theater arts from Kalamazoo College, and whose Chicago theater company, Scan, included the brothers Timothy and Greg McCain. In 1986, Hixson came to the School of the Art Institute of Chicago to do a residency and worked with both students and Scan. Within a year, the group Goat Island had been formed.

In 1990, the group was joined by Karen Christopher, a theater arts graduate of Pomona College who was also involved with the Padua Hills Playwrights' Festival and who had been working with Chicago's Neo-Futurists. In 1994, the group began working on *How Dear to Me the Hour When Daylight Dies*. In order to provide research and a shared group experience from which to begin work on the new piece, the Goats (which is what they call themselves) traveled to Ireland to participate in the massive Croagh Patrick pilgrimage, a four-hour climb up a mountain on the western seacoast outside of Westport, County Mayo, to a tiny church at the summit. While they were in Ireland, the McCains' father, Richard Williams McCain, suddenly died. It was a turning point in the McCain brothers' lives, perhaps a moment of self-realization. At any rate, not long after their return, in early 1995, both withdrew from Goat Island in order to go back to school and complete their educations. They were replaced by Antonio Poppe, a Portuguese who had little formal training in performance, and Bryan Saner, who had worked for many years in theater in Chicago. *How Dear to Me the Hour When Daylight Dies* was, in large part, conceived by this new version of the Goats.

Summary and Introduction

Works in Progress: Goat Island documents the one and one-half hour performance of *How Dear to Me the Hour When Daylight Dies*, concentrating particularly on its presentation at Dartington College, outside of the town of Totnes, in South Devon, England, in June of 1996. The Goats began working on the piece in 1994 and, as is typical of their working method, developed it over the course of two years. By November 1995, early versions of the P-Model Dance sequence, the Amelia Earhart material, and the Mr. Memory sequences had been developed and were in rehearsal at the Wellington Avenue Church gymnasium in Chicago—the Goats' home base—and were presented as a work-in-progress performance to live audiences at the church in January 1996.

The piece was developed more fully by spring, when the Goats traveled to England for a four-month residency. Originally commissioned by Arnolfini Live, in Bristol, England, and by College of Contemporary Art in Glasgow, Scotland, it premiered in its full version in Glasgow, April 27, 29, and May 1 and 3, during the city's annual Mayfest in 1996. The group subsequently toured England performing the piece, including their stop at Dartington College, a particularly appropriate venue since the college, part of the United Kingdom's college system, offers only three courses of study—music, theater, and performance, and performance writing. The Goats concluded their stay in Europe with a performance in Croatia. *How Dear to Me the Hour When Daylight Dies* toured the United States beginning in the autumn of 1996.

VIEWING GUIDE

The piece is itself a collaborative venture. It began with the pilgrimage theme, but by late 1995 Hixson had developed a set of "directives" designed to generate movement, dance, and performative material from each of the performers. Working from the list, each performer would develop ideas and try them out on the group—some would stay, some would not, others would be modified by the group as a whole. The list of directives, which the Goats also distributed to their January 1996 audience for the work-in-progress performance in Chicago, serves as a sort of cryptic key to the performance as a whole:

a shivering homage

a tumbling homage

a trembling homage

shivering glance

shy hands

a toast

"it's the rattle with which lepers crawl that in my hands
keeps singing aloud and my foot is on the edge of the grave

where nothing is need I walk like a child and my foot is on
the edge of the grave

the wind breezes out of a grove gone wild and my foot is on
the edge of a grave."
 —anna akhmatova

"a fish slaps back your face
shake out
shake out"
 —patti smith

a disappearing act

call on death
quiver in time with your gait

"an unceasing lament dragged by the wind"
"she felt she was detached from her head"
 —michael ondaatje

a task which cannot be accomplished

Invent an arrival.

How do you say goodbye?

In performances in England the group also provided a list of sources for the texts performed in the work. Aside from their own original writing, the following suggested material to them:

Harp of Burma (1956 film), Kon Ichikawa, director
The 39 Steps (1935 film), Alfred Hitchcock, director
Grand Illusion (1937 film), Jean Renoir, director
Peggy and Fred in Hell (1988 film), Leslie Thornton, director
Amelia Earhart Aviation Pioneer by Roxane Chadwick
The American Experience: Amelia Earhart
Coplas on the Death of Merton by Ernesto Cardenal
The Silent Cry by Kenzaburo Oe
Testimony of Mike Walker, Christian Farms, date unknown
Flying Dream by Richard Williams McCain
Dreams (1990 film), Akira Karosawa, director
Lightness by Italo Calvino
Mother by Yasunari Kawabati
The Aesthetics of Disappearance by Paul Virilio

Mr. Memory, for instance, is a character in Alfred Hitchcock's *The 39 Steps*. As the Goats researched him, they discovered that he was in fact a real person who plays himself in the film. Goulish then plays Mr. Memory in *How Dear to Me the Hour When Daylight Dies*.

It is obviously impossible to present the full performance of *How Dear to Me* in a one-half hour video, but we have tried to excerpt sufficiently self-contained sequences that will give you the flavor of the entire piece. If it remains mysterious, be confident that even in its full version it baffles audiences. But it fascinates them as well. Many return for several viewings. Probably the best response to it is Tim Roberts's, the technical director for the performance in its UK tour: "A number of my friends have seen the show during the course of the tour, and afterwards they were saying, 'Tim, what the hell's going on? What's it about, what are they doing?' And my response is, 'Well, I don't know. What do you think happened?' I've got my own opinion about what I think I saw, and I read various meanings into it. But again that's the beauty of the piece. Everybody sees a different show. Everybody goes away feeling different personal resonances from it. I think that's some of the beauty of the ambiguity of what they do. If they hammered it down, did a really clear solid narrative, you'd lose a lot of the personal resonances that people get from it."

VIEWING GUIDE

Ideas to Consider

1. What does the title, *How Dear to Me the Hour When Daylight Dies*, suggest?

2. We have excerpted various sequences from the performance in the video. Summarize as best you can what happens in each. How does each relate to the title? Can you see connections between any of them?

3. Goat Island is particularly known for the physicality of its movment. What does this physical exertion suggest to you? How, again, does it relate to the overall title and the overall theme of the piece as you see it?

4. Consider the list of directives Hixson provided for the Goats, quoted in the Summary and Introduction on page 160. Do any inform the sequences in the video? How so?

5. Consider the idea of collaboration. How does it inform the performance piece? Does the related idea of cooperation help you? How would you imagine *How Dear to Me* might be different if it were the creation of a single individual, such as Hixson herself?

Frequently Asked Questions

What is the origin of Goat Island's name? The group originally wanted to call itself Goose Island, but discovered that the name was already taken by another troupe. They settled on Goat Island, after an island in Rhode Island, but they have since discovered other Goat Islands in England and in Niagara Falls. The name suggests rough terrain, the kind of ground they want their work to traverse.

Is other information on Goat Island available? The Winter 1991 issue of *The Drama Review* dedicates considerable coverage to the group. The group has also produced a CD-ROM version of the performance piece immediately prior to *How Dear to Me the Light When Daylight Dies*, a piece based partly on Ken Kesey's novel *Sometimes a Great Notion* entitled *It's Shifting, Hank*. It contains long excerpts of the performance and much other information. It is available from Goat Island, 1144 N. Hoyne Ave., Chicago, IL 60622.

Can we get Goat Island to perform for us? Generally, Goat Island requires transportation and housing for the four performers, the Director, and the Technical Director. The group's per diem and fees are negotiable, but generally start at $35 per person per day and $1500 for the group per performance. Workshops are additional.

REVIEW QUESTIONS

Answers to the following questions appear in the APPENDIX: ANSWER KEY at the end of the *Study Guide*.

1. Which of the following is a means of creating ceramic objects?

 a) coiling
 b) slab construction
 c) throwing
 d) blowing

2. What is the difference between a warp and a weft?

3. Performance art

 a) comes "off the wall" into our space.
 b) is often multidisciplinary.
 c) is inclusive rather that exclusive.
 d) is all of the above.

4. Fluxus is

 a) a concept of dynamic change.
 b) a loosely-knit art multidisciplinary art group.
 c) a group that features kinetic art based on the Bergsonian concept of the flux of time.
 d) a art group dedicated to body-building.

5. What is the difference between a construction and an assemblage?

6. What is an installation?

7. What is collage?

8. What is photomontage?

SUPPLEMENTAL ACTIVITIES AND WRITING ASSIGNMENTS

Supplemental Activities: Distinguishing between fine art and the craft media is sometimes a difficult, even silly procedure. In your own living environment, find two or three things that are useful and functional objects that also possess a high degree of aesthetic value. Is their aesthetic element merely ornamental (that is, added on in a decorative way) or is it somehow intrinsic? Do any one of these objects undermine the distinction between fine art and craft? An interesting project, in fact, is for each member of your class to bring in such an object. It is even possible to create an interesting exhibition of such "found" objects.

The Website: Go to the *World of Art* website (**www.prenhall.com/sayre**). Proceed through the Chapter 14 materials. Consider your command of the objectives as stated in the website. Take the multiple choice and fill-in-the-blanks self-tests. Briefly respond to both the critical analysis and the compare and contrast questions, either formally or informally. Visit the related sites linked in both the Modern Artists and Galleries and Museums areas. A hands-on project related to the course material is suggested. Even if you are not assigned the Project, think about how you might approach it. Finally, consider participating in the Message Board or Chat Discussions.

Writing about Three-Dimensional Media: In the discussion of sculpture in-the-round in Chapter 13, we noted that one of its characteristics is that it is an active as opposed to passive medium—more precisely, it requires the active participation of the viewer, who must physically move around it in order to experience its various aspects fully. No one view is sufficient to explain it. This spatial ambiguity is in many ways comparable to the intentional ambiguities of much performance art. Compare and contrast the audience's relation to David Smith's *Blackburn: Song of an Irish Blacksmith* (Figs. 351 and 352) and to a performance piece such as Goat Island's *How Dear to Me the Hour When Daylight Dies*.

Writing to Explore New Ideas: One of the arguments against art forms such as collage, installation, and performance art is that in their very inclusiveness—their willingness to admit anything and everything into the space of art—they debase, or even destroy the idea of art itself. From this point of view, these forms of art are to art proper as noise is to music. Develop this analogy (with the understanding that one person's noise is often another person's music).

Suggested Further Reading: When it first emerged as an art form in the early 1970s, performance art was closely associated with the Women's Movement, especially on the West Coast. One of the books that most thoroughly explores the attractions of performance to women artists is Judy Chicago's *Through the Flower: My Struggle as a Woman Artist* (Garden City, New York: Doubleday, 1977), especially Chapter 6, "Womanhouse / Performances."

An excellent introduction to Happenings and performance is a collection of essays written by the inventor of the Happening, Allan Kaprow, and entitled *The Blurring of Art and Life*, ed. Jeff Kelley (Berkeley, Ca.: University of California Press, 1993).

Study Guide Lesson for

Chapter 15
The Camera Arts

LEARNING OBJECTIVES

This lesson will help you understand how artists utilize the camera arts. At the end of this chapter you should be able to:

1) Relate the early history of photography, including the advantages and disadvantages of the various new photographic processes.

2) Describe the ways in which photography addresses, particularly, the relation between form and content.

3) Detail how color photography contributes to the relation between form and content in the medium.

4) Describe what first attracted artists to film as a medium.

5) Summarize the basic "shots" utilized in filmmaking and describe the editing process including the principle of montage.

6) Describe video art's relation to television.

KEY CONCEPTS

camera obscura
photogenic drawing
daguerreotype
calotype
wet-plate collodion
 process

the "decisive
 moment"

Polaroid SX-70

editing
full shot
medium shot
close-up
extreme close-up
long shot
iris shot
traveling shot
flashback
cross-cutting
montage

the "star" system
film genres
"auteurs"

video art
Sony Portapak
video installation

STUDY PLAN

Step 1: Read Chapter 15, "The Camera Arts," in your text, *A World of Art*, pp. 309-339.

Step 2: Attempt to answer the questions posed in the CRITICAL PROCESS section at the end of the chapter. Don't worry if you find that you have a difficult time. Proceed to the next step.

Step 3: Read the OVERVIEW of Chapter 15 in this study guide lesson. When a specific work of art that is illustrated in the text is discussed, try to visualize it. If you are unable to remember it, open the text to that illustration and refresh your memory.

Step 4: Return to the LEARNING OBJECTIVES and KEY CONCEPTS sections at the beginning of this study guide lesson. Demonstrate your mastery of each of the learning objectives. Define each of the concepts—each is discussed in the text and each appears in the glossary at the end of your text as well.

Step 5: Return to the CRITICAL PROCESS section at the end of the chapter. Having reviewed the material, attempt to answer the questions again. Turn to the back of the text, p. 513, and compare your answers to those provided by the author.

Step 6: Answer the REVIEW QUESTIONS. Complete the assigned SUPPLEMENTAL ACTIVITIES and WRITING ASSIGNMENTS in this study guide lesson.

Step 7: Pursue any title from the SUGGESTED FURTHER READING that is assigned or that interests you.

OVERVIEW
of Chapter 15 - "The Camera Arts"
A World of Art

The camera arts allow artists to explore the fourth dimension—time. The images that come from still, motion picture, and video cameras are first and foremost informational. But while cameras record the world around us, our discussion of photographic media will concentrate on their function as art.

Photography

Like collage, photography is inclusive rather than exclusive. According to Robert Rauschenberg, whose combine paintings were discussed in the last chapter (Fig. 404), "The world is essentially a storehouse of information. Creation is the process of assemblage. The photograph is a process of instant assemblage, instant collage." An excellent example of the "instant collage" can be seen in Walker Evan's *Roadside Store* (Fig. 421) where it seems as if the proprietors have assembled an unimaginable amount of eclectic junk into one assemblage, as if they were waiting for Evans to photograph it.

Early History

The word *camera* is the Latin word for "room." In the sixteenth century, artists were employing the *camera obscura* (Fig. 422), a darkened (sometimes portable) room with a hole on one side and a screen or canvas on the other. Light from the outside environment would travel through the hole to be projected as an upside-down image on the opposite wall. The drawback of the *camera obscura* was that while it could capture the image, it could not preserve it. In 1839, in both France and England, that problem was being solved.

In England, William Henry Fox Talbot presented a process for fixing negative images on paper coated with light sensitive chemicals, which he called **photogenic drawing**. In France, Louis Daguerre was responsible for developing the **daguerreotype**, which created a positive image on a metal plate. The new processes were received enthusiastically by both the press and the public, many painters were put off. Paul Delaroche exclaimed, "From now on, painting is dead!" Painting would prove to be anything but dead, but portrait painting did see a steady decline after the advent of the photographic portraiture industry. Daguerreotypes (Fig. 425) were inexpensive and, unlike a painted portrait miniature, could be had for a very reasonable price.

The daguerreotype had drawbacks. It required considerable time to prepare, expose, and develop the plate. Even after chemical accelerators reduced this time, it still required that the sitter stay absolutely still so as not to blur the image. Also, the plate could not be reproduced. Utilizing paper instead of metal plate, Fox Talbot's process made multiple prints possible. He learned that the negative process could be reversed by laying a developed negative paper print over another sheet of unexposed paper and exposing them both to light. He also discovered chemical processes that greatly reduced the amount of time required to expose the paper. His **calotype** process became the basis of modern photography.

In 1843, Talbot made a picture called *The Open Door* (Fig. 426) that convinced him that the colotype could become a work

of art in its own right. Referring to *The Open Door* in his book, *The Pencil of Nature*, Talbot states, "A painter's eye will often be arrested where ordinary people see nothing remarkable." Talbot is one of the first to acknowledge the artistic potential of the photograph.

In 1850, English sculptor Frederick Archer introduced the **wet-plate collodion** process. The "negative" was a glass plate bathed in silver nitrate. This process was somewhat cumbersome, but the exposure time was very short and the rewards were quickly realized. It became the universally adopted process by 1855.

In 1864, Margaret Cameron, the wife of a British civil servant and friend to many powerful people, was given a camera and collodion processing equipment as a birthday gift. She became one of the greatest portrait photographers of all time. Regarding her photographs of famous men such as Sir John Herschel (Fig. 427), she wrote in her *Annals of My Glass House*, "My whole soul has endeavored to do its duty towards them in recording faithfully the greatness of the inner man as well as the features of the outer man." It was this ability of the photographer to capture the "soul" of the sitter that led the French government to give photography the legal status of art as early as 1862.

From the very beginning, photography also served as a documentary process. At the outbreak of the Civil War, Matthew Brady outfitted a group of photographers with equipment and pressed them to the task of documenting the war. When he insisted that all photographs taken by all photographers in his employ were his property, several of them quit, including Timothy O'Sullivan. After the war, O'Sullivan joined Clarence King's Survey of the Fortieth

Parallel in order to document an American landscape that few had ever seen. He soon realized that landscape photography, exemplified by his *Green River (Colorado)* (Fig. 429), revealed stunningly beautiful formal plays of line and texture.

Form and Content

It could be said that every photograph is an abstraction, a simplification of reality that substitutes two-dimensional for three-dimensional space, an instant of perception for the seamless continuity of time. Given the fact that early photography existed solely in black-and-white, the medium becomes a further abstraction. If the photographer further manipulates the space of the photograph in order to emphasize the formal concerns, as O'Sullivan's *Green River Canyon* (Fig. 429) seems to suggest, then the abstractness of the medium is further emphasized.

One of the most notable aspects of photography is its ability to reveal as beautiful what we take for granted. Alfred Stieglitz revealed the stark forms of the New York skyline as stunning abstract forms in *From the Shelton, New York, 1931* (Fig. 430). Charles Sheeler was hired to document the new Ford Factory at River Rogue in the 1920s, and this was precisely his task. The photographs celebrate industry, and they reveal the new factory as having the same grandeur and proportion as the Gothic cathedrals of Europe (Fig. 431).

Photojournalism does not seek to aestheticize the subject; still, it has the power to focus our attention on what we might otherwise avoid. Eddie Adams's photograph of Nguygen Ngoc executing a Vietcong soldier (Fig. 432) has great impact by its sheer matter-of-factness. This photograph describes something that really happened, what we could call the "truth factor" in photography.

Henri Cartier-Bresson, whose work *Athens* (Fig. 433) capitalizes on the immediacy of the photographic medium, states: "We must place ourselves and our camera in the right relationship with the subject, and it is in fitting the latter into the frame of the viewfinder that the problems of composition begin. . . . We compose almost at the moment of pressing the shutter. . . . If something should happen, you remain alert, wait a bit, then shoot and go off with the sensation of having got something." Cartier-Bresson called this "the decisive moment." Margaret Bourke-White's *At the Time of the Louisville Flood* (Fig. 434) is far less subtle than Cartier-Bresson's image, and juxtaposes the dream of white America to the reality of black American lives. *Life Magazine*, founded in 1936, became a major venue for American photographers to show their works for the next 30 years. According to Bourke-White, *Life* taught photographers that "Photography can be beautiful, but must tell facts too."

Color Photography

Black-and-white photography lends itself to investigating the relation between opposites because, as a formal tool, it depends upon the tension between black and white. In color photography, this tension is lost, but new challenges face the photographer. Joel Meyerwitz, who switched to color photography in 1977, explains, "When I committed myself to color exclusively it was a response to a greater need for description." In the series *Bay/Sky* (Figs. 435 and 436), Meyerwitz works within a sensibility similar to Claude Monet's *Grainstack* paintings. The view is the same from picture to picture, but, side by side, we recognize the complexity of the colorshifts. In other works taken at Cape Cod, Meyerwitz takes advantage of complementary color schemes that create contrasting tensions similar to black-and-white photographs. In *Porch, Provincetown* (Fig. 437) there is stunning contrast between the deep blue sky lit up by lightning, and the hot orange electric light from the interior of the house. Here is an example of what Cartier-Bresson called "the decisive moment."

The rise of color photography in the 1960s coincided with the growing popularity of color television. The advent of color Polaroid film and inexpensive color processing both contributed to a cultural taste for color photography. Polaroid's SX-70 was taken up quickly by many artists including Lucas Samaras, who saw an instant creative venue for exploring light and color (Fig. 438). William Eggleston, a master of color photography, exhibited a series of snap-shot style images of Memphis, TN., in which the color provided far more information than might have been revealed in black-and-white photography. His portrait of a woman entitled *Jackson, Mississippi* (Fig. 439) is a case in point. Her flower pattern dress contrasts vividly against the flower pattern chaise lounge pillow. It's as if she matches the out-of-place shoddiness of the neglected garden.

========

Works in Progress
Jerry Uelsmann's *Untitled*

Jerry Uelsmann considers his camera a license to explore. For him taking the picture is not so important as the activity that occurs afterwards, in the darkroom. In the darkroom he reassembles what he's photographed. Uelsmann calls this "post-visualization."

Uelsmann photographs both the natural world and the human figure. He then examines his contact sheets, looking for

images that might fit together—in this case, a rock (Fig. 440), a grove of trees (Fig. 441), and hands about to touch each other (Fig. 442). He then masks the other information in the photograph, framing the material of interest. Each image rests on its own enlarger, and moving from one enlarger to the next, he prints each part in sequence on the final print. The resulting image is similar to a Surrealist landscape. As Uelsmann explains:

> *I am involved with a kind of reality that transcends surface reality. More than physical reality, it is emotional, irrational, intellectual, and psychological. It is because of the fact that these other forms of reality don't exist as specific, tangible objects that I can honestly say that subject matter is only a minor consideration which proceeds after the fact and not before.*

Uelsmann first explores the formal relationship among the elements, regardless of their actual content; however, powerful transformations can emerge through the post-visualization process. With one of the two hands wounded, a suggestion of a healing touch seems to come from the other. In the first version of the final print (Fig. 443), the stone containing the hands thus becomes an egg-like symbol of nurturing, but unsatisfied with the image, he returned to his contact sheets. In a second version, he placed the hands and stone in the foreground of a mountain landscape (Fig. 444). The lines of the hands formally echo the lines of the mountains beyond. The final print seems more mysterious than the earlier version. It is, as Uelsmann is fond of saving, "obviously symbolic, but not symbolically obvious."

Film

Almost as soon as photography was invented, people sought to extend its capacity to capture motion. As we have seen in Chapter 3, both Eadweard Muybridge and Etienne-Jules Marey captured the locomotion of animals (Fig. 68) and humans (Fig. 69) in successive still phototgraphs. It was in fact the formal, rather than the narrative, potential of film that first attracted artists, who saw it as a medium through which rhythm and repetition could be explored in a new way. In Fernand Léger's *Ballet Méchanique* (Fig. 445), the artist combined a number of different images—smiling lips, wine bottles, metal discs, and a number of pure shapes such as circles and squares. By repeating the same image again and again in separate points of the film, Léger was able to create a visual rhythm that, to his mind, embodied the beauty of ballet, machines, and machine manufacture in the modern world.

Assembling a film, the process of editing, is a sort of linear collage, the arranging of sequences of a film after it has been shot in its entirety. The first great master of editing was D.W. Griffith, who invented the standard techniques of editing in a film called *The Birth of a Nation* (Fig. 446). Griffith created visual variety by alternating between a repertoire of **shots,** including the **full shot** (actor from head to toe), **medium shot** (from the waist up), the **close-up** (head and shoulders) and the **extreme close-up** (a portion of the face). The image of the battle scene is a **long-shot,** taking in a wide expanse and many characters all at once. The edge of the frame is blurred and darkened to make the viewer focus on the action in the center—this is an **iris shot.** Related to the shot is the **pan,** in which the camera moves across the scene from one side to the other. Griffith also invented the **traveling shot,** in which the camera moves from front

to back, or back to front. Two of Griffith's more famous editing techniques are **cross-cutting** and **flashback**. In cross-cutting, high drama is developed as the editor cuts back and forth between two separate events happening simultaneously. In flashback, the editor cuts to narrative episodes that have supposedly taken place before the start of the film. Both techniques are now standard in film practice.

Another innovator of film editing was Russian filmmaker Sergei Eisenstein, who did his greatest work after the 1917 revolution. Eisenstein created the technique called **montage**—the sequencing of widely disparate images to create a fast paced, multifaceted image. In the Odessa Steps Sequence from the *Battleship Potemkin* (Fig. 447), Eisenstein utilized 155 separate shots in four minutes and 20 seconds of film. Eisenstein felt that the strength of montage resulted from the creative mind of the viewer to assemble the image.

While Eisenstein's work emphasized action and emotion through enhanced time sequencing, Andy Warhol created just the opposite effect. Warhol equated "reel" time with "real" time. In *Sleep*, he filmed a subject sleeping for six continuous hours. In *Empire* (Fig. 448), he filmed the Empire State Building for eight hours with a stationary camera set up on the 44th floor of the nearby Time-Life building. In many respects, these films become the equivalent of John Cage's famous piano composition *4'33"*, which consists of 4 minutes and 33 seconds of silence. The drama in both cases becomes the audience's reaction to the work.

The Popular Cinema

Warhol's film, though interesting on an intellectual level, would not be appreciated by most audiences. Audiences expect a **narrative,** or story, to unfold—characters with whom they can identify, and action that thrills their imaginations. In short, they want to be entertained. After World War I, American movies dominated the screens of the world precisely because they entertained audiences so completely. The town where these entertainments were made became synonymous with the industry itself—Hollywood.

The largest studios in Hollywood were Fox and Paramount, followed by Universal and Metro-Goldwyn-Mayer. When sound was added in 1926, Warner Brothers came to the forefront as well. Also, a few well-known actors—Douglas Fairbanks, Mary Pickford, and Charlie Chaplin, formed their own company, United Artists. Their ability to do so is testimony to the power of the "star" in Hollywood.

The greatest early star was Charlie Chaplin, who managed to merge humor with a deeply sympathetic character (the tramp) who could pull the heartstrings of any audience. In *The Gold Rush* (Fig. 449), he portrayed the abysmal conditions faced by miners working in the gold fields during the Alaska gold rush of 1898. *The Gold Rush* is a silent film, but a year after it was made Warner Brothers and Fox were busy readying their theaters for sound. On October 6, 1927, the first words uttered by a performer in a film were spoken by Al Jolson in *The Jazz Singer* (Fig. 450). By 1930, the conversion to sound was complete.

For the next decade, the movie industry produced films in a wide variety of **genres**—comedies, romantic dramas, war films, horror films, gangster films, and musicals. By 1939, Hollywood had reached a zenith.

Some of the greatest films of all time date from that year, including *Stagecoach*, *Gone With the Wind*, and *Mr. Smith Goes to Washington*. As significant was the arrival of Orson Welles in Hollywood. Welles, whose 1938 broadcast of H. G. Wells's novel *War of the Worlds* convinced many listeners that Martians had invaded New Jersey, produced, directed, wrote, and starred in *Citizen Kane*, a story loosely based on newspaper publisher William Randolph Hearst. The film utilized every known trick of the filmmaker's trade, with high-angle and low-angle shots (Fig. 451), and a variety of editing effects including dissolves between scenes, and a fragmented narrative technique consisting of different points of view. *Citizen Cane* stands as one of the greatest American films.

The year 1939 also marked the emergence of color in films. Though *The Black Pirate*, released in 1926, was the first successful color film, color was considered an unnecessary ornament. With the release of *Gone With the Wind*, however, audiences reacted differently. In *The Wizard of Oz* (Fig. 452), when Dorothy arrives in a full-color Oz, from a black-and-white Kansas, the magical transformation of color became stunningly evident.

Meanwhile, Walt Disney had begun to create feature-length animated films in full color. The first was *Snow White and the Seven Dwarfs* in 1937, which was followed, in 1940, by both *Pinocchio* and *Fantasia* (Fig. 453). Animation ("bringing to life"), was realized during the earliest days of the industry when it became evident that film itself was a series of "stills" animated by their movement in sequence. Quite evidently, one could draw these stills as well as photograph them. But in order for the motion to appear smooth, thousands of drawings had to be executed for each film. "The Sorcerer's Apprentice" section of *Fantasia* was conceived as a vehicle to reinvigorate the stock Disney cartoon character of Mickey Mouse. As a film, *Fantasia* is an experiment in animation, an anthology of human fantasy freed of the constraints of reality.

After World War II, the idea of "film as art" resurfaced, especially in Europe. International film festivals, particularly in Venice and Cannes, brought "art cinema" directors to the fore, who saw themselves more as **auteurs**, or "authors," of their works. Federico Fellini's *La Dolce Vita* earned him an international reputation. Swedish director Ingmar Bergman and the French "New Wave" directors Jean-Luc Godard and Alain Resnais also gained fame. By the end of the 1960s, Hollywood had lost its hold on the film industry.

Italian director Michelangelo Antonioni's *Blow-Up* is the story of a fashion photographer, who, in processing a series of photographs he has taken in a park, becomes convinced that he has unwittingly recorded a murder. He blows up his photographs into larger and larger images (Fig. 454), hoping to reveal the killer, but as he blows up the photographs they are reduced to abstract patterns of dots. The movie is, in essence, an essay on the "truth" of photography.

In the late 1970s, Hollywood regained its control of the popular cinema with the unqualified success of George Lucas's *Star Wars* (Fig. 455) in 1977. An anthology of stunning special effects, the movie made over $200 million dollars even before its highly successful twentieth anniversary re-release in 1997, and it inaugurated an era of "blockbuster" Hollywood attractions, including *E.T.* and *Titanic*.

Video

For artists, the drawback of film was the sheer expense. With the advent of the Sony Portapak in 1965, artists were suddenly able to explore the implications of seeing in time. One of the first artists to explore this medium was the Fluxus artist Nam June Paik, who had been making video installations since the 1950s. *TV Buddha* (Fig. 456) is perpetually contemplating itself on the screen, a self-contained version of Warhol's exercises in filmic duration. The work is deliberately and playfully ambiguous, being both "live" on TV and an inanimate stone object. It is peacefully meditative and mind-numbingly boring, and in short, represents the best and the worst of TV. Paik's playfulness can also be seen in the work *TV Bra for Living Sculpture* (Fig. 457), a literal realization of the "boob tube." The piece was done with cellist Charlotte Moorman, who has worked collaboratively with Paik for many years. *TV Bra*'s humor masked an underlying serious intention, to humanize technology.

The mindlessness of commercial television, especially T.V. advertising, has been hilariously investigated by William Wegman. In one clip, entitled *Deodorant*, the artist sprays an entire can of deodorant under his arm all the while extolling the product's virtues. In *Rage and Depression* (Fig. 458), the artist describes how his terrible rage and depression were disguised after shock therapy permanently affixed a smile to his face.

In *Live/Taped Video Corridor and Performance Corridor* (Fig. 459), artist Bruce Nauman mounted a closed-circuit video camera on the ceiling of a narrow corridor and placed two monitors at each end. One monitor played a video tape of the empty corridor with no one in it, while in the other monitor viewers watched themselves on closed circuit TV as they entered the space. The act of entering interrupted the tranquility of the empty corridor, and the viewer becomes an intruder on camera, committing an aggression on the empty space.

Video is extremely effective in installations such as Bill Viola's *Room for St. John on the Cross* (discussed in Chapter 8), which demonstrates how video brings all the formal elements into play. Another of his works, *Stations* (Fig. 460), consists of five video images of the human body submerged in water. Each image is projected upside down onto a separate cloth screen suspended from the ceiling, with a polished granite slab beneath which reflects the image right side up. The installation includes a soundtrack of running water, and it seems to position us in a dreamstate—somewhere between memory of birth, and the soul's flight from the body after death.

════════════

Works in Progress
Bill Viola's *The Greeting*

The *Works in Progress* video series continues with a discussion of video artist Bill Viola, America's artist designate for the 1995 Venice Biennale. See the VIEWING GUIDE in this lesson.

════════════

In his video installation *Crux* (Figs. 464 and 465), Gary Hill transforms the traditional image of the crucifixion. The installation consists of five monitors mount-

ed to the wall in the shape of a cross. Hill attached five cameras to himself, one pointing at his face, two pointing at his two hands, and two pointing at his feet. All the recording equipment was attached to Hill's back as he moved about on a deserted island in the middle of the Hudson River. The twenty-six minute "journey" is a reminder of Christ's journey as he carried his own cross to the top of the hill where he was crucified. In the monitors, viewers see Hill become weary, his shins are bruised from the equipment, and his fatigue becomes apparent.

In part because they have been denied ready acceptance as painters and sculptors, women artists have tended to dominate video as a medium, using it to depict the manner in which women have been defined in our culture. Dara Birnbaum's *Technology/Transformation* (Fig. 466) is a ground-breaking example. It consists of a series of taped loops from the series *Wonder Woman,* in which Wonder Woman transforms from her normal self to an all-powerful agent in the never-ending fight of good versus evil. Birnbaum wants to expose the underlying message that somehow being normal isn't enough.

Lynn Hershman created an interactive art video disk, *Lorna* (Fig. 467), which allows the viewer to participate in the story of Lorna, a middle-aged agoraphobic, fearful of leaving her tiny apartment. "The premise," according to Hershman, "[is] that the more she stayed home and watched television, the more fearful she became." In the disk, each object in her room is numbered and becomes a chapter in her life that viewers activate with a remote control device. The plot has multiple variations and three separate endings.

THE CRITICAL PROCESS
Thinking about Video

Jeff Wall's *A Sudden Gust of Wind* (Fig. 469) is a large, back-lit photographic image modeled on Hokusai's, *Ejiri in Suruga Province* (Fig. 468). Wall's interests include the transformations contemporary culture has worked on traditional media. In comparing his billboard-like photograph to the print, what transformations can you see? Comparisons include businessmen in the photo image instead of Japanese in traditional dress. Why has Wall eliminated Mt. Fuji, held virtually in spiritual reverence by the Japanese?

Wall's photographic image also mirrors cinema. Wall employed professional actors, staged the scene carefully, and shot it over the course of nearly five months. The final image, in fact, consists of fifty separate pieces of film spliced together through digital technology to create a completely artificial but absolutely realistic scene. What is cinematic about this piece? How does it relate to motion picture film? Where does "truth" lie?

VIEWING GUIDE
to *Works in Progress: Bill Viola*

Bill Viola
Biographical Sketch

Video artist Bill Viola was born January 25, 1951, in New York City. From his earliest days, he was captivated by television, and in fifth grade, at P.S. 20 in Queens, he was named Captain of the "T.V. Squad." He attended Syracuse University, where he studied in the Experimental Studios of the College of Visual and Performing Arts and was graduated with a Bachelor of Fine Arts in 1973. After graduation, he studied and performed with composer David Tudor in the new music group "Rainforest" (later called "Composers Inside Electronics"). He worked as technical director in charge of production at Art/Tapes/22, a video studio in Florence, Italy, from 1974–76, and as artist-in-residence at WNET Thirteen Television Laboratory in New York from 1976–83.

Since 1976, he has traveled extensively: to the Solomon Islands in 1976 to record traditional music and dance; to Java, Indonesia, in 1977 to record traditional performing arts; and that same year to Australia, where he met Kira Perov, now his wife and managing director. In 1979, he traveled to Tunisia to videotape mirages, and he lived in Japan from 1980–81 supported by a Japan/U.S. Creative Arts Fellowship, at which time he was also artist-in-residence at Sony Corporation's Atsugi Laboratories.

He has had well over 30 one-person exhibitions of his work, and has won numerous prizes and fellowships, including two Visual Artist Fellowships from the National Endowment for the Arts, a Guggenheim Fellowship, and, in 1989, a John D. and Catherine T. MacArthur Foundation Fellowship. He was most recently selected to represent the United States at the 1995 Venice Biennale. One of the works created for that exhibition, *The Greeting*, is the subject of this segment of *Works in Progress*. Since 1995, he has had one-person exhibitions in museums around the world.

Summary and Introduction

Works in Progress: Bill Viola outlines the process of video artist Bill Viola as he creates a work entitled *The Greeting* for inclusion in his exhibition *Buried Secrets* at the 1995 Venice Biennale. Based on a 1528 painting by Jacopo Pontormo entitled *The Visitation* (reproduced as Fig. 118 in your text), *The Greeting* recreates, in over ten minutes of slow motion film, the scene depicted in the painting.

What fascinated Viola about Pontormo's painting was, first of all, the scene of three women meeting each other in the street. They embrace as two other women look on. An instantaneous knowledge and understanding seems to pass between their eyes. The visit, as told in the Bible by Luke (I: 36-56), is of the Virgin Mary to Elizabeth. (In the *Works in Progress* video, incidentally, Viola says that Elizabeth is Mary's sister—she is not. She is Mary's cousin. Even famous artists get things wrong occasionally!) Mary has just been told by the angel Gabriel: "You shall conceive and bear a son, and you shall give him the name Jesus," the moment of the Annunciation. In Pontormo's painting, the two women, one just pregnant with Jesus, the other six months pregnant, after a lifetime of barrenness, with the child who would grow to be John the Baptist, share each other's joy. For Viola, looking at this work, it is their shared intimacy—that moment of contact in which the nature of their relationship is permanently changed—that most fascinated him. Here was the instant when we leave the isolation of ourselves and enter into social relations with others. Viola decided that he wanted to recreate this encounter, to try and capture in a medium such as film or video—media that can depict the passing of time—the emotions buried in the moment of greeting itself. This is one of the "buried secrets" of life. In the catalogue to his exhibition in Venice, Viola quotes the thirteenth-century Sufi, or Muslim, mystic and poet, Rumi: "When seeds are buried in the dark earth, their inward secrets become the flourishing garden."

Works in Progress: Bill Viola falls into two roughly equal parts. In the first half of the show, Viola explains what video art is and what his aims are as an artist in a general sense. The second half of the video details the making of *The Greeting*, which is in fact a slow-motion film. One of the questions he had, though, was the size to project it. His video background tempted him to show it in small scale, television-size, but he finally projected it lifesize onto the wall (still smaller than the size of film projection). One of his most intriguing discoveries was the importance sound plays in the final piece—and the importance of sound to both film and video as media.

Ideas to Consider

1. The video begins with Bill Viola, Sr., the artist's father, explaining the difficulty of understanding his son's work. Think about how Viola's work addresses questions of space based on the clips of his work that are interspersed with his father's explanation. Specifically:

- Think of water as liquid space, or as space given body or substance.

- Think of *falling* as a kind of movement through space.

- Think of a hallway as perspectival space.

- Consider the hallway's space, which we move through when Viola screams (yes, it is Viola himself sitting in the chair at the end of the hall), as it is transformed into a flat photograph *falling* into a puddle.

2. After the opening, Viola discusses various aspects of video art and describes its characteristics. Note these characteristics down. What two types of video art does he make? What distinguishes video art from painting?

3. A series of still photographs shows Viola shooting video in a variety of landscapes. This is followed by a series of demonstrations of various kinds of cameras that Viola has used and by a sequence about fires on the beach in California near Viola's home. Consider landscape as space.

- What are our normal expectations about how the space of landscape is constituted or constructed? Consider terms like foreground, background, the near, the far, the horizon, and any others that you can think of.

At the beach, Viola says that his art is about transformation, about how what we normally see is suddenly transformed, and how, finally, what we see stays the same, but that it's we who change.

- How, in the segments of his work that you've seen to this point in the video does he transform your expectations about what you see? Consider segments from *Déserts*, from *The Passing*, and from *Chott el-Djerid (A Portrait of Light and Heat)* in particular.

- As you watch the remainder of the video, consider whether, in seeing *The Greeting*, you are somehow transformed. If so, in what way?

4. The last half of the video outlines Viola's creation of *The Greeting*. In what ways is his process in this piece the same as his usual process? In what ways is it different?

- Consider the question of film. What can the special camera he uses to shoot *The Greeting* do that a video camera can't?

- Consider the idea of collaboration. Viola says he normally works alone. Does he really?

- Think about slow motion. Can you guess why it attracts him?

5. Can you describe the relationship between the three women in *The Greeting*? What does Viola mean when he says, at one point, that each of the women has her own "little idiosyncracy"?

6. What is the relationship, finally, between Viola's video, *The Greeting*, and its source, Pontormo's painting, *The Visitation*? What do they share? How are they different?

- Why does Viola choose not to use Pontormo's title?

- What elements does video introduce into visual space that painting cannot? What important roles do these elements play?

- Why do you suppose there are four women in the original painting and only three in Viola's video? Does this tell us something about the space of painting versus the space of video?

- In which medium do you think it is easier to represent both the near and the far, elements close to us and those farther away, simultaneously? Why?

Frequently Asked Questions

How does Viola finance his work? Viola's work is collected by most major contemporary museums, and they purchase his work from the Anthony d'Offay Gallery in London, England, which represents him. Like all artists, he shares the proceeds from sales with the gallery. He has also received many large grants from both private and public sources. The exhibition, *Buried Secrets*, at the Venice Biennale, was supported by a wide range of sponsors. The Fund for U. S. Artists at International Festivals and Exhibitions, a public/private patnership of the National Endowment for the Arts, the United States Information Agency, The Rockefeller Foundation, and The Pew Charitable Trusts, supported U.S. participation in the Biennale. Viola's five-part installation was supported by the Bohen Foundation, New York; his own gallery, Anthony d'Offay Gallery; the National Endowment for the Arts; California Tamarack Foundation, San Francisco; Polaroid Corporation; the College of Fine Arts, Arizona State University; the Committee in Support of Arizona State University Art Museum at the Venice Biennale; the Regents of the State of Arizona; and several private people from Phoenix, Arizona.

We saw many clips from Viola's work in the video. How long are the actual pieces? *The Greeting* is just over 10 minutes in length. *Chott el-Djerid (A Portrait in Light and Heat)* is 28 minutes long. *The Passing*, Viola's longest work, runs for 54 minutes. And *Déserts* is 26 minutes in duration.

Can we rent or buy his tapes? Yes, but, like all video art tapes, they are comparatively expensive. If your school or institution has a media center, you could approach them about purchase. Viola's tapes are available from

Electronic Arts Intermix
536 Broadway - 9th Floor
New York, NY 10012

Tel: (212) 966-4605
Fax:(212) 941-6118

Rentals of standard VHS tapes are approximately $50 for tapes under 30 minutes and $75 for tapes over 30 minutes. Sales are $200 and $275, respectively. Archival quality tapes are considerably more expensive.

REVIEW QUESTIONS

Answers to the following questions appear in the APPENDIX: ANSWER KEY at the end of the *Study Guide*.

1. What advantage did Fox Talbot's photogenic process have over Daguerre's?

2. What advantage did Fox Talbot's calotype process offer?

3. Photography is particularly interested in the relationship between

 a) the camera and the lens.
 b) the camera and the print.
 c) form and content.
 d) people and things.

4. Define montage.

5. As art media, film and video are particularly interested in

 a) duration.
 b) entertainment.
 c) rhythm and repetition.
 d) "real" time.

6. What is an "auteur"?

SUPPLEMENTAL ACTIVITIES AND WRITING ASSIGNMENTS

Supplemental Activities: We all take photographs. Find a collection of your own or a friend's. What distinguishes them from "art"? Do any begin to achieve, in your eyes, the status of "art"? What are the criteria that you use to judge?

The Website: Go to the *World of Art* webssite (**www.prenhall.com/sayre**). Proceed through the Chapter 15 materials. Consider your command of the objectives as stated in the website. Take the multiple choice and fill-in-the-blanks self-tests. Briefly respond to both the critical analysis and the compare and contrast questions, either formally or informally. Visit the related sites linked in both the Modern Artists and Galleries and Museums areas. A hands-on project related to the course material is suggested. Even if you are not assigned the Project, think about how you might approach it. Finally, consider participating in the Message Board or Chat Discussions.

Writing about the Camera Arts: One of the most interesting things about photographs is the way in which we tend to see them in two different ways—as isolated art objects, with their own formal integrity, and as instances in larger narrative situations. For instance, O'Sullivan's *Green River* (Fig. 429), Stieglitz's *From the Shelton* (Fig. 430), and Sheeler's *Criss-Crossed Conveyors* (Fig. 431) all possess extraordinary aesthetic integrity in their own right but are also part of larger sequences of photographs on the same theme—O'Sullivan on the American West, Stieglitz on New York City, and Sheeler on Ford's River Rouge Plant. Go to the library and look at one or more of the larger bodies of work from which these images have been taken. What is the relation between the single image and the sequence?

Writing to Explore New Ideas: One of the films that explores the camera arts, particularly the relationship between photography and film, is Michelangelo Antonioni's classic *Blow-up* (see Fig. 454). View the film (it is readily available in most larger video rental outlets). How does it challenge the documentary status of photography? How does it manipulate your expectations about film (pay particular attention to the question of sound and its role in film)? What do you take the meaning of the film to be?

Suggested Further Reading: Susan Sontag's *On Photography* (New York: Farrar, Strauss, and Giroux, 1977) is one of the most readable accounts of photography's impact on modern consciousness.

A more generic, but in many ways equally interesting account, is Vicki Goldberg's *The Power of Photography: How Photographs Changed Our Lives* (New York: Abbeville, 1993).

The best history of film is Robert Sklar's *Film: An International History of the Medium* (New York: Abrams and Prentice Hall, 1993).

The best introduction to video as an art is *Illuminating Video: An Essential Guide to Video Art*, ed. Doug Hall and Sally Jo Fifer (New York: Aperture, 1990).

Chapter 16
Architecture

LEARNING OBJECTIVES

This lesson will help you understand the various forms of architecture. At the end of this chapter you should be able to:

1) Outline some of the ways in which the built environment is influenced by topography.

2) Briefly outline how technological innovations have changed the built environment.

3) Understand the underlying principles and historical development of the basic forms of architectural construction— load-bearing, post-and-lintel, arches and domes, cast-iron, suspension, frame, and steel and reinforced concrete.

4) Describe the basic components of the infrastructure and outline how artists can influence them.

KEY CONCEPTS

topography
technology

pyramids
ziggurats
kiva

shell system
skeleton-and-skin system
tensile strength

load-bearing
post-and-lintel
arches and domes
 voussoir
 barrel vault

groined vault
pointed arch
flying buttress

Greek columns
 fluting
 entasis
 colonnade
 elevation
 platform
 column
 entablature
 orders
 Doric
 Ionic
 Corinthian

cast-iron
suspension
wood-frame
 truss
steel
 I-beams
reinforced concrete
 cantilever

Prairie House
International Style
Postmodernism

infrastructure

STUDY PLAN

Step 1: Read Chapter 16, "Architecture," in your text, *A World of Art,* pp. 340-75.

Step 2: Attempt to answer the questions posed in the CRITICAL PROCESS section at the end of the chapter. Don't worry if you find that you have a difficult time. Proceed to the next step

Step 3: Read the OVERVIEW of Chapter 16 in this study guide lesson. When a specific work of art that is illustrated in the text is discussed, try to visualize it. If you are unable to remember it, open the text to that illustration and refresh your memory.

Step 4: Read the VIEWING GUIDES to *Works in Progress: Mierle Ukeles* in this study guide lesson.

Step 5: View the video *Works in Progress: Mierle Ukeles*, following the VIEWING GUIDE as you watch. Take notes and jot down ideas in response to the VIEWING GUIDE. Your instructor may require you to hand in written responses, formal or informal, to some or all of the topics that the VIEW-ING GUIDE sets out for your consideration. View the video a second time if necessary.

Step 6: Return to the LEARNING OBJECTIVES and KEY CONCEPTS sections at the beginning of this study guide lesson. Demonstrate your mastery of each of the learning objectives. Define each of the concepts—each is discussed in the text and each appears in the glossary at the end of your text as well.

Step 7: Return to the CRITICAL PROCESS section at the end of the chapter. Having reviewed the material, attempt to answer the questions again. Turn to the back of the text, p. 513, and compare your answers to those provid-ed by the author.

Step 8: Answer the REVIEW QUESTIONS. Complete the assigned SUPPLEMEN-TAL ACTIVITIES and WRITING ASSIGNMENTS in this study guide les-son.

Step 9: Pursue any title from the SUGGESTED FURTHER READING that is assigned or that interests you.

OVERVIEW
of Chapter 16 - "Architecture"
A World of Art

In Philip Johnson's collaboration with John Burgee to create the College of Architecture Building at the University of Houston (Fig. 470), the architects topped the building with a colonnade that, while it does announce the idea of architecture, serves no purposeful function. The building is directly reminiscent of Claude-Nicolas Ledoux's design for the House of Education (Fig. 471), a building that was never constructed and that Ledoux had planned for a utopian community. Johnson and Burgee's design reflects the contemporary stylistic trend called **Postmodernism**, with its eclectic combination of multiple styles, past and present.

This chapter examines the "look" of our "built environment," which depends on two different factors—the landscape characteristics of the local site, its **topography**, and the forms of our built environment as determined by available forms of **technology**. Both factors affect the way in which we build.

Topography

A building's form might echo its environment or it might contrast with that environment. Many early examples of architecture were intended to resemble natural forms. The pyramids at Giza (Fig. 473) are thought to have deliberately mimicked the rays of the sun. Sumerian ziggurats (Fig. 474) are thought to be patterned after mountains and their surrounding foothills. The Sumerians believed that gods resided in mountains, thus ziggurats served as artificial homes for gods.

The Anasazi cliff dwellings in Mesa Verde National Park (Fig. 475) in south-western Colorado reflect a similar relationship between humans and nature. The caves provided a natural security that allowed the Anasazi to survive for hundreds of years. The *kiva* was a round room covered with stacked logs which in turn created a type of dome up to an access hole (Fig. 476). The roofs were paved over with stone to create a flat communal area. Down below in the kiva floor was a *sipapu*—a small round hole symbolic of the Anasazi creation myth which describes their ancestors as having emerged from the depths of the earth.

Technology

While the cliff dwellings are a response to the topography of the place, the structure of the kiva roof represents a technological innovation of the Anasazi culture. The basic technological challenge faced in architecture is to build walls and put a roof over the space they enclose. There are two basic approaches: the **shell system**, in which one basic material provides the structural support and the outside covering of the building, and the **skeleton-and-skin system**, which consists of an interior frame or skeleton, supporting a more fragile outer covering—the skin.

In buildings several stories tall, the walls or frame of the lower floors must bear the weight of the upper floors. The ability of a given material to support weight is thus a factor in how high the building can be. The horizontal span between elements of support such as walls or columns is determined by a material's **tensile strength**. Almost all tech-

nological advances in architecture have either been through the discovery of new means of distributing weight, or new materials with improved tensile strength.

Load-bearing Construction

The simplest method of building is to make the walls bear the weight of the roof. This can be done by stacking bricks or stones up to the height of the roof. The kiva is built this way. The walls surrounding the Lion Gate at Mycennae (Fig. 477) were load bearing, but the gate itself represents a basic construction device called **post-and-lintel**, a horizontal beam supported at each end by a vertical post or wall.

Post-and-lintel construction is fundamental to Greek architecture. In the Basilica at Paestum (Fig. 478), the columns or posts supporting the structure were spaced relatively close together to compensate for the stone's tendency to crack and buckle across a long span. Each column in the basilica is made up of several sections called barrels, which are grooved or fluted, visually uniting these sections as one. Each column also tapers dramatically toward the top, and slightly toward the bottom, creating a kind of bulge called **entasis**. Entasis deceives the eye and makes the column look absolutely vertical.

The values of the Greek city-state were embodied in its temples. The temple was usually on an elevated site called an **acropolis**—*acro* meaning above, and *polis* meaning city. The outer portion of the temple was a row of columns— a **colonnade**, which supported the weight of the roof. The vertical design, or **elevation**, of the Greek temple is composed of three basic elements—the **platform**, the **column** and the **entablature**. The relationship among these three elements is referred to as their **order**.

The temple reflects a preoccupation with order, and, in fact, so specific were the Greeks about the order of their architecture that there are three distinct classifications— the **Doric, Ionic,** and **Corinthian** (Fig. 479). The Greeks rarely used the Corinthian order, but it became a favorite of the Romans who adapted many Greek styles in art and architecture. Doric style is quite heavy in appearance compared to Ionic. In ancient times the Doric was considered masculine, while the Ionic was thought to be more feminine. The Temple of Athena Nike (FIg. 480) is the oldest Ionic temple on the Acropolis in Athens.

The geometric order of the Greek temple suggests a conscious concern on the part of the Greeks to control nature. This same impulse, the will to dominate the site, can be seen in Roman architecture. The Sanctuary of Fortune at Praeneste (Figs. 481 and 482) seems to embrace the whole of the landscape below, as if it were literally the Roman empire itself. It is as if the Roman state is so large that it is nature.

Arches and Domes

The development of the arch and vault revolutionized the built environment. The Romans perfected the **arch** (Fig. 483) at the end of the first century C.E., and the structure allowed them to span greater distances than were possible with post-and-lintel. The wedge-shaped stones, called **voussoirs,** formed a half circle with each stone receiving equal pressure. A series of arches, such as are evidenced in the Pont du Gard aqueduct (Fig. 484), could be made to span a wide canyon with relative ease.

The **barrel vault** is essentially an extension in depth of the arch, and it enabled the Romans to create large uninterrupted interior spaces. The Roman Colosseum (Fig.

487), essentially two gigantic amphitheaters facing each other, utilizes barrel vaulting. The Colosseum also relies heavily upon **groin vaulting**, barrel vaults that cross one another at right angles (Fig. 485)

The Roman system of vaulting was in use throughout Europe a thousand years after the building of the Colosseum. It was especially prevalent in Romanesque architecture, which used many Roman architectural conventions. The barrel vault of St. Sernin in Toulouse, France (Figs. 488 and 489), is a magnificent example of Romanesque architecture. The plan (Fig. 490) reflects Romanesque preference for rational order and logical development. Every measurement is based on the central square in the crossing where the two **transepts** (side wings) cross the main length of the nave.

The roof over the apse of St. Sernin is a half-dome. The Romans were also the first to perfect the **dome**, a hemispherically shaped roof. The Roman Pantheon (Fig. 491) consists of a 142-foot high dome set on a cylindrical wall 140 feet in diameter. Over 20 feet thick where it meets the wall (the springing), it thins to 6 feet at its center where the circular opening, the **oculus**, is located.

The basic architectural inventions of the Romans provided the basis for building construction in the Western world for nearly 2000 years. The idealism or mysticism inherent in the Pantheon found its way into the Christian Churches as Christianity came to dominate the West. Large congregations could gather beneath the barrel vaults of churches. The culmination of this spiritual direction is the Gothic cathedral, which rises to an incredible height and is illuminated by stained glass windows.

Gothic cathedrals attained their great heights due to the development of the pointed arch. The earlier Roman-inspired rounded arch limited, through its height, the span that was possible, but the pointed arch could be adjusted to accommodate almost any span. By utilizing the **pointed arch** (Fig. 494) in its scheme of groined vaults, the ethereal space and verticality of the Gothic cathedral are realized. The cathedral Notre Dame of Paris (Fig. 492) is an exquisite example of the results of verticality and the ethereal sense of light.

All arches tend to push outwards, and the Romans learned to support the sides of the arch to counteract this lateral thrust. In French Gothic cathedrals, including Notre Dame of Paris, this problem was overcome by developing secondary exterior arches outside the cathedral which transferred the thrust down into massive buttresses. These **flying buttresses** (Figs. 495 and 496) are an aesthetic solution to a practical problem.

Cast-Iron Construction

Until the nineteenth century, architecture was determined by innovations revolving around the same materials, usually stone. However, during the nineteenth century, iron, which had been known for centuries, began to be used for architecture, thereby transforming the built environment. Hector Guimmard employed wrought iron for his entryways to the Paris Métro (Fig. 497), and the French engineer Gustave Eiffel used cast iron girders and a lattice beam construction technique to build the tower which bears his name.

The Eiffel Tower (Fig. 498), built for the Paris Exposition of 1889, soared to almost 1000 feet, instantly becoming the tallest structure in the world. The "openness" of the tower's lattice construction

allowed the wind to pass through it, making it extremely resilient to the forces of nature. Although many Parisians initially hated the look of the great monument, (some newspapers printed articles requesting that it be "clothed"), it soon became clear that it heralded in a new potential for architectural construction—skeleton-and-skin.

Suspension

The advent of steel, with its superior strength compared to iron, further transformed the built environment. The sheer strength of steel cable made beautiful suspension bridges, such as the Golden Gate Bridge (Fig. 499), a reality. The principle is simple: the weight of the entire span is supported from cables hung between two vertical pylons. The Golden Gate also used a lattice structure beneath its roadway which added to its strength. This was not the case with the Tacoma Narrows Bridge in Washington State (Fig. 500), which suffered from miscalculations in engineering and a single sheath of steel beneath the roadway. "Galloping Girtie" as it was nicknamed, collapsed ten months after its construction.

Frame Construction

The importance of steel and iron in architecture is indeed important, but two humbler technological innovations also added much to the look of our built environment.

Standardized milling specifications of lumber, namely, the 2x4, led to uniform construction methods and the advent of the **balloon-frame** house (Fig. 501), first introduced in Chicago in 1933 and still common today. In balloon-frame construction, a framework skeleton of 2x4s is nailed together. Windows are placed in the skeleton in basic post and lintel construction,

then the entire skeleton is sheathed in with clapboard, planks or other suitable material. The roof is more complex, but not too unlike the **truss** system used in the basilica of old St. Peters in Rome (Fig. 502). The truss is a triangular framework that is one of the strongest forms in architecture, and because of its rigidity, can span longer distances than a single wooden beam.

Steel and Reinforced Concrete Construction

When C.R. Ashbee, a representative of the British National Trust, visited the United States in 1900, he was especially impressed by the architecture he saw in Chicago. He recognized that an "aesthetic handling of material had evolved out of the industrial system." While a young architect named Frank Lloyd Wright impressed Ashbee the most, his mentor, Louis Sullivan was perhaps most responsible for Ashbee's response. The Chicago fire of 1870 had provided architects with the unique opportunity of rebuilding the entire core of the city. As Sullivan saw it, the problem facing the modern architect was how "the building" would transcend the sinister urban conditions from which it must arise. He sought an architecture which was lighter than the heavy appearance of buildings such as Henry Hobson Richardson's Marshall Field Wholesale Store (Fig. 504). The answer, he felt, rested in the development of steel construction techniques combined with a "system of ornament." A steel skeletal frame freed the wall of load bearing necessity, opening it to ornament and large numbers of windows. Vertical emphasis became fundamental and "the building" no longer seemed massive.

To Sullivan, a building's real identity and "spirit" depended on ornamentation

The geometric lines of the steel frame would flow into graceful curves, as exemplified by Sullivan's Bayard Building in New York (Fig. 505), in which vertical columns blossom in a "Gothic explosion of floral decoration." Ornamentation seems to contradict the dictum that Sullivan is most famous for—"Form follows function." However, Sullivan's original meaning has been largely forgotten. He was not promoting design akin with practical utility as in the Model T Ford. For Sullivan, "the function of all functions is the Infinite Creative Spirit," and this spirit was evidenced in the rhythm, or the growth and decay found in nature. The elaborate organic forms attached to Sullivan's buildings were intended to evoke the Infinite. For Sullivan, the primary function of a building was to elevate the spirit of those working in it.

Sullivan's exuberance for ornamentation was obviously not transferred to the architecture of Frank Lloyd Wright, whom many consider the first "modern" architect. But Wright worked as a draftsman for Sullivan, and Sullivan's belief in the unity of design and nature is instrumental to Wright's work. Wright was routinely translating the natural and the organic into what he called the "terms of building stone."

Wright's intentions can be seen in the so-called Prairie House, of which the Robie House in Chicago (Fig. 506) is a prime example. Although the house is contemporary in feeling, its fluid open interiors and rigid geometry were, in Wright's opinion, purely "organic" in conception. Wright spoke of the Prairie Houses as "of" the land, not simply "on" it. The horizontal sweep of the roof and the open interior reflect the vast expanses of the Midwestern prairie landscape. The cantilever roof allowed one to be simultaneously outside and under a roof, and tied together the interior space of the house with the natural world outside.

The innovations of Sullivan led to the modern skyscraper, which became a reality due to the use of structural steel as opposed to the brittler cast iron. Up until this time, buildings relied upon bearing wall construction, essentially post-and-lintel technology, which required that the ground floor walls had to support the weight of everything above. But the steel cage, connected by concrete floors, themselves reinforced with steel bars, overcomes this necessity. The simplicity of the resulting structure can be seen in Le Corbusier's diagram for the Domino Housing Project (Fig. 509). Any combination of windows and walls can be hung on this frame, and even the stairwell can be moved.

In 1932, a curator at the Museum of Modern Art named Alfred H. Barr wrote that "a new International Style based primarily upon the nature of modern materials and structure" had taken hold. Citing the steel posts and beams and steel reinforced concrete floors, Barr identified French/Swiss architect Le Corbusier as one of the founders of this new style. Le Corbusier's Villa Savoye in Poissey, France (Fig. 510), takes full advantage of this, and seems to float effortlessly on its steel posts. The building is an example of Le Corbusier's belief in the importance of "primary forms" —circles, rectangles, and grids.

Barr felt another innovator of **International Style** was Miës van der Rohe, whose German Pavilion at the 1929 International Exposition in Barcelona (Figs. 511 and 512) simplified these same rhythms to an extreme. As the floor plan suggests, Miës wanted most of all to open the space

of architecture. With its bands of marble walls, sheets of glass and stainless steel poles, the entire structure seems to shimmer in light. Miës's Farnsworth House (Fig. 513), built in 1950, proves how enduring the style is. It is both homage to Le Corbusier's Villa Savoye, and his own German Pavilion. An example of the International Style Skyscraper is the Seagram Building in New York City (Fig. 514), designed by Miës and Philip Johnson. Johnson went on to design his Glass House (Fig. 515), which rises directly out of the surrounding space and opens, though its glass walls, directly into it. It is a purely aesthetic statement.

Eero Saarinen's architectural work rejects International Style forms, and seeks its unity in design through observation of natural forms. The TWA Terminal at Kennedy International Airport in New York (Figs. 516 and 517) was designed so that the building's interior space would be a contrast of the openness of the broad expanses of windows and the sculptural mass of the reinforced concrete walls and roof. The tremendous exterior concrete wings seem to resemble the very notion of flight itself. The "wing" effect is also restated in his design of Dulles International Airport in Washington, DC. (Fig. 518).

Works in Progress
Frank Lloyd Wright's *Fallingwater*

Frank Lloyd Wright's Kaufmann House (Fig. 520) is arguably the most famous modern house in the world. Edgar Kaufmann, owner of Kaufmann's Clothing Stores, contacted Wright about the project, and in 1934 Wright visited the site. Initial drawings didn't appear until the following September. Wright felt that an architect should conceive a building in the mind before beginning to sketch.

The first drawings were done in two hours when Kaufmann made a surprise call and said he would like to see plans. Wright completed several floor plans in that session, as well as a cross-section of remarkable similarity to the finished house (Fig. 519). Kaufmann, who was skeptical of Wright's radical design, hired engineers who said the 18-foot cantilevers wouldn't function structurally. The contractor ultimately added twice as much steel as Wright called for, and, as a result, the main cantilever droops to this day. Wright made the house in the same spirit as his famous "Prairie Houses," which were "of the land," and the forms of Fallingwater deliberately blend with its environment.

Community Life

Although the Seagram Building is a stunning example of International Style, it represents to some architects the impersonality and anonymity of urban life. Moshe Safdie's Habitat (Fig. 522) created for the international trade fair at Expo '67 in Montreal, is an attempt to "enliven" the basic architectural "unit" as conceived by Le Corbusier by stacking it in unpredictable ways.

Safdie's plan accepts the crowded conditions of urban life, even as it revises the city's visual vocabulary, as does Itsuko Hasegawa's Shonandai Cultural Center, (Fig. 523) in Fujisawa City, Japan. The Cultural Center (which is two-thirds underground) houses a variety of public spaces. Above ground it combines space-age building design with the traditional Japanese garden.

Hasegawa's design actually reflects a strong reverence for the natural world. Since the middle of the nineteenth century there have been attempts to reestablish the values of rural life within the urban context. New York's Central Park, designed by Olmsted and Vaux (Fig. 524), is an attempt to put city-dwelling humans back in touch with their natural roots.

Olmsted favored a park that resembled an English garden, "gracefully curved lines, generous spaces, and the absence of sharp corners . . . to suggest and imply leisure." Olmsted imagined the city dweller escaping the rush of urban life. He was subsequently commissioned to design many other urban parks. However, he showed his greatest foresight in the belief that the crowded conditions of the inner city would give birth to another form of community adjoining the city, the suburb. In 1869, Olmsted laid out the general plan for the city of Riverside, Illinois (Fig. 525), one of the first suburbs of Chicago. The design of Riverside set the standard for suburban development in America. The pace of that development was slow until the 1920s when suburbia suddenly exploded; by the 1950s, the suburbs were growing at a rate ten times that of cities. For the first time, cities began to lose population.

There were two great consequences to suburban emigration: first, the rise of the automobile as the primary means of transportation, and second, the collapse of the financial base of the urban center itself. In 1930, the city of Los Angeles decided not to spend any more money on mass transit, but instead, began to build a giant freeway system (Fig. 526). In 1940, the Pennsylvania Turnpike and the Pasadena Freeway both opened.

As more and more middle-class families began moving to the suburbs, so did their money, and, consequently, the infrastructure of many urban centers began to decline. **Infrastructure** refers to a city's delivery systems—water, power, communications, waste removal, and transportation. Infrastructure promotes quality of life and has been a concern of city planning for centuries. Leonardo's plan for a canal for the city of Florence (Fig. 527), which would have given it access to the sea, anticipates the same route as the modern Autostrada. The Roman aqueducts and the Paris Metro serve as historic examples of infrastructure. Historically, when infrastructures collapse, cities begin to deteriorate.

Works in Progress
Mierle Ukeles's *Fresh Kills Landfill Project*

Mierle Ukeles's art, designed to transform the infrastructure, most notably the largest landfill in the United States, on Staten Island, New York, is the subject of the last *Works in Progress* video. See the VIEWING GUIDE in this lesson.

Urban decline brought about the first "revitalization projects," as early as 1950 in Baltimore and Boston. Baltimore developer James Rouse led the way as both cities turned their attention to the revitalization of their port areas. Baltimore's Inner Harbor (Fig. 530) and Boston's Quincy Market and Boston Waterfront projects were huge undertakings, but marked economic benefits almost immediately. Today, Baltimore's Inner Harbor attracts over 22 million visitors a year. Of these, 7 million are tourists,

roughly the same number that visit Walt Disney World in Florida each year. It is, in fact, Walt Disney World, with its Main Street USA (Fig. 531), that provides the model for the new inner city, a wholesome, safe environment where the entire family can have a good time and spend money. Walt Disney World might be an imaginary kingdom, but it functions like a continuous world's fair, a "Tomorrowland projection of how we would like the real world to appear."

THE CRITICAL PROCESS
Thinking about Architecture

Charles Moore's design for the *Piazza d'Italia* in New Orleans (Figs. 532 and 533) is both an anthology of architectural orders, and an example of revitalization. Intended to honor Italian immigrants of New Orleans and to serve as the gateway to a new group of urban buildings behind it, the plaza and fountain are composed of a compendium of styles, referencing virtually the entire history of architecture—in fact, readers are challenged to identify many styles visible in the images. While some columns are fluted and made of marble, others are smooth and made of stainless steel. What is the effect of this transformation? How do the ideas of Postmodernism help us understand Moore's *Piazza d'Italia*?

VIEWING GUIDE
to *Works in Progress: Mierle Ukeles*

Mierle Ukeles
Biographical Sketch

Mierle Ukeles received her Bachelor of Arts degree in History and International Relations in 1961 from Barnard College in New York, writing her graduation thesis on "Checks and Balances in the History of Tanganyika Territory." This training led her to conclude, early on, that every society shapes its own space, and that the shape a society makes of its space is its "work." Ukeles began to think of such work as a kind of art, and to define her own "work" as an artist in terms of helping us rethink and reshape our space as a society.

In the late 1960s, two events occurred in Ukeles's life that had a profound effect on her career. First, she gave birth to her first child, and the responsibilities of raising children led her to question the polarization between life and art. Secondly, she wrote her "Manifesto for Maintenance Art," in which she defined all of her activities, all of her "work"—as a mother, as a wife, as a woman, and as an artist— equally "art."

Since 1970 she has been the unsalaried artist-in-residence for New York City's Sanitation Department, where she builds and orchestrates major public projects that explore the social and ecological issues of waste management. Her work asks the community to rethink its common disregard of waste and its disrespect for those who work with it. Such reexamination of our cultural space will allow her, at Fresh Kills Landfill, for instance, literally to reshape our environment. Her *Flow City*, begun in 1985 and closely tied to the Fresh Kills project, is a walk-through installation for observing the maintenance process that raises questions about waste removal and relocation, and the relation of the nation's fragile river systems to the problem.

Summary and Introduction

Works in Progress: Mierle Ukeles introduces us to a project that is so vast in scope, so long term in its consequences, that it seems almost impossibly utopian in its aspirations, Ukeles's *Fresh Kills Landfill Project*.

But Ukeles's ability to see such projects through to their end is evidenced in the ongoing installation of *Flow City*. She initiated the *Flow City* project in 1983. It remains a work in progress, with construction proceeding in fits and starts, as funds become available. She has overseen the transformation of the 59th Street Marine Transfer Station (MTS), located on Pier 99 in the Hudson River, from a rusted and decrepit warehouse to a fully rebuilt and rejuvenated modern waste disposal facility. She convinced the New York Department of Sanitation that, as they rebuilt the MTS, a $25 million project, that she could make "environmental art" out of it—"a place," as she says, "where the public, industry, and sanitation workers can all come together." Her design calls for a special corridor in which the public, without ever interfering with the work, can view the everday operations of the MTS in detail—over 14,000 tons of solid waste are processed through the station and shipped to Fresh Kills on 15-24 barges each day. She received over $700,000 in grants from the Department of Sanitation, the New York State Council on the Arts, the National Endowment for the Arts, and the John Guggenheim Foundation. She needs at least that much again to finish the project, which she now conceives as part of her larger *Fresh Kills Landfill Project*. As she says, her work is not just about "a flow of waste, it's a flow of life. The Hudson River adds to the notion of constant flow. It's like our primal source cleansing the whole city—very much a part of life."

One of the most remarkable things about Ukeles is her ability to turn "waste" into an object of beauty (a characteristic, incidentally, of assemblage and collage, with which her work has much in common). Her barge ballet in Pittsburgh, and the stunning night performance of barges on the Rhone River in Givors, France, both demonstrate this ability. In the Works in Progress video itself, she works with Director Marlo Bendau to create a video dance of New York Department of Sanitation cranes.

Ideas to Consider

1. For many people, Ukeles's work is difficult to think of as art. She is most obviously an environmental artist. But, as is suggested above, also compare what she does to the process of assemblage and collage.

2. One of the formal elements that her work addresses in an interesting way is the question of time and motion. How does her work address this issue?

3. Consider the ways in which the example of Ukeles changes or expands your notion of the possibilities of art or your ideas about what "art" is.

REVIEW QUESTIONS

Answers to the following questions appear in the APPENDIX: ANSWER KEY at the end of the *Study Guide*.

1. What is a lintel?

2. An example of skeleton-and-skin construction is

 a) Notre Dame Cathedral.
 b) the pyramids at Giza.
 c) the Parthenon.
 d) a shotgun house.

3. The favored Greek order of the Romans was

 a) the Doric.
 b) the Ionic.
 c) the Corinthian.
 d) none of the above—the Romans invented their own order.

4. What is the top wedge-shaped stone in an arch called?

5. Gothic cathedrals are noted for

 a) their use of vaulted arches.
 b) their use of flying buttresses.
 c) their extraordinarily high interior space.
 d) the lightness of their stonework.

6. Which of the following is an important nineteenth-century technological innovation?

 a) cast-iron construction
 b) the mass production of the common nail
 c) the standardization in the process of milling lumber
 d) mass production of the I-beam

7. What does the phrase "Form follows function" mean to its inventor, Louis Sullivan?

8. Frederick Law Olmsted designed or helped to design

 a) the Empire State Building.
 b) New York's Central Park.
 c) Riverside, Illinois, one of the earliest suburbs.
 d) the Inner Harbor of Baltimore, Maryland.

SUPPLEMENTAL ACTIVITIES AND WRITING ASSIGNMENTS

Supplemental Activities: Make a timeline that encapsulates the history of architecture, particularly the history of technological innovation that has made for advances in construction techniques. (This exercise will help you learn and control the materials in this lesson.)

The Website: Go to the *World of Art* website (**www.prenhall.com/sayre**). Proceed through the Chapter 16 materials. Consider your command of the objectives as stated in the website. Take the multiple choice and fill-in-the-blanks self-tests. Briefly respond to both the critical analysis and the compare and contrast questions, either formally or informally. Visit the related sites linked in both the Modern Artists and Galleries and Museums areas. A hands-on project related to the course material is suggested. Even if you are not assigned the Project, think about how you might approach it. Finally, consider participating in the Message Board or Chat Discussions.

Writing about Architecture: Compare and contrast the architecture of the Greeks, particularly as expressed in the Greek orders and the elevations of Greek temples, to the architecture of Louis Sullivan, as expressed in buildings such as the Bayard Building (Fig. 505).

Writing to Explore New Ideas: From our perspective late in the twentieth century, one of the most disturbing implications of Le Corbusier's Domino Housing Project (Fig. 509), together with his insistence on mass-manufactured furnishings, is the possibility that it might lead not so much to an egalitarian utopian world, as Le Corbusier hoped, but to a stultifying conformity and monotony, as we have seen again and again in large urban renewal projects and in suburbs such as the one Frank Gohlke depicts in his *Housing Development South of Fort Worth, Texas* (Fig. 244). This is, in fact, one of the implications of rhythm and repetition as a basic principle of design as well. From this point of view, consider what aesthetic and social forces might be responsible for the demise of modernism (as exemplified by Le Corbusier) and the rise of postmodernism in the last half of this century. (It might be useful to consult some of the other discussions of postmodernism in the text—consult the index.)

Suggested Further Reading: The beautifully illustrated catalogue to Fred Wilson's extraordinary curatorial installation at the Maryland Historical Society, *Mining the Museum*, is available from the New Press, New York (1994), edited by Lisa G. Corrin.

An irreverant, but sometimes stunningly perceptive, account of modern architecture is Tom Wolfe's *From Bauhaus to Our House* (New York: Farrar, Straus, Giroux, 1981).

A fascinating account of the infrastructure of America's largest city is Mike Davis's *City of Quartz: Excavating the Future in Los Angeles* (New York: Vintage Books, 1992).

Chapter 17
Design

LEARNING OBJECTIVES

This lesson will help you understand the role of design in the arts of everyday life. At the end of this chapter you should be able to:

1) Detail the characteristics of the major design styles from the Arts and Crafts Movement through contemporary Postmodern design, including the styles of Art Nouveau, Art Deco, the various avant-gardes, such as Le Corbusier's L'Esprit Nouveau, the Dutch De Stijl movement, and the Russian Constructivists, the Bauhaus, Streamlining, and the organic designs of the 1940s and 1950s.

2) Describe the ways in which the relation between the organic and the geometric helps determine design history.

3) Describe the role of handicraft in the history of design and its relation to mass manufacture.

KEY CONCEPTS

"ornamental" vs. "useful" ware

Morris's notion of "simplicity"

"state" vs. "workaday" furniture

Art Nouveau
Art Deco

L'Esprit Nouveau
De Stijl
Constructivism
the Bauhaus

Streamlining

Organic design

Postmodern design

STUDY PLAN

Step 1: Read Chapter 17, "Design," in your text, *A World of Art,* pp. 376-406.

Step 2: Attempt to answer the questions posed in the CRITICAL PROCESS section at the end of the chapter. Don't worry if you find that you have a difficult time. Proceed to the next step.

Step 3: Read the OVERVIEW of Chapter 17 in this study guide lesson. When a specific work of art that is illustrated in the text is discussed, try to visualize it. If you are unable to remember it, open the text to that illustration and refresh your memory.

Step 4: Return to the LEARNING OBJECTIVES and KEY CONCEPTS sections at the beginning of this study guide lesson. Demonstrate your mastery of each of the learning objectives. Define each of the concepts—each is discussed in the text and each appears in the glossary at the end of your text as well.

Step 5: Return to the CRITICAL PROCESS section at the end of the chapter. Having reviewed the material, attempt to answer the questions again. Turn to the back of the text, p. 513, and compare your answers to those provided by the author.

Step 6: Answer the REVIEW QUESTIONS. Complete the assigned SUPPLEMENTAL ACTIVITIES and WRITING ASSIGNMENTS in this study guide lesson.

Step 7: Pursue any title from the SUGGESTED FURTHER READING that is assigned or that interests you.

During the 1920s in the United States, people who had once described themselves as being involved in the graphic arts, industrial arts, craft arts, and arts related to architecture began to be referred to as designers. Their job was to design products that could meet the needs of an urban society. They could take any object or product, a shoe, a chair, or an automobile and make it appealing. Design is so intimately tied to industry that its origins can be traced back to the advent of the industrial age.

Design, Craft, and Fine Art

In 1759, Englishman Josiah Wedgwood opened a pottery manufacturing plant. With extraordinary foresight, he chose to make two very different types of pottery: an "ornamental ware" (Fig. 534) and a "useful ware" (Fig. 535). The first were elegant luxury items, the second were described by Wedgwood as "earthenware for the table, and consequently cheap." This "cheap" earthenware was the first to be made by machine—consequently, the look of the world would be forever changed. Up until this time, ceramic objects had all been handmade—each was unique.

Wedgwood's business illustrates how the art of design is different from both traditional "**crafts**" and "fine arts." The term "crafts" typically refers to handmade objects created by highly skilled but nevertheless uninventive artisans to serve useful functions. Designers differ from craftspeople in that they often have nothing to do with the making of the object, which is produced by mechanical means. In these terms, craftspeople and fine artists have more in common, as both are involved in personally making objects. The word "ornamental," in Wedgwood's case, separates it from the useful, and lends it the status of art. It is often difficult to decide whether an object is an example of craft, fine art, or design. Although his company is still in business, Wedgwood's 1790 copy (Fig. 536) of the famous Portland Vase was his crowning achievement. The original (glass) Portland Vase was made in Rome around 25 B.C.E.

Wedgwood's success as a manufacturer turned out to be the "useful" rather than the "ornamental" ware. It was slip cast, made by pouring liquid clay into plaster molds, and could be rapidly produced in quantity. Designs were chosen from a pattern book (Fig. 537) and printed mechanically onto the pottery. Because of this efficiency in production, a quality tableware was available to middle-class European and American markets.

The Arts and Crafts Movement

As mass production became more prevalent in England, the quality of goods declined. As early as 1835 there was a general consensus among British industrialists that England was lagging behind in quality design. This led a designer named Henry Cole to organize the Great Exhibition of 1851. The exhibition demonstrated, once and for all, just how bad things really were! One observer commented: "We have no principles, no unity; the architect, the upholsterer, the weaver . . . run each their independent course; each struggles fruitless-

ly, each produces in art novelty without beauty, or beauty without intelligence."

The Crystal Palace (Fig. 538), the building which housed the exhibition, was a different matter. Totally without precedent, it was designed by Joseph Paxton, who had no formal training as an architect. Constructed of over 900,000 square feet of glass set in prefabricated wood and cast iron, it required only nine months to build, was three stories tall, and measured 1,848 by 408 feet. It hailed in a new age of architecture.

While the Crystal Palace received high accolades from some architects, not everyone concurred. A.W.N. Pugin, who had collaborated on the Gothic style Houses of Parliament, referred to it as a "glass monster." John Ruskin, a champion of preindustrial Gothic style, called it a "cucumber frame." Under their influence, William Morris, a poet, artist, and ardent socialist, dedicated himself to a renewal of English design through a renewal of medieval craft traditions. Morris asked architect Philip Webb to design and build a house for him in "medieval spirit." His Red House (Fig. 539) was the antithesis of Paxton's Crystal Palace, and signaled, Morris hoped, a return to craft traditions.

Morris was frustrated in his initial attempts to furnish the house. Nothing seemed to match the house's medieval nature, so he founded his own firm (eventually Morris and Co.) to build furnishings that would satisfy his tastes. The company began producing stained glass, painted tiles, furniture, embroidery, metalwork, etc. Morris longed for a return to the handmade craft tradition for two reasons—1) he felt mass production alienated men from their labor, and 2) he missed the quality of handmade items. In his design, Morris constant-

ly emphasized two principles, simplicity and utility. *The Woodpecker* tapestry (Fig. 540) seems anything but simple in its design, but for Morris, simplicity was defined as natural and organic. The pattern possesses, in Morris's words, "a logical sequence of form" and is beautiful as long as it's in accord with nature.

Morris's desire for simplicity led him to create what he called "workaday furniture," as illustrated by the company's Sussex Rush-Seated Chairs (Fig. 541). These were meant to be simple and appeal to the common man. Morris, like Wedgwood, also produced more ornamental furniture which he called "state furniture." An example is the sofa designed by Morris's friend Dante Gabriele Rossetti (Fig. 542), infinitely more ornamental and plush than any of the rush-seated furniture.

By the 1870s, embroidered wall hangings were among the most popular items produced by Morris and Co. At first, Jane Morris (his wife) headed the group of women who were the company's embroiderers, but eventually his daughter May took over the section. May Morris trained many women in the art of embroidery, and many of the designs attributed to her father were actually created by her (Fig. 543). Morris claimed his purpose as a designer was to elevate the circumstances of the common man. But common people were in no position to afford the elegant creations of Morris and Co. It was the expensive creations such as the state furniture and tapestries, purchased by the wealthy, which kept the firm afloat. Morris finally had to conclude that the handcrafted tradition made any object prohibitively expensive. He had to recognize the necessity of mass manufacture.

In the United States, Gustav Stickley's magazine *The Craftsman* was the most important supporter of the Arts and Crafts tradition. Stickley's furniture became popular throughout the United States. Machine manufactured, it was massive in appearance and usually lacked ornamentation (Fig. 544). Its aesthetic appeal depended upon the beauty of its wood.

By the turn of the century, architect Frank Lloyd Wright was deeply involved in furniture design. Like Morris, Wright was designing furniture (Fig. 545) to complement his Prairie Houses such as the Robie House in Chicago. "It is quite impossible," Wright wrote, "to consider the building as one thing, its furnishings another, and its setting and environment still another." His design of the table lamp for the Dana House (Fig. 546) is based on the Sumac plant motif used throughout the house.

The furniture designs of Morris, Stickley, and Wright point to some key issues in twentieth-century design. The first is the tension between the handcrafted and the manufactured. The second concerns formal issues: Wright and Morris believed in "simplicity," but each applied the word differently to design. For Morris, simplicity was the organic design of nature, for Wright, it was related more to geometric abstraction and plainness. The history of design demonstrates the continuous choice between organic and geometric.

Art Nouveau

In 1895, Siegfried Bing opened a shop in Paris called the Galleries de l'Art Nouveau. It was successful, and in 1900, Bing opened his own pavilion at the Universal Exposition in Paris. By the time the exposition ended, Art Nouveau had come to designate not only the work Bing displayed, but an international decorative arts movement. Bing had visited the United States in 1894, and was most enthusiastic about American arts and crafts, particularly the work of glassmaker Louis Comfort Tiffany. Tiffany's work inspired Bing to create his new design movement, and he contracted with the American to produce a series of stained glass windows designed by such French artists as Toulouse-Lautrec and Bonnard. Since the electric light bulb was phasing out traditional oil lamps, Bing also placed emphasis on new modern modes of lighting. Tiffany's stained glass lamps (Fig. 547) brought a new sense of color to an interior space.

Bing also admired Tiffany's iridescent Fabrile glassware, in which every detail is built up by hand by the craftsperson out of what Tiffany called "genuine glass," rather than having the details painted or etched on the surface. In the Peacock Vase (Fig. 548) we can see many of Art Nouveau's typical design characteristics (self-conscious asymmetry) and motifs (peacock feathers). The formal vocabulary of Art Nouveau consisted of anything organic and undulating, including women's hair, as in Jan Van Toorop's *Delftsche Slaolie* (Fig. 549) advertising poster for salad oil.

The organic qualities of Art Nouveau lent themselves to an intensely personal style. In the work of Spanish architect Antoni Gaudí, a level of formal invention was attained that becomes one of the most important artistic impressions of the period. Gaudí's Church of the Sagrada Familia (Fig. 550) is a twisting, spiraling, almost fluid, mass of forms, as if the masonry had been transformed into something pliable.

Still, some found Art Nouveau excessively subjective and personal. In Vienna,

Art Nouveau (called *Jugendstil*—the style of youth) gave way to simple geometry and symmetry. The Viennese architect Josef Hoffman designed the Palais Stoclet (Fig. 552) to be geometrically simple and plain. By contrast the interior was luxurious. For Hoffman, the interior of the house was a private space, a place where fantasy and emotion could have free reign. Erotic mosaics such as *Salomé* (Fig. 551), designed by the artist Gustav Klimt, adorned the interiors. Because of buildings like the Palais Stoclet, Art Nouveau became associated with an interior world of aristocratic wealth, while realizing the necessity of suggesting order, simplicity, and control in its exteriors.

Art Deco

In 1925, The Exposition Internationale des Arts Décoratifs Industriels Modernes opened in Paris. A very influential event, the exposition was the showcase of the style of design called Art Moderne, better known as Art Deco.

Throughout, the emphasis was on French fashioned luxury. There was no evidence of the practical side of design. Herbert Hoover, then Secretary of Commerce, declined to enter an American exhibit. "Works admitted to the Exposition must show new inspiration and real originality," Hoover explained. "Americans cannot meet the requirements."

The Cabinet designed by the French company Süe et Mare (Fig. 553) is typical of Art Deco at its most elaborate. It was made of ebony, preferred by Art Deco designers, due to its rarity and expense, and inlaid with mother of pearl, abalone, and silver. This richness of materials, together with the slightly asymmetrical design of the doors, link the cabinet to the Art Nouveau movement which preceded it.

There was another style of Art Deco that preferred more up-to-date materials such as chrome, steel, and Bakelite plastic, and gave expression to the speed of everyday "moderne" life. The Skyscraper Bookcase (Fig. 554), by Paul T. Frankl, is maple wood and Bakelite that referenced the American skyscraper. Benito's *Vogue* magazine cover (Fig. 555) and the corset advertized in an earlier issue (Fig. 556) demonstrate an impulse toward simplicity and rectilinearity comparable to Frankl's bookcase. Both artists' direction mirrored the world of fashion, and the boyish silhouette with the "Eton crop" became the hairstyle of the day.

The Avant-Gardes

At the 1925 Paris Exposition, French architect Le Corbusier's pavilion *Pavilion de l'Espirit Nouveau* (Fig. 557) stood apart from the rest. Le Corbusier rejected the decorative art that dominated the exhibition's theme and stated that decorative art was "a dying thing." This attitude naturally horrified the promoters of the exhibition, who did their best to conceal his pavilion of concrete, steel, and glass. Le Corbusier's determination prevailed, and, he said, "1925 marks the turning point between old and new." To Le Corbusier, the expensive handcrafted objects in the exposition were antiques in a contemporary world. The modern world was dominated by the machine. "The house," declared Le Corbusier "is a machine for living."

The geometric starkness of Le Corbusier's design had been anticipated by developments in the arts previous to World War I. Avant-garde ("advance guard") artist groups had sprung up who were ded-

icated to overturning traditional rules of art making.

One was the Dutch **De Stijl** ("the style") group, which, like other movements, took its lead from the paintings of Picasso and Braque. The De Stijl artists (chief among them—Piet Mondrian) simplified visual vocabulary even further, employing only primary colors—red, blue, and yellow, plus black and white. Their designs relied heavily on the vertical and horizontal grid, broken occasionally by a circle or diagonal line. Rather than enclosing forms, their forms seemed to open up in the space surrounding them.

Gerrit Rietveld's *Red and Blue Chair* (Fig. 558) is a summation of De Stijl design principles. His Schroeder House (Fig. 559) is an even further extension. The interior of the house is completely open in plan, as openness was essential to Rietveld. Space implies movement, and Rietveld's design created a dynamic situation that might, idealistically, allow the residents to release their own creative energies.

The idea of dynamic space can also be found in the work of the Russian **Constructivists**, who worked in the post-revolutionary Soviet state. The artist, they believed, should "go to the factory where the real body of life is made." El Lissitzky's poster *Beat the Whites with the Red Wedge* (Fig. 560) is a formal design with propagandistic aims. It represents the "red" Bolshevik cause (the triangle) attacking the "white" static circle. Along with obvious sexual overtones, it also illustrates an orientation of attacking from "the left."

Geometrical simplification can also be found in Aleksandr Rodchenko's design for a catalogue cover (Fig. 561) for the Russian exhibition at the 1925 Paris Exposition. Rodchenko also designed the Worker's Club, part of the Soviet exhibit at the exposition, and the cover embodies the design of the space. The furniture was simplistic and versatile, chairs could be stacked and folded, tables turned on their sides could function as screens or display boards. Red, white, grey, and black were the only colors.

Russian Constructivism was perhaps best expressed in Tatlin's design for the *Monument to the Third International* (Fig. 562). Though never actually built, a model did appear at the 1925 Paris Exposition. Its steel frame was deliberately reminiscent of the Eiffel Tower, and the intent was that it would become, at a height of 1300 feet, the tallest building in the world. The spiraling steel was to contain three monumental glass elements, a cube, a cylinder, and a pyramid, the essential forms of Constructivism, and each would revolve within the tower at different speeds. Furthermore, each element served as administrative offices of the Communist International.

The French abstract painter/designer Sonia Delauney also contributed to the geometric abstraction at the 1925 Paris Exposition. Every evening Delauney dressed 20 models in her geometric clothing designs and paraded then through the grounds (Fig. 563).

The Bauhaus

At the German pavilion at the 1925 Exposition, a number of machines designed to make living easier were on display. Among them were a washing machine and dryer and, when asked "who could afford such items," Walter Gropius, founder of the Bauhaus School of Design in Germany replied, "To begin with, royalty—later on, everybody."

Like Le Corbusier, Gropius saw the machine as the salvation of humanity, and he sympathized with Le Corbusier's difficulty in finding modern "machine age" furniture for his Pavilion de l'Espirit Nouveau. Ironically, at that moment, Marcel Breuer, a furniture designer at the Bauhaus, was creating such furniture. Inspired by a tubular steel bicycle he had purchased, Breuer decided the material was perfect for modern furniture, and set about designing the first tubular steel chair, of which the *Club Chair* (Fig. 564) is a refined version. It was easily mass produced and is still in production today. When Gropius saw how succinctly Breuer's design typified the machine-age concept he was seeking, he had Breuer design the furniture for the new Bauhaus at Dessau. As a result, Breuer's furniture became totally identified with the Bauhaus.

The Bauhaus was much more, however. Gropius was determined to break the barriers between the Crafts and Fine Arts. He felt, in fact, that there were no "teachers" either, but rather just "masters, journeymen and apprentices." The curriculum he defined has influenced many schools of art to follow. It consisted of a basic course of two- and three-dimensional design, color theory, and in-depth study of each of the media. All of this would culminate in what Gropius believed was the "ultimate aim of all creative activity—the building." Herbert Bayer's cover design *Bauhaus 1* (Fig. 565) supports this idea. Each of the three-dimensional forms casts a two-dimensional shadow. Bayer included his own universal type, references to mechanical drawing, and finally the illustrated article itself, which is a treatise on architecture.

Streamlining

As the geometry of the machine came to dominate design of the 1930s, a much more organic and curvilinear design was rapidly gaining acceptance. In 1926, the Daniel Guggenheim Fund for the Promotion of Aeronautics granted $2.5 million to four universities for the development of "windtunnels." Designers soon began to "wind tunnel test" cars, boats, planes, and trains and found that by rounding the edges of these objects, the air would pass around them with less drag, requiring less energy to power them. This led to the innovation of streamlining.

The nation's railroads were the first to take advantage of this new information, and the first streamlined train, the Zephyr (Fig. 566), took its maiden voyage in 1936. The trip normally required 26 hours for the standard passenger train to complete, but was completed by the Zephyr in just 13 hours. The railroad was enthralled by the train's efficiency, the public by the train's speed. The Zephyr became the symbol of the new age.

Wind tunnel testing revealed that the ideal streamlined form most closely resembled a teardrop. A long train could not achieve such a shape, but an automobile could. In 1934, Chrysler corporation revealed their streamlined auto, the Airflow (Fig. 567). The inspiration for this car came from Norman Bel Geddes. Geddes was a designer who, after the stock market crash of 1929, assigned his staff a series of imaginative projects that might impact a more positive future. Among them was Airliner #4 (Fig. 568), designed in cooperation with Otto Koller, a veteran airline designer. the design plans of Airliner #4, along with other efforts of Geddes' team, were published in a book called *Horizons*, which was immensely popular with the public. This response prompted Chrysler to go ahead with production of the Airflow. Although the car never attained real popularity, and production soon ceased, Geddes was inspired to

continue streamlining everything imaginable. Speed was no longer at issue: style was.

Other designers, both in the U.S. and abroad, joined in. To be modern everything had to be streamlined, exemplified by the 1930s Dutch designed vacuum cleaner (Fig. 570) and Russel Wright's *American Modern Dinnerware* (Fig. 569).

The Forties and Fifties

Russel Wright's "American Modern" dinnerware also anticipated a shift away from design dominated by the right angle. In 1941, the Museum of Modern Art hosted a design competition entitled "Organic Design in Home Furnishings." First prize was awarded jointly to two Cranbrook Design Academy instructors, Charles Eames and Eero Saarinen. Under the direction of Eliel Saarinen, Cranbrook was in many ways similar to the Bauhaus, but considered to be more experimental.

The furniture submitted by Eames and Saarinen (Fig. 571) made use of organically shaped and molded plywood laminates. As Eames wrote, "the problem becomes a sculptural one." Eames collaborated with his wife, Ray Eames, also a Cranbrook graduate, on the Side Chair (Fig. 572), which the Herman Miller Co. produced. The effect is elegant and dramatic, combining organic plywood forms and floating them on steel rods. Eero Saarinen sought a more unified organic approach, of which his Tulip Pedestal Furniture (Fig. 573) is an exceptional solution.

An explosion of design came about at the end of World War II as a result of the demobilization of 12 million American men and women and a subsequent wave of consumerism. Passenger car production soared from 70,000 units a year in 1945, to 6.6 million by 1950, to almost ten times that by 1960. In keeping in line with the new organic furniture of the 1950s, cars began to have fins added to them, inspired in part by the U.S. Air Force's P38 fighter plane. Fins on cars became bigger and bigger, reinforcing the adage "bigger is better." The Cadillac Fleetwood (Fig. 574), in many respects, represents the excess of American style during this time period, which saw the advent of fast food, Las Vegas, *Playboy*, and a TV in every home.

Still, there were some statements of true elegance in design during this time period. Swiss graphic designer Armin Hofmann's poster for the ballet *Giselle* (Fig. 575) is among them, which combines the image of dance with the spirit of dance.

Contemporary Design

One way to view the evolution of design since the 1960s is to recognize that organic versus geometric concerns were being incorporated together. Hofmann's graphic design and the Eames's chair state this idea quite eloquently.

Another consideration has been indicated in the discussion of Postmodernism: the willingness to incorporate anything and everything into a given design. In our age of rapid-paced communication, we are approaching a plurality of styles. Stylistic pluralism in contemporary design can be illustrated by looking at several examples of corporate identity packages. We will compare a traditional corporate identity package with a Postmodern one.

Works in Progress
Fred Wilson's *Mining the Museum*

Fred Wilson is a contemporary museum curator who has challenged the notion of the coherent, homogeneous exhibition space. From the "white room" effect, where all the walls are white, to more elaborate design ideas such as evenly designed installations —the principle of an intellectually coherent space predominates.

Wilson believes that this traditional curatorial stance has caused most museums to "bury" or ignore works that do not fit easily into the dominant "story" that the museum tells. In 1992, Wilson was asked to install an exhibition at the Maryland Historical Society. Wilson saw it as an opportunity to reinterpret the Historical Society's collection and present a larger story about Maryland history than the museum was used to telling. In the archives and collections of the museum, Wilson found a wealth of never exhibited material that related to a part of embarrassing Maryland history—slavery. Wilson intermixed these objects with elements of the collection that viewers were used to seeing.

Behind a "punt gun" ostensibly used for hunting game birds on Chesapeake Bay, Wilson placed reward notices for runaway slaves. An inventory of the estate of one Nicolas Carroll (Fig. 576) lists his slaves and animals, and their estimated value. Most disturbing—the "negro woman Hannah seventy-three years of age," valued at a mere one dollar, less than the "old Mule called Coby." Fine silver repoussé objects (Fig. 578) are placed next to iron slave shackles, a reminder that Maryland's luxury economy was built on slavery. Similarly, in a display of Maryland cabinetmaking, he

placed a whipping post (Fig. 577), which was used until 1938, in front of the Baltimore city jail.

Ironically (or not) the museum had marble busts of Henry Clay, Napoleon Bonaparte, and Andrew Jackson, none of whom had any particular impact on Maryland history, but had no busts of three great black Marylanders, Harriet Tubman, Frederick Douglass, and the astronomer and mathematician Benjamin Banneker. Thus, at the entrance to the museum, across from the three marble busts in the museum's collection, he placed three empty pedestals, each identified with the name of its "missing" subject.

"Objects," Wilson says, "speak to me. I am trying to root out ... denial. Museums are afraid of what they will bring to the surface and how people will feel about issues that are long buried. They keep it buried, as if it doesn't exist...instead of opening that sore and cleaning it out so it can heal."

Stylistic pluralism in contemporary design can be illustrated by looking at several examples of corporate identity packages and comparing a traditional corporate identity package with a Postmodern one. In the first case, we can see how the Coca-Cola bottle (Fig. 579) has changed over the course of the years. The bottle was "streamlined" in 1957 by Raymond Loewy to reflect the style of the day. Yet the lettering itself remains virtually unchanged since 1886. Coke claims that more than 90 percent of the world's population recognize the bottle.

By contrast, The MTV logo (Fig. 580) and the designers of Swatch Watches (Fig. 581) conceive of their design identities as

kinetic and ever-changing variations of a basic theme. Corporations, product manufacturers, and television networks all follow this lead of tailoring their images, products, or programs to target specific groups. The Swatch Watch examples depicted in the text are just 8 of 300 versions available that all address various cultures and styles.

Pluralist vision is also represented in the design works of graphic designers April Greiman and Jayme Odgers (Fig. 581). In the words of one critic, designs such as this "make opposites play on a common field: East/West, Stability/Change, Order/Randomness . . . Tension/Balance, Technical/Tribal, Classic/Eclectic . . . Cerebral/Sensual, New Wave/No Wave."

The development of the pluralist aesthetic has been amplified by reaction in the design community against the "good taste" of aesthetic mass consumption. A chief figure in this movement is the Italian designer Ettore Sottsass, who spearheaded a design group called Memphis in the mid 1970s. For Sottsass, personal expression takes precedence over mass appeal. His *Casablanca* cabinet (Fig. 583) functions as a cabinet, but is primarily a visual statement. As one Memphis designer has put it, "Industry must face up to a new strategy of production, no longer ...seemingly objective (and substantially anonymous), but personal and subjective...From high tech and high touch."

THE CRITICAL PROCESS
Thinking about Design

Consider how consumer spaces—from boutiques, restaurants, arcades, and malls—have increasingly appealed to a highly subjective sense of taste. Nigel Coatess Caffè Bongo in Tokyo, Japan (Fig. 584), is, in a sense, "disposable architecture," made to appeal to the taste of the moment—but what a plurality of tastes! It also captures Coates's notion of the contemporary urban experience: "...the imprint of one reality on another." Identify the various "realities" in the work. The airplane wing, the statuary, the Greek order column in the back wall and rear entrance all seem randomly eclectic, or are they? Are styles indicated by the brickwork or the steel I-beams? Finally, what does this space reveal about Coates's attitude toward the idea of stability and per-

206

REVIEW QUESTIONS

Answers to the following questions appear in the APPENDIX: ANSWER KEY at the end of the *Study Guide*.

1. Fill in the blanks: Wedgwood's _____ ware is to his ornamental ware

 as Morris's _____ furniture is to his state furniture.

2. What motivated William Morris to start Morris and Co.?

3. For Morris, "simplicity" is, by definition,

 a) something to be avoided.
 b) the natural and the organic.
 c) the chief ill of British design.
 d) unnatural.

4. In what city were both Art Nouveau and Art Deco introduced?

5. Which of the following are characteristic design elements in Art Nouveau?

 a) peacock feathers
 b) cubes and squares
 c) vines
 d) machine forms

6. According to Le Corbusier, a house is a _____.

7. What is at the center of the Bauhaus curriculum?

8. For Ettore Sottsass, in a reversal of traditional design philosophy, personal expression takes precedence over_____.

SUPPLEMENTAL ACTIVITIES AND WRITING ASSIGNMENTS

Supplemental Activities: Go to any of the several large chain stores such as Target or Wal-Mart and try to find items that you think are well designed, that is, that are both aesthetically pleasing and functionally useful. You will find that it is harder than you might think, and you will be surprised at some of the things that turn out to be well designed. (Good examples of superior design can be discovered, for instance, in the garden supply area—sprinkler heads, hose couplings, and so on.) With budgets limited to $5 per person, whole classes have conducted this exercise. The resulting displays have proven both amusing and stimulating, giving rise to important discussion about just what mades for good design.

The Website: Go to the *World of Art* website (**www.prenhall.com/sayre**). Proceed through the Chapter 17 materials. Consider your command of the objectives as stated in the website. Take the multiple choice and fill-in-the-blanks self-tests. Briefly respond to both the critical analysis and the compare and contrast questions, either formally or informally. Visit the related sites linked in both the Modern Artists and Galleries and Museums areas. A hands-on project related to the course material is suggested. Even if you are not assigned the Project, think about how you might approach it. Finally, consider participating in the Message Board or Chat Discussions.

Writing about Design: One of the primary features shared by most of the examples of design in this chapter is their preference for asymmetrical balance. Detail some examples. Can you surmise why it is that designers might lean toward asymmetrically balanced designs?

Writing to Explore New Ideas: A design issue not dealt with in this chapter that has become increasingly important in recent years is *ergonomics*—the physical relation or interface between the object and its user. Consider the objects represented in this chapter. Which are the least friendly, ergonomically speaking? Which are the most? What role does ergonomics play in your daily life? How important is it in contemporary design and why?

Suggested Further Reading: The classic text on the history of design is Nikolaus Pevsner's 1968 *The Sources of Modern Architecture and Design*, now published by Thames and Hudson.

More recent books include Peter Dormer's *Design since 1945* (Thames and Hudson, 1993) and Jonathan M. Woodham's *Twentieth-Century Design* (Oxford University Press, 1997).

Study Guide Lessons for

Chapters 18 - 22
The Visual Record:
Placing the Arts in Historical Context

A Note to the Student

The last five chapters of **A World of Art** are a brief historical survey of the history of art. They serve a different function than the first seventeen chapters, which are designed to give you the tools to approach any work of art, no matter its historical period or origin, and to help you understand the formal elements, principles of design, and questions of media informing its creation. The last five chapters are companion chapters to the first seventeen. They fill in the historical context of the works discussed earlier. You and your instructor can approach them in a number of ways: as material to be read and assimilated as you work through the earlier discussions; as a capstone to the book; or even as something that you can more or less ignore given that a full-fledged history of art course is generally the next level of class offered after art appreciation in most curricula. We recommend that you at least familiarize yourself with the material in these chapters, since we believe some familiarity with this historical material will help you understand more fully much of the work discussed in the first three-quarters of the book. These chapters are extremely condensed histories. We have, as a result, dispensed with the format of the the study lessons used in Chapters 1 through 17. There is no need to provide you with an Overview of what is already an overview. What follows, then, are outlines of the key concepts and historical events that are discussed in each of the last five chapters.

LEARNING OBJECTIVES

These lessons are designed to help you place the works of art discussed so far in **A World of Art** into a broader historical context. At the end of these lessons you should:

1) Be able to outline the major developments and movements in art from the earliest to the most recent times.

2) Have some sense of the historical events that are contemporaneous with the developments and movements in art.

3) Given a period or style, be able to outline its characteristics and recognize clear examples of it.

Chapter 18
The Ancient World

Period/Style	Principle Social Issues and Historical Events
(dates indiate beginning point of a period or style)	

Paleolithic Period (25,000 B.C.E.)
"Paleo" from the Greek *palios*, meaning "old"; *lithos*, meaning "stone."

Sophisticated abstraction in stone, "Venus" figurines (*Venus of Willendorf*, Fig. 586). Cave paintings at Chauvet, Lascaux, and other sites (Figs. 587 and 588) exhibit remarkable sense of dynamism. First examples of pigment being placed on a ground.

Modern humans arrive in Europe. Sense of community through small established groups, or "clans." Belief in "magic" as an explanation for virtually all natural phenomena, including procreation.

Technology limited to stone tools and artifacts. Shelter limited to existing cave dwellings or other preexisting natural forms of protection.

Neolithic Period (8000 B.C.E.)
At sites such as Çatal Hüyük (Fig. 589), Neolithic peoples abandon temporary shelters for permanent housing built of wood, brick, and stone. By 4000 B.C.E. **Sumerian Culture** flourishes in Tigris and Euphrates valléys. Small figurines representing various gods possess enlarged eyes that represent "windows to the soul"(Fig. 591).

Domestication of plants and animals. Large societal communities established. Development of "body and soul" concepts.

Architecture (*ziggurat*) "bond between Heaven and Earth" reflects monotheistic culture. Concept of singular god residing in the "heavens."

Egyptian (Old Kingdom) (3000 B.C.E.)
Canon of proportion established in figurative art—rigidity reflecting strength of Pharaoh (*Palette of King Narmer*, Fig. 592, and *King Khafre*, Fig. 593).

Development of pyramids. Pharaoh, son of Ra, possesses soul called "Ka." Mummification to preserve body and soul.

Egyptian (New Kingdom) (1400 B.C.E.)
Akhenaten style features flowing naturalistic portraiture in sculpture and painting. (*Queen Nefertiti*, Fig. 594, chest from King Tut's tomb, Fig. 595, and *Acrobatic Dancer*, Fig. 597).

Relaxing of strict Egyptian religion, societal focus shifts from preoccupation with death to celebration of life.

Aegean Civilization (Crete) (1600 B.C.E.)
Stiff figurative representation, broad shoulders and narrow waists, but, still, demonstration of strong movement, in both sculpture and newly developed medium of

Theocratic society, practice of fertility rites, Chief Deity, fertility snake goddess. Sports and athletics revered, potentially influencing the Greek Olympic games.

fresco painting (*Snake Goddess*, Fig. 598, and *Toreador Fresco*, Fig. 599). Elaborate palaces constructed of both stone and wood.

Aegean Civilization (Mycennae) (1400 B.C.E.)
Large stone fortresses are built, "bee-hive tombs." Ceramic arts flourish, similar in style to Minoan (Cretan) imagery (*Warrior Vase*, Fig. 600).

Contemporary with Minoan culture. Warring and military strategies pivotal to society. Practiced burial of dead.

Greek Art (500 B.C.E.)
Development of art and architecture to reflect Greek concerns with order and rationality, with use of Golden Section as design element. Architecture developed along lines of three specific orders: Doric, Ionic and Corinthian (Acropolis, Fig. 601). Development of an unparalleled naturalistic style in sculpture (**Phidian Style**, see *Nike* from Temple of Nike, Fig. 602) and (by all accounts) painting.

Blended cultures of Mycennian and Doric mix. Beginning of Western culture as we know it.

Development of independent city-states.

Human body elevated to highest ideal. Gods given human form and human weaknesses.

Advent of philosophy, democracy, medicine, geometry, algebra, and astronomy.

Greek Art (Hellenistic) (325 B.C.E.)
Absolute naturalism of *Nike of Samothrace* (Fig. 604) and of Lysippos recalls classical age (*Victorious Athlete*, Fig. 603). Work also begins to demonstrate strong emotion (*Laocoön*, Fig. 605).

Greek Empire reestablished through Alexander the Great.

Collapse of empire, in all likelihood due to inept generals who succeeded Alexander.

Etruscan Art (750 B.C.E.)
Portraiture begins to reflect realism, largely from Greek influence. Preferred media are bronze and terra-cotta (*Mars*, Fig. 606, and *She-Wolf*, Fig. 607).

Established city-states ruled by powerful kings. Adopted Greek gods, believed in afterlife, buried their dead in tombs. Most powerful city-state was located at Rome, legend suggests by Remus and Romulus.

Roman Art
Adopted Greek naturalism, gods, and architectural orders. Contributed Realism in figurative sculpture and painting (*Ara Pacis*, Fig. 608, and *Ulysses in the Land of*

Developed Republic ruled by two consuls, public officials, and a senate.

the Lestrygonians, Fig. 609). Developed arch and dome. Architecture becomes symbol of the power (*Column of Trajan*, Fig. 610 and Roman Forum, Fig. 611).

Developments in Asia (1200–300 B.C.E.)
Animal style prevalent in earliest bronzes *(Ding,* Fig. 590) and reaches superb level of craftsmanship in China (*Flying Horse,* Fig. 612). The *Ritual Disc with Dragon Motif (Pi)* disc reveals China's desire for unity (Fig. 613). Development of *stupas* (Fig. 614) in India, dome-shaped (resembling the earth) shrines housing relics of Buddha.

Republic ends with victory of Octavius Augustus, beginning of Empire that would dominate the Western world.

Shang dynasty, whose great art form is bronzes, rules China 1766–1122 B.C.E.

Chinese empire dissolves into numerous warring feudal states by sixth century B.C.E.

Confucius born 551 B.C.E.; development of Confucian principles for living. Advent of Taoism, becomes primary Chinese philosophy.

China united by Shih Huang Ti in 221 B.C.E. Building of Great Wall.

Birth of Buddha (Siddhartha Guatama) in 537 B.C.E. Rise of Buddhism, with its belief in reincarnation and Nirvana.

Chapter 19

The Christian Era

Early Christian Art (to 1000 C.E.)
Development of Christian **basilica** from Roman (Greek) longitudinal plan. (Church of Sant' Apollinaire, Fig. 615; see also Old St. Peter's, Fig. 502).

Early Byzantine Art (to 1000 C.E.)
Byzantine church architecture characterized by domed central plan (Santa Costanza, Fig. 616; San Vitale, Fig. 617; and Hagia Sofia, Figs. 620 and 621). Mosaic becomes highly developed art form. Naturalism and realism totally lost

Constantine legalizes Christianity in Edict of Milan, 313 C.E. Constantine moves throne of empire to Byzantium, renamed Constantinople. Beginning of Byzantine culture, eastern "orthodox" religion.

Gradual decline of Western empire, Rome sacked by various nomadic groups. Byzantine empire begins to flourish.

Emperor Justinian assumes Byzantine throne in 527. His projects are unsurpassed, with Hagia Sophia his crowning achievement.

as portraiture styles (*Theodora and Her Attendants*, Fig. 618, and *Justinian and His Attendants*, Fig. 619). In late Byzantine art, Hellenistic naturalism begins to reappear, for instance, in the thirteenth-century *Christ* in Hagia Sophia (Fig. 622).

Muslim empire gains strength, begins encroachment upon Byzantine empire.

Christian Art (Northern Europe) (550–1000 C.E.)

Animal style characteristic of western European tribal groups (Sutton Hoo clasp, Fig. 623) fuses with Christian imagery.

Establishment of monastic system in Ireland. Premier centers of learning and scholasticism, preservation of writing. In 597, St. Augustine brings Christianity to England. Revival of visual arts in monasteries.

Melding of Roman and Celtic styles, awkward figurative art (*Lindesfarne Gospels*, Fig. 624).

Roman style becomes more deeply fused due to Charlemagne. Gradual improvement in figurative art in **Carolingian** art (*St. Matthew*, Fig. 625).

Charlemagne conquers Franks in 771, and in 800 becomes Emperor of the Holy Roman Empire. Establishes monastic system throughout Europe.

Romanesque Art (1050 C.E.)

Though Roman basilica style still stressed, beginning of recognizable style of architecture featuring rectangles, cubes, cylinders, and half cylinders. Wooden roofs replaced with stone (Cluny, Fig. 620; see also St. Sernin, Figs. 488–90). Reemergence of sculpture in cathedrals (Cluny capital, Fig. 626, and Gislebertus's *Last Judgment*, Fig. 628).

Dissolution of Holy Roman Empire, return to small feudal states called fiefdoms.

Pilgrimages to holy centers, Romanesque Cathedrals built. Pictorial imagery still dominant form of Christian education.

Building of Abbey of Cluny begins in 1085; stresses intellectual life, study of music, pursuit of the arts.

Gothic Art (French)

Church of St. Denis, outside of Paris is first Gothic cathedral, 1137 (Fig. 630). Pointed arch introduced, along with buttress system, lending extraordinary height to interior (Chartres cathedral, Fig. 629, and Cologne Cathedral, Fig. 631). Slender stonework and glass give aura of weightlessness.

Abbot Suger of St. Denis equates light in architecture with ethereal presence.

Secular age of towns, universities. Scholasticism dominates theology and philosophy.

Free-standing sculptural figures now used (Reims Cathedral, Figs. 633 and 634).

THE VISUAL RECORD

Gothic Art (Italy) (c. 1300)

Never full-fledged style as in the rest of Europe. Awkward blend of Roman with Gothic. Florence cathedral (Fig. 632) seems outwardly Romanesque, but with Gothic arches on interior. More naturalistic sculpture develops (Pisano's *Nativity*, Fig. 635).

Dante writes *The Divine Comedy* (c. 1300).

Developments in Islam and Asia (600–1100)

Principle form of Islamic architecture is the Mosque, featuring a tower (*minaret*) used in calling to prayer. Mosque at Samara (Fig. 636) largest in the world; Mosque at Cordoba (Fig. 637) gives sense of vast interior structure.

Islamic empire expands from 622 onward, consuming Syria, Palestine, and Iraq. Crusades to regain Jerusalem from Islamic control begin in 1096.

In India, Hindu temples covered with intricate relief sculptures, often erotic in nature (Kandariya Mahadeva Temple, Figs. 638 and 639).

In 1500 B.C.E. Aryan tribes from northern Europe invade India, bringing Vedic tradition which includes class system.

Development of Hindu religion, based on Vedic gods, headed by trinity of Brahma, Vishnu, and Shiva. Belief that carnal love was aspect of spiritual love, and path toward virtue and redemption.

Chapter 20
The Renaissance through The Baroque

Early Renaissance

The period is marked by an ever increasing naturalism. In the illuminated manuscript *Les Très Riches Heures du Duc de Berry* (Fig. 640), humans cast shadows and architecture is rendered with some measure of perspectival accuracy. In architecture, Brunelleschi's sense of measure, order, and proportion, evidenced in his design for Florence Cathedral, leads him to the invention of linear perspective. In sculpture, Donatello depicts the human body in motion in the first lifesize nude since antiquity (*David*, Fig. 641). And in painting, Masaccio's *Tribute Money* (Fig. 642) is dramatically more realistic than any painting before it.

In Flanders, works like Rogier van der Weyden's *Deposition* (Fig. 643) reveal extraordinary, realistic effects oil painting makes possible. Northern painting seems emotionally charged beside the mathematical certainties of Italian painting (compare Piero della Francesca's *Flagellation of Christ*, Fig. 644).

An era characterized by what Petrarch called, as early as the 1330s, a new Humanism, a philosophy emphasizing the value of each person.

In 1485, the philosopher Pico insists that no man should be constrained by any limits, giving rise to the Renaissance ideal of genius.

The Medici family supports the arts in Florence, Italy, making it the cultural center of the Renaissance.

In Northern Europe, rising merchant class promotes artistic developments rivaling those of Florence.

High Renaissance

Botticelli's *Birth of Venus* (Fig. 645) embodies Neoplatonic thought.

The three great artists of the Renaissance—Leonardo, Michelangelo, and Raphael—converge on Florence at the beginning of the sixteenth century. They embody the cult of genius—the Neoplatonist's divine insight—that marks the Renaissance.

In Florence, under the rule of Lorenzo de' Medici, Neoplatonic thought predominates, arguing that in the contemplation of beauty, the inherently corrupt soul can transform its love for the physical and material into a purely spiritual love of God. Reacting to the pagan subjects of Neoplatonic art, Savonarola denounces the Medicis and they are banished from Florence in 1494.

Leonardo, who had worked in Milan since 1481 for Ludovico Sforza designing war machines such as illustrated in his *Scythed Chariot, Armored Car, and Pike* (Fig. 646) and had painted *The Last Supper* there as well, returns to paint the *Mona Lisa* (Fig. 647). Raphael arrives in 1504 to find Leonardo and Michelangelo competing for a commission to decorate the city council chamber. In 1508, he paints the papal apartments in the Vatican in Rome with frescoes, including *The School of Athens* (Fig. 648).

The papacy in Rome attracts artists from Florence, including Raphael and Michelangelo, to work at the Vatican. Balance, serenity, perfection, and beauty of forms characterize the High Renaissance.

Renaissance ideals quickly spread to Venice where Giorgione and Titian develop a painting style of blurred edges, softened forms, and sensually expressive line (see their two Venuses, Figs. 649 and 650).

Venice grows prosperous from trade, and a succesful merchant class creates a city-state free of despotic rulers and conducive to intellectual freedom and exploration.

In the North, Albrecht Dürer, who traveled to Italy in 1495 to study, strives to establish Renaissance ideals in Germany. Sensing the importance of the individual, he paints many self-portraits (Fig. 651), synthesizing the northern love for precise and accurate naturalism with the southern idealist desire to transcend the world of real things.

Writers like Erasmus and Luther introduce Germany to Humanistic ideals. The Reformation leaves the Netherlands split into Catholic Belgium and Protestant Holland. In France, Italian masters are brought to the court of Francis I.

Art in China
Self-expression in the arts, favored by Taoist teaching, embodied in landscape painting, are considered the highest form of artistic endeavor. In landscape, the artist seeks to reveal the *li*, or "principle," upon which the universe is founded (see Guo Xi's *Early Spring*, Fig. 652).

The Venetian Marco Polo visits China in 1275, establishing himself as the favorite of the Mongol ruler, Kublai Khan. Returns to Venice in 1295.

Kublai Khan rules as a tyrant, forcing artists into exile.

In 1368, the Mongols are overthrown. Ming dynansty is founded.

Exiled artists make surreptitously political art, bamboo representing a plant that like the Chinese people will bend but not break under Mongol rule (Fig. 653), and orchids symbolizing an art that flourishes without soil around its roots (Fig. 654).

Pre-Columbian Art

Olmec culture is centered at La Venta, a city centered around a pyramid facing a courtyard on an astronomically determined axis, and is the basis of planning in Mexico and Central America for centuries to come. Giant stone heads (Fig. 655) dominate the courtyard.

Mayan culture reaches its peak at Teotihuacán. Narrative relief sculpture predominates their art (*Great Dragon*, Fig. 656).

Aztecs celebrate the calandar, two of which had achieved widespread use in Pre-Columbian cultures since the sixth century B.C.E., one the traditional 365-day calendar based on the sun, the other a 260-day calendar based on the length of human gestation. *Coatlicue* (Fig. 657), with two fanged serpents symbolic of flowing blood, connects to menstruation and the 260-day calendar.

Art in Mexico realized in three major cultures—the Olmec (1500–300 B.C.E.), the Maya (300–900 C.E.), and the Aztec, whose culture is not even 200 years old when Hernán Cortes conquers Mexico in 1519.

Aztec capital is Tenochtitlan (now Mexico City), described by one of Cortes's men as "a dream."

Mannerism

A conscious rejection of the High Renaissance's emphasis on balance and proportion, Mannerist art emphasizes dramatic theatricality, as well as technical virtuosity, highly individualistic style, and consciously artificial, or *mannered*, expression (Michelangelo's *Last Judgment* in the Sistine Chapel, Fig. 658, and Tintoretto's *Miracle of the Slave*, Fig. 659). Figures are elongated and colors are often bright and clashing (Bronzino's *Venus, Cupid, Folly, and Time*, Fig. 660). Often, more than one focal point is utilized, as in El Greco's *Burial of Count Orgaz* (Fig. 661), which also employs bizarrely elongated figures—a highly personal and abstract brand of painting.

Mannerism develops against a background of political, economic, and religious upheaval. Italy is invaded by the French and Spanish, and Rome is sacked in 1527. In the 1530s, Florentine independence ends and the state is made into a grand duchy under the crown of the Hapsburgs.

The Baroque

Anticipated by Mannerism, the Baroque is notable for its theatricality and drama (see Bernini's Cornaro Chapel, Figs. 664 and 665).

Bernini adds monumental oval piazza surrounded by colonnades to the front of St. Peter's (Fig. 662). But his taste seems conservative and classical next to Borromini's facade for San Carlo alle Quattro Fontane in Rome (Fig. 663), with its asymmetrical and eccentric invention.

Caravaggio's use of light is highly dramatic, but more important is his literalization of painting. Even his religious works seem to depict ordinary people in ordinary situations (*The Calling of St. Matthew*, Fig. 666). But the great master of light is a Northerner, Rembrandt van Rijn (*Resurrection of Christ*, Fig. 667).

In Northern Europe, where Protestantism reigns, secular works become especially popular. Still life, landscape, and genre painting prevail (Annibale Carracci's *Landscape with Flight into Egypt*, Fig. 668; Claude Lorrain's *Pastoral Landscape*, Fig. 669; and Jacob van Ruisdael's *View of Haarlem*, Fig. 670). The pastoral landscape is Edenic space, and the spiritual is found in nature.

An age of powerful, wealthy nations. Around 1600, in reaction to growing popularity of Protestantism, the Vatican takes action, intending to turn Rome into the most magnificent city in the world. But France, governed by the sun king Louis XIV, is the largest and most prosperous nation. England is a maritime power. Philip II unifies Spain, and with the vast wealth accumulated from the Americas inspires its Golden Age, the era of Cervantes and Velázquez.

Art becomes a commodity, a marketable product, as everyone from Spanish kings to wealthy Dutch merchants, to an increasingly large group of middle-class bourgeoisie with disposable incomes and the desire to refine their tastes, become patrons of art.

Chapter 21
The Eighteenth and Nineteenth Centuries

French Classicism

Evolves from Baroque and is epitomized by the classicism of Bernini's colonnade at St. Peter's. In architecture, Louis XIV completes the Louvre on the plan of a Roman temple (Fig. 671). Academic painting focuses on style of Poussin (*Landscape with St. John on Patmos*, Fig. 672). Color is repressed, classical order is stressed.

Science and technology advance, beginning the Age of Enlightenment. Louis XIV installs Charles Lebrun, who had studied in Rome with Poussin, as head of Royal Academy of Painting and Sculpture. A hierarchy of the arts develops with the best being the art of the Greeks and Romans and the worst being the genres of landscape and still life.

The Rococo

Emphasis on curvilinear style that typified the Baroque of Borromini, becomes more delicate and refined.

In 1715 Louis XIV dies. French society seems to embrace its own decadence; Parisian "Salon" society develops. Louis XVI and his Queen Marie Antoinette are seen as leading needlessly extravagant lives at the expense of the people.

Painting style is reaction to French Classicism, embraces Rubens (*The Arrival and Reception of Marie de' Medici at Marseilles*, Fig. 673), emphasizing color and theatrical nature of Baroque lighting (Vigée-Lebrun's *Duchess of Polignac*, Fig. 676).

Painting (Fragonard's *Bathers*, Fig. 674) and sculpture (Clodion's *Bacchante and Faun*, Fig. 675) both reflect motion and erotic themes.

Neoclassicism

Return of classic composition. Work becomes socially inspired, with underlying political themes (David's *Death of Marat*, Fig. 677). Virtue is the theme of much neoclassical art (Angelica Kauffmann's *Cornelia, Pointing to Her Children as Her Treasures*, Fig. 678). Dramatic lighting still used.

Discoveries of Herculeneum and Pompeii renew interest in classical themes.

Aristocratic "values" replaced with a social consciousness that questioned monarchies as viable governments. French Revolution in 1789 overthrows monarchy. French Republic is established, along with centralized government.

Architecture adopts Greco/Roman style directly. Thomas Jefferson brings style to U.S., where it becomes Federal Style (Fig. 679).

Napoleon rises to power.
Napoleon expands French holdings, crowns himself Emperor. Neoclassicism used to legitimize new "empire."

Ingres's style of Neoclassicism reflects slightly more sensual themes, less high moral tone (*Grand Odalisque*, Fig. 680). In fact, his work seems Neoclassical only in comparison to Romantic painting such as Delacroix's (*Odalisque*, Fig. 681).

Romanticism

Return to color, movement, and expressive treatment of subject matter. Political content dominates subject matter for many Romantic painters (Goya's *Saturn Devouring One of His Sons*, Fig. 682, and Gericault's *Raft of the Medusa*, Fig. 683).

Individuality and the power of the individual mind become prevalent social themes.

Tourism expands, as people travel to see natural beauty; writing of Thoreau and Emerson contribute to renewed interest in nature.

In landscape painting an emphasis on the sublime, man's insignificance in the face of the infinite (Friedrich's *Monk by the Sea*, Fig. 684, and Church's *Heart of the Andes*, Fig. 685).

Realism

Romantic idealism fades in favor of depictions of reality—the "here and now"—especially in the face of the reality of war—witness the increasing realism as we move from Goya's *Third of May, 1808* (Fig. 687) to Delacroix's *Liberty Leading the People* (Fig. 688) to Meissonier's *Memory of Civil War* (Fig. 689).

The notion of "modernity" is established. Baudelaire asserts that it is "necessary to be of one's own time."

Advent of photography brings about new vision of society. Social inequities examined in art and literature.

Courbet's style announces the end of Romantic painting style (*Burial at Ornans*, Fig. 690). The art of the past, exemplified by Daumier's depiction of Idealism in his cartoon (Fig. 654), is thought to be worn out. Painters such as Rosa Bonheur (*Plowing in the Nivernais*, Fig. 692), Edouard Manet (*Olympia*, Fig. 693), and

Marx writes the *Communist Manifesto*, which examines political inequities, demands a "reexamination of the ordinary."

Edgar Degas (*Glass of Absinthe,* Fig. 694) values the everyday, the commonplace, the low, and even the ugly.

Manet's painting style sets stage for Modernism, reevaluating and rejecting Renaissance ideals in representation.

Impressionism

Focus on pleasures of life, backing off from Realism and social Realism. **"Plein air"** painting, atmospheric perspective dominate style (Monet's *Impression-Sunrise*, Fig. 695, and Renoir's *La Moulin de la Galette*, Fig. 696). Leisure is their subject (Morisot's *The Artist's Sister*, Fig. 697).

Interest in optical mixing, dissolution of linear styles altogether. Paintings attempt to represent time as "a fleeting moment," to reflect the "presentness" of the scene (Monet's *Bridge over a Pool of Water*, Fig. 698).

Painting becomes an end in itself. Paint becomes interesting as paint (Whistler's *Nocturne in Black and Gold, the Falling Rocket*, Fig. 699).

Post-Impressionism

No dominant visual style, individual artists seek to extend the formal and symbolic possibilities offered by Impressionism.

Some critique the conditions of modern life as Manet and Degas had done (Toulouse-Lautrec's *At the Moulin Rouge*, Fig. 700). Van Gogh and Gauguin (*The Day of the God*, Fig. 701) explore the expressive possibilities of color and celebrate the "primitive." Georges Seurat experiments with the optical mixing of color even as he critiques the ideal of leisure (*The Bathers*, Fig. 702).

Progress of industrialization results in advent of a "leisure class." Painters such as Manet become notorious *flâneurs,* a man of impeccable taste and perfect manners whose sole occupation seems to be to stroll the city, observing its habits and commenting on it with flair.

Industrial development continues at rapid pace. Electric light, internal combustion engines, and advances in technology begin new era of synthesized energy, celebrated at Paris World's Fairs in 1889 and 1900. At the heart of each fair is the new monument to the future of architecture, the Eiffel Tower.

221

Cézanne places new emphasis on reevaluating both space and form, particularly the act of composition in *Still Life with Cherries and Peaches* (Fig. 703). Evaluating the world in terms of "the cone, the cylinder, and the sphere," he emphasizes the architecture of the canvas (*Mont Sainte-Victoire*, Fig. 704, and *The Large Bathers*, Fig. 705).

The motion picture camera is invented in 1895. Freud publishes his *Intepretation of Dreams* in 1900. As the new century dawns, Pablo Picasso, eighteen years old, makes his first trip to Paris from his home in Barcelona.

Chapter 22
The Twentieth Century

Cubism
After Picasso completes *Les Demoiselles d'Avignon* (Fig. 60) in 1907, Picasso and Braque embark upon Cubism, responding to Cézanne's advice to see the world in terms of the "cone, cylinder, and sphere" (Braque's *Houses at l'Estasque*, Fig. 706). The three-dimensional world is increasingly and insistently treated in two-dimensional terms (Braque's *Violin and Palette*, Fig. 707). Painting, they imply, is about painting.

In collage, Picasso and Braque allow for the placement of real objects directly into the composition.

Marconi's first radio transmission in 1901 and the Wright Brothers' 1903 flight at Kitty Hawk further reduce the sublime scale of the world. Henry Ford's Detroit automobile plant opens, and a new modern industrial spirit dominates the modern world.

The Fauves
Brilliant color used for expressive possibilities (Matisse's *Green Stripe*, Fig. 708, and Derain's *Westminster Bridge*, Fig. 710). This serves as another step toward abstraction in painting.

Einstein's Theory of Relativity in 1905 brings about a new notion of time and space. There are pluralistic themes in both art and society.

German Expressionism
Die Brücke—raw and direct style, expressionist artists embrace the wood block

A new model of the atom is presented by Bohr, profoundly affecting Wassily

print for its starkness and contrast. Themes of powerful emotion dominate.

Der Blaue Reiter—Kandinsky begins to explore color for its own expressive power. His *Sketch for Composition VII* (Fig. 709) considered first fully abstract expressionist work of the twentieth century. His color symbolism is adopted by other Blaue Reiter artists, including Franz Marc (*Large Blue Horses*, Fig. 711).

Futurism
Founded by Italian poet/writer Marinetti, Futurism champions speed, motion, energy, and the machine. Painting depicts movement (Balla's *Dynamism of a Dog on a Leash*, Fig. 712). Futurist art and literature revels in the potential of the new science of the twentieth century. Sculpture (Boccioni) seeks to make all three dimensions of object visible at once.

Dada
In response to WWI, art reflects nihilistic point of view. Nonsensical juxtapositions of ideas, anarchy without hope. Dadaists see society as undeserving of aesthetic principles. They attack tradition (Duchamp's *L.H.O.O.Q.*, Fig. 713). Duchamp's urinal (*Fountain*, Fig. 714) challenges the status of art's sacred or precious images.

Surrealism
More positive than Dada, exploration of dream images, and incorporation of chance events into compositions, i.e., *automatism*. Two basic forms of Surrealism exist: 1) Representational Surrealism, Salvadore Dali's and Giorgio de Chirico's psychological landscapes and citiscapes (de Chirico's *Melancholy and Mystery of a Street*, Fig. 715); 2) Abstract Surrealism, typified by the more highly

Kandinsky, who sees the material world disintegrating before his eyes.

WWI begins in August 1914. First use of poison gas in western warfare. Blaue Reiter painter Franz Marc dies on the Western Front.

Bolsheviks take power in Russia in 1917.

Treaty of Versailles ends First World War in 1918.

Women's Suffrage gains strength in the U.S. Establishment of Bauhaus in Weimer, Germany, 1923.

Theories of Freud and significance of the subconscious explored by Surrealists. Dreams being explored for their expressive content.

First television transmission, 1928.

abstracted and often simplified forms and shapes of Joan Miro (*Painting*, Fig. 716).

Picasso's *Guernica* (Fig. 717) embodies three primary characteristics of all twentieth century art: abstraction, expressionism, and surrealism. Becomes inspiration for new generation of American painters.

American Modernism

Lee Krasner effectively fuses European forms of abstraction (*Untitled*, Fig. 721). Mondrian's compositions (Fig. 722) inspire realist painters such as Hopper (*Nighthawks*, Fig. 723). Georgia O'Keeffe fuses expressionism and abstraction with landscape (*Purple Hills Near Abiquiu*, Fig. 724) and still lifes, creating emblematic paintings that reflect original American style.

Abstract Expressionism

Jackson Pollock influenced by Surrealist automatism. His Action Paintings become hallmark of Abstract Expressionist style with their energetic use of line, color, and ability to document actions of the artist (*Convergence*, Fig. 725). De Kooning's work has similar energy, but opens door to more representational imagery (*Woman and Bicycle,* Fig. 726). Mark Rothko revisits Kandinsky's interest in emotional power of color, but in quieter terms, making large color fields (*Four Darks in Red*, Fig. 727). During this same era, Frank Lloyd Wright designs the Solomon R. Guggenheim Museum in New York (Fig. 728).

Pop Art

Art reflects more humorous, less serious approach (Rauschenberg's *Bed*, Fig. 729). Common images from popular culture, advertising, television, magazines abound (Lichtenstein's *Whaam!,* Fig. 730). The

Great Depression takes place, beginning 1929.

Rise of the Nazi party in Germany, Hitler taking power in 1933.

Civil War wracks Spain, with Franco's Fascist forces supported by Hitler. Bombing of Guernica on April 26, 1937.

Works Progress Administration (WPA) started in 1935. Federal Arts Project employs artists and craftspersons throughout the U.S.

Germany invades Poland, 1939. WWII begins. Holocaust in 1941, migration of artists, writers, and victims of Nazi persecution to U. S.

Focus of art world shifts from Europe to New York City.

U. S. drops Atomic Bomb on Hiroshima, Nagasaki, ending war in 1945. A year later, ENIAC, the first computer, is built. The atomic age and the information age are simultaneously inaugurated.

In the 1950s, America postwar consumerism increases exponentially. Fast food industry with the advent of McDonald's and the TV dinner.

transformation of the commonplace into the monumental becomes dominant theme.

Minimalism

Addresses the notion of space and the material presence of shape and form, both in painting (Stella's *Empress of India*, Fig. 731) and sculpture. Minimalist sculpture reduces "artist intervention" in presentation of materials.

Beginning of space race with launch of Sputnik. And the Civil Rights Movement begins with integration of Little Rock schools.

Postmodernism

Pluralistic art incorporating diverse ideas and cultural values (Jimmie Durham, *Headlights*, Fig. 732, and Jaune Quick-to-See Smith's *Petroglyph Park*, Fig. 694). Art reflects new and old technologies intermixed. In architecture, postmodernism manifests itself in the collision of competing styles (I. M. Pei's Grand Louvre Pyramid, addition to the Louvre, Fig. 734). Reevaluation of traditional canons of art history, particularly roles of women artists (Kahlo's *Las Dos Fridas*, Fig. 735, and Chicago's *Dinner Party*, Fig. 736).

The question of identity is constantly mined in works such as Cindy Sheman's self-portraits (Fig. 737) and Jonathan Borofsky's *Man with a Briefcase* (Fig. 740). The mass media becomes a favorite subject (Kruger's *Untitled*, Fig. 738) and Holzer's electronic signboards, Fig. 747). Autobiographical anecdote informs otherwise formalist work (Truitt's *Nicea*, Fig. 739, and Marden's *Cold Mountain*, Fig. 742). George Green's *Magician* brings together in one work a multitude of stylistic effects (Fig. 741). Finally, Richard Gehry's new Guggenheim Museum in Bilbao (Fig. 745) and Richard Serra's sculptural *Snake* (Fig. 746), commissioned for the new museum's largest space, reflect the growing concern for **site-specific** art.

Assassination of JFK, 1963. Civil Rights Act signed into law the following year. By 1965, the U.S. has dramatically increased its military commitment to Vietnam. Youth movement rallies against the undeclared war.

Assassination of Martin Luther King, 1968.

Apollo XI lands on the Moon, 1969.

In the early 1970s, the Feminist Movement takes root, as well as the environmental movement after the first Earth Day is celebrated in 1970.

In the 1980s, copper telephone wire is replaced by glass fiber. AIDS epidemic begins.

In the 1990s, the Soviet Union collapses, the Berlin Wall comes down unifying Germany, and apartheid ends in South Africa.

THE VISUAL RECORD

THE CRITICAL PROCESS
Thinking about the History of Art

Artist Robert Rauschenberg draws on the history of art by incorporating images from history into his own work. In his 1962 painting *Crocus* (Fig. 748), he reproduces Diego Velázquez's *Venus and Cupid* (Fig. 749), known as the Rockeby Venus, in black and white. This activity of "appropriation" both announces the continuity of Rauschenberg's work with tradition and his difference, or independence, from it.

How has Rauschenberg transformed the earlier work? What ideas of "representation" inform both the Velázquez and his own? How do they differ? How has history changed our ideas of representation? These are just a few of the questions that might help you understand how art history informs Rauschenberg's art in particular and contemporary art in general.

REVIEW HINTS

If you are responsible for the materials in the last five chapters of *A World of Art*—the materials in the timeline—a good way to study is to make flashcards. Xerox each of the images. The quality need not be terrific—the image simply needs to be legible. Glue each of the xeroxed images onto its own piece of cardboard, and then write what you need to know about each image on the back of the cardboard. Though your flashcards will not be uniform in size, you can readily study them, mixing them up if need be, so that you can learn to recognize period styles, and so on. If you go on to take art history courses, which often require, especially in the beginning surveys, memorization work, you will find that this is a method of studying that is particularly valuable. Simply making the cards is a useful learning tool. Once they are made, you can master the material in relatively short order.

Appendix

Answer Key

Chapter 1 - A World of Art

1. They might serve as tools of ritual, social, or utilitarian function. They might serve to document events. Or they might help to record family and community relationships.
2. They all create visual images. They are all four *creative* people.
3. Physically, seeing is creative because in the act of extraction it chooses the information it decides to process. Psychologically, seeing is even more creative because the viewer's prejudices come into play. The viewer sees and interprets what is seen through the filter of a long history of fears, desires, customs, and beliefs.
4. b, c, d
5. a, b, d

Chapter 2 - Developing Visual Literacy

1. d
2. c
3. The subject matter of a work is what it *depicts*, while the content of a work is what the image *means*.
4. In *nonobjective* works of art, which are about their own form.
5. He believed that the characteristics of the facial features reflect a psychological reality within, a distinctly Western notion.
6. d
7. d

Chapter 3 - The Themes of Art

1. c
2. A genre painting is a depiction of everyday life.
3. b
4. Though in the cultures of their origin, objects such as cooking utensils or clothing might serve a simple utilitarian <u>function,</u> they are nevertheless all susceptible to <u>aesthetic</u> treatment.
5. c
6. d
7. b

Chapter 4 - Seeing the Value in Art

1. Sobieszek felt that Mapplethorpe's work documented his "tortuous" personal experience and was similar to van Gogh's "painting himself with his ear cut off."
2. Experiencer, reporter, analyst, and activist.
3. *The Judgment of Paris*. In his painting, Manet is judging the moral character of Paris, France, in the mid-nineteenth century.
4. d
5. b
6. d
7. c

Chapter 5 - Line

1. An outline delineates the edge of an object while a contour line defines its volume.
2. An implied line is any line that we percieve even though it doesn't actually exist as a mark. Examples are line of sight or the line that something makes moving through space.
3. Analytic or classical line. (Note that the figure's shoulders and arms form a pentagon.)
4. Analytic or classical line again (lending the figure its mechanical look).
5. Expressive line. Calder wants the public to associate his massive steel figure with natural, even insect-like forms.
6. Expressive line. The painting is about the dream world, a world opposite the world of reason and order embodied in classical or analytic line.

Chapter 6 - Space

1. c, d, e
2. Most simply, a shape is a two-dimensional form or area, the boundaries of which are measured in terms of height and width, while a mass is a three-dimensional form or volume, measured in terms of height, width, and depth.
3. If Mantegna had painted Christ's feet as large as they would appear to him from this angle, they would be so large as to be almost comical. In order to maintain the seriousness of the painting's theme, Mantegna has foreshortened Christ's feet.
4. a, b, c, d
5. b
6. b

Chapter 7- Light and Color

1. The cast shadow is the darkest area, and the highlight is the lightest.
2. a
3. a, b
4. a) green
 b) yellow
 c) orange
5. a) blue-violet
 b) green
 c) red-orange
6. Seurat utilized very small dots of color in his Pointillism, while Signac utilized larger squares and dashes of color in his Divisionism.

Chapter 8 - Other Formal Elements

1. Visual texture appears to be actual but is not.
2. b
3. Temporal media are those that cannot be experienced all at once, as spatial media can. Rather we experience them in a linear way.
4. a, b
5. A work can *suggest* the passing of time by, for instance, telling a story in a sequence of panels or actions; it can create the *optical illusion* of movement; or it can *actually* move.

Chapter 9 - The Principles of Design

1. Balance, emphasis and focal point, scale and proportion, repetition and rhythm, and unity and variety.
2. c
3. Proportion refers to the relationship of parts to the whole while scale refers to the relationship of a whole object to its context.
4. b
5. d
6. They are all the same, cast from the same mold, but positioned as they are in a semi-circle, they each look different.

Chapter 10 - Drawing

1. c
2. Vasari felt that drawing revealed the personality of the artist and that artists' draw-

ings comprised a sort of dictionary of their styles.

3. b

4. Pigments are the coloring agents of a medium; the binder is what holds the pigment together.

5. d

6. Scissors.

Chapter 11 - Printmaking

1. impression, edition, matrix, proofs

2. relief

3. intaglio

4. a

5. c

6. a, b

7. It is a very direct process, offering the artist an expressive gestural freedom comparable to the spontaneity and immediacy of drawing.

Chapter 12 - Painting

1. e

2. pigment, binder (or medium), support

3. encaustic

4. watercolor

5. turpentine

6. buon fresco and fresco secco. Leonardo used fresco secco. Moisture eventually crept under the paint, causing it to peel.

7. gesso

8. glazing

9. Oil painting's slow drying characteristics made it unsuitable for painting out-of-doors.

Chapter 13 - Sculpture

1. In low relief sculptures less than 180° of the figure extends from the base. In high relief sculptures more than 180° of the figure extends from the base.

2. Greek art is more naturalistic (compare Figs. 339 and 340).

3. c

4. d

5. In a construction the artist forms all of the parts that are put together, while in an assemblage the artist finds the various parts in the world.

Chapter 14 - Other Three-Dimensional Media

1. a, b, c
2. The warp is the vertical threads in weaving, held tight on the loom, and weft is the horizontal threads that are woven loosely over and under the warp.
3. d
4. b
5. In a construction the artist forms all of the part that are put together, while in an assemblange the artist finds the various parts in the world.
6. An installation is a work designed to fill interior space.
7. Collage is the process of pasting or glueing fragments of printed matter, fabric, or anything relatively flat onto a two-dimensional surface.
8. Photomontage is collage made of photographic fragments.

Chapter 15 - The Camera Arts

1. The photogenic process allowed for multiple prints while each daguerreotype was unique and not reproducible.
2. The calotype process allowed for much quicker exposure times.
3. c
4. Montage is the sequencing of widely disparate images to create a fast-paced, multifaceted image.
5. a, c
6. An *auteur* is a film director who worked, particularly, in the European "new cinema." The director is considered the "author" of the film.

Chapter 16 - Architecture

1. The horizontal beam supported on each end by a post.
2. d
3. c
4. keystone
5. b, c, d
6. a, b, c
7. For Sullivan, the primary function of a building was to elevate the spirit of those it housed. Thus the building's form should evoke what he called the "Infinite Creative Spirit."
8. b, c

Chapter 17 - Design

1. useful; workaday
2. His inability to find furniture suitable for his Red House.
3. b
4. Paris
5. a, c
6. machine for living in
7. architecture
8. mass appeal

Photo Credits